19th-Century
British Photographs

19th-Century British Photographs

from the National Gallery of Canada

Lori Pauli
with an essay by John P. McElhone

Ottawa, 2011

19th-Century British Photographs is the third in a series of publications focusing on selected masterpieces from the Photographs collection of the National Gallery of Canada.

The exhibition *19th-Century British Photographs from the National Gallery of Canada* is organized and circulated by the National Gallery of Canada.

National Gallery of Canada, Ottawa
4 February – 17 April 2011

National Gallery of Canada, Ottawa
Acting Chief, Publications: Ivan Parisien
Editor: Marcia Rodríguez
Picture Editor: Andrea Fajrajsl
Production Coordinator: Anne Tessier

Copyright © National Gallery of Canada, Ottawa, 2011

Designed and typeset by Fugazi, Montreal
Printed and bound in Italy by Conti Tipocolor, Florence

Cover: Oscar Gustave Rejlander, *Poor Jo* (detail), before 1862, printed after 1879 (cat. 45)

Library and Archives Canada Cataloguing in Publication
National Gallery of Canada
19th-century British photographs from the National Gallery of Canada / Lori Pauli; with an essay by John McElhone.
Exhibition catalogue.
Issued also in French under title: Photographies britanniques du xix^e siècle du Musée des beaux-arts du Canada.
"3" – Spine.

ISBN 978-0-88884-886-4

1. Photography – Great Britain – History – 19th century – Exhibitions.
2. Photography, Artistic – History – 19th century – Exhibitions.
3. Photograph collections – Ontario – Ottawa – Exhibitions.
4. National Gallery of Canada – Exhibitions. I. Pauli, Lori, 1960–
II. McElhone, John III. Title.

TR57 N37 2011 779.0941'09034 C2010-986007-1

Distribution
ABC Art Books Canada
www.abcartbookscanada.com
info@abcartbookscanada.com

Contents

Foreword

19th-Century British Photographs from the National Gallery of Canada is the third instalment in a series of exhibitions (and their accompanying publications) that showcase the depth and variety of our national collection of photographs. From the historically important paper negatives and "photogenic drawings" on paper by William Henry Fox Talbot done around 1839 to the sophisticated architectural studies in platinum made by Frederick H. Evans at the dawn of the twentieth century, the collection of nineteenth-century British photographs contains superb examples of works made over half a century.

The twenty-first century witnessed the change from a predominantly chemical medium to a digital one. While this has been swift and revolutionary in terms of picture making, an equally important transition took place during photography's first decades, as John McElhone demonstrates in his essay for this catalogue. At that time, photographers switched from using paper negatives to glass plates and from printing images on sensitized salted papers in favour of albumen-coated papers. Developments in photographic technologies resulted in evolving tastes and new ways of talking about photography and art.

Among the first British photographs from this period to enter the National Gallery of Canada's collection were a group of magnificent prints by Julia Margaret Cameron. These fourteen images were acquired between 1967 and 1968, the collection's formative years, by James Borcoman, the first Curator of the Photographs Department.

The history of photography and its early practitioners provided the guideposts for the National Gallery of Canada's collecting objectives. Four photographs by William Henry Fox Talbot were among the most important initial purchases. As the inventor of paper photography and the photographic negative, Talbot occupies not only a crucial place in nineteenth-century British photography, but also in the history of the medium itself. The National Gallery of Canada is fortunate in having enviable holdings of Talbot's early salted paper prints and paper negatives.

Over the years, more works by both Cameron and Talbot have been added to the collection, along with photographs by other British practitioners such as Anna Atkins, David Octavius Hill and Robert Adamson, Frederick H. Evans, Roger Fenton, Thomas Annan, Samuel Bourne, John and Harriet Tytler, John Thomson, and Henry Peach Robinson.

This outstanding collection could never have been realized without the generous support of donors, who, over the years, have shared their passion for photography. We are immensely grateful to Dorothy Meigs Eidlitz, Phyllis Lambert – whose gifts of many of the British daguerreotypes are now in the collection – the Melson family, the Lewall family, and the numerous other donors who have so richly enhanced our national collection.

Marc Mayer
Director and CEO
National Gallery of Canada

Acknowledgements

It is a privilege to work with the Photographs Collection at the National Gallery of Canada, and it has been deeply satisfying to research and write about some of the most important nineteenth-century British photographs that are part of this collection. I want to express my thanks to the Director of the National Gallery, Marc Mayer, and to the Board of Trustees for their continued support of the series of exhibitions that concentrate on the richness of the permanent collection.

I would also like to acknowledge my appreciation for the thoughtful guidance of Ann Thomas, Curator of Photographs, who oversees the entire series and who, along with Jim Borcoman, Curator Emeritus, is responsible for the acquisition of many of the superb photographs that make up this exhibition. They also authored several of the catalogue entries: cat. 19–21 and 66 and cat. 40 and 50, respectively.

Another colleague, John McElhone, Photographs Conservator, was an essential part of this project. I am grateful for his excellent analysis of the photographic processes of this period, which appears in the appendix of this catalogue, and for all of his good advice over the years.

I was honoured to have several experts on nineteenth-century British photography agree to write catalogue entries. Larry J. Schaaf (cat. 3, 26, 32, 48, and 52–55), Roger Taylor (cat. 9, 23–24, and 60), and David Harris (cat. 46) have all made important contributions that advance our understanding of some of the works in the collection.

The English editor for the catalogue, Marcia Rodríguez, was a major source of support. Her passion for the subject was evident through her careful reading of texts and her assistance with cat. 41, 47, 49, and 63. The French editors, Danielle Chaput, Sylvie Chaput, Mylène Des Cheneaux, and Danielle Martel, also cast a meticulous eye over the texts and made many valuable changes and suggestions. Julie Desgagné and Christine Gendreau expertly translated the English text into French. As usual, Andrea Fajrajsl in her role as Picture Editor was cheerful and unflappable in her pursuit of illustrations and plates for the catalogue. Thanks also to Anne Tessier for ensuring a smooth publication production schedule and to François Martin for his work on the design of the book. I am grateful for the patience of Ivan Parisien, who as Acting Chief, Publications, along with Serge Thériault, Director, Publications, New Media and Distribution, shepherded the project to its conclusion.

The organization of the exhibition and catalogue was greatly aided by the enthusiasm and hard work of several interns and summer students. Clare Mackenzie, first as an intern from Carleton University and later as a summer student, helped with researching biographical information for the artists whose work was selected for the exhibition and assisted with the collection of comparative illustrations as well as information about provenance for each work. I would like to extend my gratitude to Katherine Stauble, Sobey Curatorial Assistant, who carefully transcribed the inscriptions and annotations for each of the works and who looked after last-minute research requests with aplomb. Marie Lesbats (University of Paris), Rebecca Lesser (University of British Columbia), Courtney Murray (Carleton University), and Jennifer Roger (Ryerson University) all provided much needed assistance during different phases of the project.

Shawn Boisvert, Documentation Officer, managed various demands with a calm professionalism and Louise Chénier, Administrative Assistant, adeptly handled a variety of requests. I would also like to thank Mark Paradis, Chief, Multimedia Services, and Paul Elter, who worked on reproducing the images for both the catalogue and the electronic presentations for the exhibition.

Several individuals in the Exhibitions Department helped to ensure that the organization of the exhibition ran smoothly and efficiently, in particular, Karen Colby-Stothart, Deputy Director, Project Managers Christine La Salle and Anne Troise, and Travelling Exhibitions Coordinator Kristin Rothschild. Megan Richardson, Chief, Education and Public Programs, and Barbara Dytnerska, Education Officer, were

instrumental in arranging the educational activities that accompany the exhibition. David Bosschaart, Design Services, brought his impressive skills to bear on several elements of the exhibition installation. I also want to express my appreciation to Stephen Gritt, Chief, Restoration Conservation Laboratory, and Robert Roch, who completed a masterful restoration of the Melson daguerreotype frame. I owe a major debt of gratitude to Erika Dolphin, Assistant Curator, Chief Curator's office, for assisting with research into some of the photographs made in Spain and for her Spanish-language skills, which she used to help obtain in-text illustrations.

I would also like to acknowledge the many people who helped in answering research questions or other requests that arose during the writing of the entries for this catalogue:

Jodi Aoki, Trent University, Peterborough, Ontario; Christopher Bastock, Tate Gallery, London; Katalin Bikadi, Eötvös Loránd University Library, Budapest; Nuno Borges de Araújo, Braga, Portugal; David John Butler, Madrid; Bob Clark, The Auchindrain Trust, Furnace, Inverary; Malcolm Daniel, Curator in Charge of the Department of Photographs, Metropolitan Museum of Art, New York; Robert Evans, Carleton University, Ottawa; John Falconer, British Library, London; Lee Fontanella, Connecticut; Alison Gill, Manchester County Record Service; Sophie Gordon, Curator of Photographs, The Royal Collection, Windsor; Hope Kingsley, Wilson Centre for Photography, London; Hans P. Kraus, Jr., New York; Gerardo F. Kurtz, Madrid; Anne Leyden, Associate Curator of Photographs, The J. Paul Getty Museum, Los Angeles; Nicola Lovett and Joy Cann, City of York Library; Muriel Morris, Chilliwack, British Columbia; Charles Nes, New York; Frances Pattman and Lianne Smith, Archives, King's College London; Guy Peppiatt, London; David Simkin, Sussex; Philip Somervail, London; Carlos Texidor, Instituto del Patrimonio Cultural de España (IPCE) del Ministerio de Cultura, Madrid; and Carole Troufleau, Société française de photographie, Paris.

My heartfelt thanks go to Ken and Jenny Jacobson and Robert and Paula Hershkowitz, who rearranged their own schedules and provided me with kind hospitality during my research visit to England. Sincere thanks as well to Brian Liddy and the staff at the National Media Museum in Bradford, who allowed me to view dozens of photographs that greatly facilitated my research for this publication and exhibition, and to Marta Weiss and the staff at the Victoria and Albert Museum, who were incredibly helpful in several ways. Finally, a very special note of appreciation to Roger and Chris Taylor, who opened their home in Settle, England, to me for several days while Roger shared his meticulously kept research notes and answered a multitude of questions about individual photographers and British photography in general. I will always remember their kindness and generosity.

Lori Pauli
Associate Curator, Photographs
National Gallery of Canada

Introduction

The tantalizing idea that images could be created through the action of light upon silver salts was known in Britain long before William Henry Fox Talbot produced one of his first calotypes in 1833. Thomas Wedgwood, son of the famous Staffordshire potter Josiah Wedgwood, had conducted experiments with the English chemist Humphry Davy and created photograms, or what he called "sun prints," around 1800. But even before this time, in 1794, Elizabeth Fulhame published a book titled *An Essay on Combustion, with a View to a New Art of Dying and Painting,* which included her own discoveries about how light and silver reacted to form patterns and images on cloth.[1]

Although Talbot's inventions, first of photogenic drawing and then the calotype (a paper negative made by chemical development), originated and were used in Britain, the French invention of a photographic process known as the daguerreotype (a photographic image made on a piece of silver-plated copper) was also employed by several British photographers during this period. Louis Jacques Mandé Daguerre acquired a patent in Britain for his photographic process in 1839.[2] That same year Antoine Claudet, who was born in France but lived and worked in London, purchased a license to make daguerreotypes while on a trip to Paris. In 1840 a speculative businessman and former coal merchant named Richard Beard bought the rights, obtained originally by Miles Berry, to be the exclusive provider of daguerreotypes in "England, Wales, and the Town of Berwick-upon-Tweed and in all Her Majesty's Colonies and Plantations abroad."[3] Beard then sold licenses that granted daguerreotypists regional exclusivity in places such as Plymouth, Brighton, Bath, Liverpool, and Manchester. Later, he would also establish patents for refinements on Daguerre's method in Scotland and Wales.

The National Gallery of Canada owns thirty-two British daguerreotypes, including fourteen by Antoine Claudet. Most of the Claudet daguerreotypes are hand-coloured and appear to be portraits of the same extended family. Unique to the collection is a very large daguerreotype portrait (measuring an impressive 30.6 × 25.5 cm) of the polymath physician John Barritt Melson by an unknown photographer (see cat. 66). Daguerreotypes of this size were rare and variously referred to as Imperial or Mammoth plates.

Photographic albums and books form another important component in the National Gallery's nineteenth-century British photographic holdings. Copies of Talbot's seminal 1843 publication *The Pencil of Nature* and his 1844 paean to Sir Walter Scott, *Sun Pictures in Scotland*, are represented, as are albums by lesser known or anonymous photographers. A small album known as the *Hatfield Rectory* album (see cat. 67) falls into this category. Made up of a mixture of salted paper prints and albumen prints, this poignant family keepsake was made to commemorate the death of a well-loved rector of the Hertfordshire village of Hatfield.

The Photographic Album for the Year 1855 (see fig. 9 in John McElhone's essay) has a special place in the collection. Dated to the midpoint of the century, the album occupies a pivotal position representing both a culmination of photography from its earliest days and a view forward, providing a compendium of the various directions photography would take over the second half of the century. The physical manifestation of a group of like-minded enthusiasts who came together in 1853 to found the Photographic Society, the album also contains images by many of Britain's leading photographers, along with others who would remain at the periphery of the medium's history. The Society published a journal,[4] held annual exhibitions, and organized meetings where members could present papers on aesthetics or on their latest photographic discoveries and inventions. In about 1856, the Photographic Society Club was born, a more exclusive sub-group of the main Society with a limited membership and the goal of arranging photographic excursions to various locations and of producing two photographic albums.

The Photographic Album for the Year 1855 contains forty-four photographs, each with a text including technical information about the making of the photograph, such as the kind of lens used, the date and weather conditions, and the type of negative employed. These facts were often accompanied by a more literary text – usually lines from a poem – that prompted viewers to regard the photographic image as a visual allegory. Many of the texts alluded to the brevity of youth, for example, William Lake Price's *The Miniature* (cat. 44), Fallon Horne's *Youth and Age* (cat. 30), Philip Henry Delamotte's *Innocence* (cat. 15), Joseph Cundall's *The Alms-House* (cat. 13), and Henry White's *The Garden Chair* (cat. 64). Other images constituted nostalgic references to Britain's rural past, a sentiment expressed in Robert Howlett's elegiac *The Valley of the Mole* (cat. 31), Benjamin Brecknell Turner's *Bredicot Court* (cat. 61), and Thomas Mansell's *Highland Cottage, Village of Ardnahèrra, Loch Fine* (cat. 37). Mansell, an amateur meteorologist, suggested that all contributors to the album include as much detail as possible about the conditions and equipment that were involved in making the photograph. The combination of scientific data and poetry is symptomatic of the ambivalent status of photography in this period. As Steve Edwards has shown, the place of photography by the 1860s in Victorian Britain was an unstable one, hovering between the classifications of scientific "documents" or fine art "pictures."[5]

The Photographic Album for the Year 1855 is also a microcosm for some of the major shifts that occurred in photographic technology over the course of the nineteenth century. The transition from salted paper prints to albumen silver can be seen by the type of prints included on the pages of this album. The quest for sharpness in photographic images was a common theme in much of the photographic literature of the time, and the introduction of the wet-plate collodion negative process in 1851 ushered in a new photographic aesthetic. The change from salted paper to albumen was a gradual one and involved numerous experimentations and variations. As a consequence, the identification and classification of these prints has become a tricky business, but one that John McElhone, using *The Photographic Album for the Year 1855* as his case study, has set out to untangle in his essay for this catalogue (see pp. 169–85)

Exactly who was making photographs also shifted from the days of photography's beginnings in Britain in the 1840s up to the close of the century. What began as a series of experiments conducted by men of science quickly turned into a leisure activity for wealthy upper-class men and women.

Rapid changes in photographic technology coupled with an insatiable public desire for images meant that not long after its invention, photography as a source of employment or pleasure was available to the middle and in some cases even to the working class. Census records show that several of the photographers whose work is now part of the National Gallery of Canada's collection began their professional lives as opticians, lens makers, chemists, or merchants. The nineteenth-century photographer in Britain was also increasingly female. While figures such as Julia Margaret Cameron (see cat. 8 and fig. 1)[6] or Anna Atkins (see cat. 3) have had their photographic work recognized through publications and exhibitions, the contribution of hundreds of other women, from the often underacknowledged work of a photographer's spouse, as in the case of Charles Clifford's wife, Jane (see cat. 12 and figs. 12.1 and 12.2), and the unknown recorders of family albums, to the armies of women who were hired to hand-colour photographic prints or do other more menial chores in the studio, waits to be fully examined.

The National Gallery's collection of nineteenth-century British photographs also reveals some of the major preoccupations of the period, subjects that were of interest to photographers of the Victorian era along with the tastes, biases, and prejudices of their time and place. Ideas about the importance of family, for instance, can be discerned in carefully assembled albums. A desire to record the likenesses of family and friends is evidenced by the explosion of photographic studios and the thousands of portraits that emerged from them. Many of the most eloquent examples came from the photographic team of Hill and Adamson (see cat. 27 and 28 and fig. 2), whose intimate portraits of associates, friends, and family are now invaluable records of a small slice of Scottish culture and some of its major figures at mid-century.

A growing awareness about how disease was spread and the need for a re-shaping of the urban environment inspired projects such as Thomas Annan's *The Old Closes and Streets Etc. of Glasgow* (see cat. 2). In addition, the British public became more attuned to the plight of the poor, partly through the works of authors such as Charles Dickens and Henry Mayhew.[7] Images like Oscar G. Rejlander's *Poor Jo* (cat. 45) or the series of photographs titled *Street Life in London* (see cat. 59) provided visual illustrations of social issues.

Britain's role as a colonizing nation resulted in the production of photographic images of exotic lands and their people. Francis Frith's views of the monuments and landscapes of Egypt (see cat. 25),

Fig. 1 Julia Margaret Cameron, *Mrs. Duckworth (Mrs. Leslie Stephen),* April 1867, albumen silver print. National Gallery of Canada, Ottawa (21276)

Fig. 2 David Octavius Hill and Robert Adamson, *Lady Ruthven,* before December 1847, printed July 1905, photogravure. National Gallery of Canada, Ottawa, Gift of Dorothy Meigs Eidlitz, St. Andrews, New Brunswick, 1968 (34999.44)

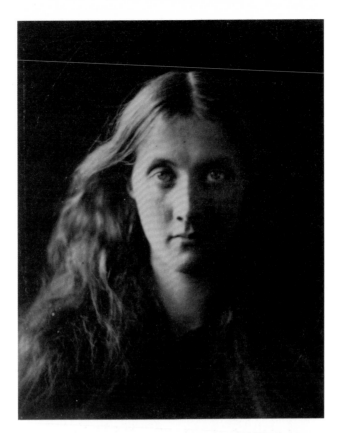

Samuel Bourne's images of the architecture of India (see cat. 6), studies by W. L. H. Skeen & Co. of Ceylon's plantation economy (see cat. 49), and even Julia Margaret Cameron's moving portraits of the unfortunate Abyssinian boy-prince Dejátch Álámáyou (see cat. 8) were all made possible through British political interests in many of these countries, along with a wider curiosity about travel to faraway places and the urge to record what was there.

Increasing industrialization during this period significantly determined what kinds of subjects were photographed. Examples of the influence of technological invention can be seen in Roger Fenton's images of the construction of Charles Vignoles's bridge over the Dnieper river (see cat. 22), William England's views of the Niagara railway suspension bridge (see cat. 18), the records by James Valentine & Sons of the Forth Bridge (see cat. 63), or James Mudd's portraits of steam-powered trains (see cat. 40). These advances in industrialization also had the effect of arousing the concerns of many about the mechanization of their world, resulting in a longing for Britain's rural past,[8] an emotion probably best articulated in the work of Peter Henry Emerson, particularly his volume of photographs titled *Life and Landscape of the Norfolk Broads* (see cat. 17). Other photographers, including Francis Bedford, Henry Peach Robinson, and, later, Frank Meadow Sutcliffe, were engaged in a similar romanticization of the English countryside.

A nostalgic view of Britain can also be understood as part of the inspiration for many of the architectural photographs that were made at this time. Images of London's older buildings by the brothers Alfred and John Bool and Henry Dixon, Archibald Burn's records of Edinburgh, or Robert Cheney's views of country estates are all based on a desire to, at least photographically, preserve the past. Frederick Evans's interest in British cathedrals went far beyond a need for historical record. His delicately toned platinum images reveal not only a profound understanding of Gothic architecture, but also a consummate mastery of the photographic medium that allowed him to translate the spiritual ecstasy that lay behind its physical forms.

British photographers of the nineteenth century used the new medium as a way to show and record the wonders and inventions of the age. The discoveries of science and the marvels of the natural world became the subjects of early photography. Examples such as Anna Atkins's brilliant blue cyanotypes of algae or the photograms of ferns made by a number of photography and fern enthusiasts, including the work of three unknown photographers (see cat. 34 and figs. 3 and 4) allowed plant collectors to consult detailed documents without the distortions or eventual degradation that resulted from the use of real specimens.

The Great Exhibition of 1851[9] and the Manchester Art Treasures Exhibition in 1857 were significant events for the development of British photography. At once objects for display and as records of the exhibition and its contents (see, for example, cat. 42, Hugh Owen's photograph of a camel gun), photographs enjoyed a new and exciting presence at the Great Exhibition's Crystal Palace. Reportedly more than one million people visited the Art Treasures Exhibition in Manchester, where over five hundred photographs were on view, including Oscar G. Rejlander's controversial *Two Ways of Life*, which was later purchased by Queen Victoria and Prince Albert, both enthusiastic supporters of the new art of photography.

The Victorian drive to invention and a sense of wonder are clearly manifest in the National Gallery's collection of nineteenth-century British photographs. These images are the visual clues to some of the remarkable events and discoveries that occurred during Queen Victoria's reign. Ideas about social reform and "progress" along with an unquestioning optimism about Britain's place as both a past and future leader in all things are implicit in many of the photographic images from this era. The photographs are evidence of their makers' fascination with the natural world, their need to understand how things work, their compulsion to codify, to document, and to act as witnesses to the previously unseen or unknown. These records of a not-so-distant past also serve as potent reminders of our common frailties and provide glimpses into our shared humanity.

Fig. 3 Unknown (British, mid-19th century), *Untitled (Study of Ferns)*, c. 1855, albumen silver print. National Gallery of Canada, Ottawa (42475.93)

Fig. 4 Unknown (British, mid-19th century), *Hypolepis eepeny*, c. 1855, cyanotype. National Gallery of Canada, Ottawa (39164)

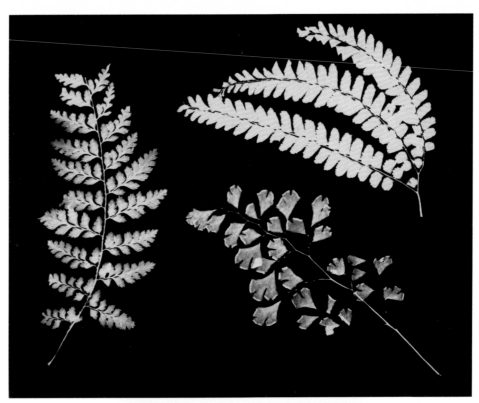

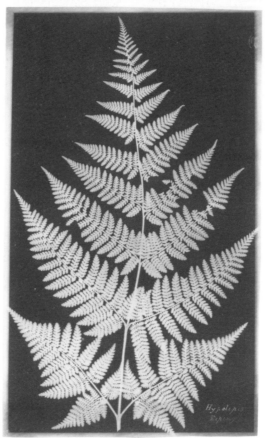

Note to the Reader

Dimensions for prints – height × width in centi-
metres – are for the image/sheet. If the image
is smaller than the sheet, the size of each is noted
separately. Plate dimensions are given for
daguerreotypes. Inscriptions are handwritten by the
artist; annotations are by others, or are printed
mechanically.

Abbreviations

u.l.	upper left
u.c.	upper centre
u.r.	upper right
c.l.	centre left
c.	centre
c.r.	centre right
l.l.	lower left
l.c.	lower centre
l.r.	lower right
t.	along or at the top
b.	along or at the bottom
l.	left
r.	right
[...]	an erased or illegible portion of the inscription or annotation

Catalogue

Near Blencarn, Cumberland 11 March 1813–1877 Rome
Fountain of the Villa Medici **c. 1865**
Albumen silver print, 27.4 × 40.3 cm
40647

Inscriptions secondary support, l.l., graphite [erased], *Italie*, verso, l.l., graphite, *Rome. Terrasse devant. la Villa Medici*, l.c., *2724.96*

Provenance collection of André and Marie-Thérèse Jammes; purchased from Hans P. Kraus Jr., Inc., New York, 2001

In *Fountain of the Villa Medici*, the photographer has taken particular care to emphasize the broad masses of dark foliage and the deep pools of shadow cast by the trees that flank the oval basin of a fountain. Through the natural arch created by the two trees, St. Peter's Basilica and the surrounding buildings of Rome shimmer in the distance, in delicate contrast to the silhouetted heavier forms of the fountain in the foreground. According to one legend, the sixteenth-century fountain incorporated a cannonball that Queen Christina of Sweden had had fired, without any apparent provocation, onto the Pincio hill from the Castel Sant'Angelo in 1655. The nearly perfect balance of the composition with water gushing through the sphere in the centre of the fountain is echoed by the celebrated dome, made famous by Corot in his painting *Fountain of the French Academy – Rome* (fig. 1.1). The view had been a popular subject of paintings by many other artists, including Valenciennes, Michallon, and Goethe.

Recalling his visit to Rome in the mid nineteenth century, the American travel writer George Hillard recommended the fountain as meriting a detour: "It is an attractive sight, not merely from its good proportions and unpretending simplicity, but from its fine position and its harmony with the objects around it. The view of St. Peter's over its flowing and restless waters, though not set down in the guidebooks, is well worth a long and patient look."[1]

The photograph is attributed to James Anderson, partly owing to his reputation as a photographer of Roman sites and antiquities, and also because he made other, similar views of the same subject (see fig. 1.2). Born Isaac Atkinson to Harriet (née Topping) and John Atkinson, Atkinson/Anderson studied to be a painter, later adopting William Nugent Dunbar as a nom d'art. He changed his name to James Anderson when he moved to Rome in 1838 and began exhibiting his paintings.[2] Turning to the new art of photography and taking advantage of the burgeoning tourist industry, he quickly established himself in the city as a photographer and began selling his photographs around 1849, primarily through Josef Spithover's publishing firm. He married Maria de Mutis, with whom he had four sons. Founded in 1853, Anderson's photographic firm was taken over by his eldest son, Domenico, and eventually by his grandsons. The business was finally closed in the 1950s and the prints and negatives became a part of the Alinari Archives in Florence.

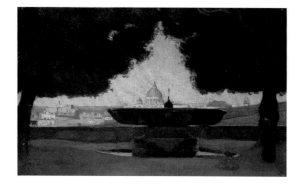

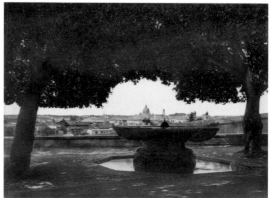

Fig. 1.1 Jean-Baptiste-Camille Corot, *Fountain of the French Academy – Rome*, 1826–28, oil on canvas. Dublin City Gallery, The Hugh Lane Municipal Gallery of Modern Art

Fig. 1.2 James Anderson, *Panoramic View of Rome with St. Peter's Basilica, from the Garden of Villa Medici*, c. 1890, albumen silver print. Alinari Archives

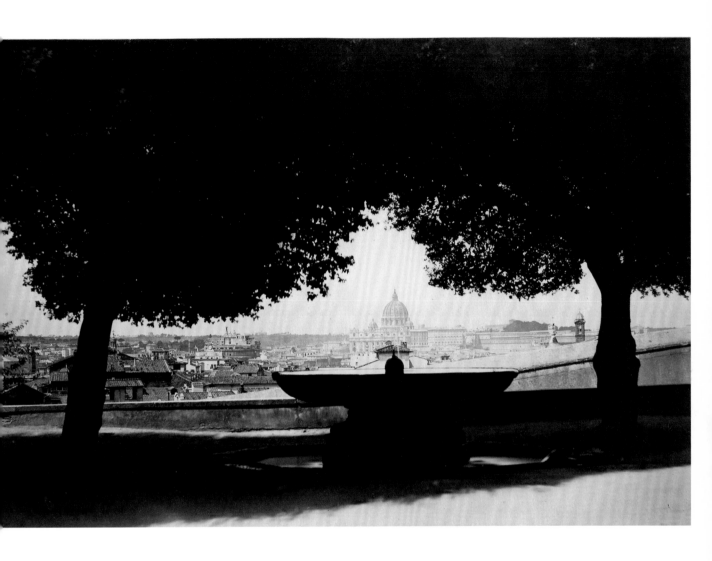

2 Thomas Annan

Dairsie, Fife 14 July 1829–11 December 1887 Lenzie, East Dunbartonshire

Close, No. 193 High Street **1868, printed c. 1878–79**

Carbon print, 28.1 × 23.1 cm

26751

Annotations secondary support, l.c., letterpress, *9. Close, No. 193 High Street.*, l.r., graphite, *R290*; verso, l.l., graphite, *24*

Provenance purchased from Yarlow/Salzman Gallery, Toronto, 1981

The fifth of seven children born to Agnes (née Bell) and John Annan, Thomas Annan set out to learn the trades of lithographic writing and engraving.[1] Following an apprenticeship that lasted about four years, he moved to Glasgow, where he worked as a lithographer for Joseph Swan's firm. Annan may have acquired his photographic skills from Swan, or possibly from his friend David Octavius Hill.[2]

In 1855 Annan and a medical student named Berwick set up a photography business in Woodlands Road, announcing themselves as "collodion calotypists." The partnership lasted only two years, and by 1857 Annan had moved the firm to Sauchiehall Street.

Close, No. 193 High Street was made for what has become Annan's most famous body of work, *The Old Closes and Streets Etc. of Glasgow*. The Glasgow City Improvements Trust commissioned the photographs in order to provide a historic record of the buildings and closes[3] in an eight-acre area in Glasgow's centre. Dark, unsanitary, and at times dangerous, these urban slums were slated for demolition. Annan began the project in 1868, and by the time he finished three years later, he had made thirty-one images, with two sets of albumen prints.[4]

The series is a fascinating glimpse into a rarely seen side of Victorian life.[5] Ranging from long, narrow views down dark passages to more open and sometimes crowded squares (see fig. 2.1), Annan's photographs now stand as poignant records of Glasgow history. In *Close, No. 193 High Street*, we see a long passageway between two tenement buildings, the cobblestone ground streaked with water that seems to leak from the building on the right and pool on the ground towards the left of the image. Four ghostly figures are just barely visible in the picture – most obvious are the two small children in the foreground. In the background are two other figures: one leans against a wall on the right while a woman stands looking directly toward the photographer in the centre. Because the figures moved while Annan was exposing the wet collodion plate, their features are blurred. The low levels of light meant that he was forced to use lengthy exposure times, with the result that many who posed impromptu could not stay still long enough for the camera to capture a detailed likeness. High above the scene, white clouds provide a sharp contrast to the dank atmosphere of the street below, and the laundry is animated by the moving air that enters from above the rooftops.[6]

Annan was also commissioned to make photographs of the building of the Loch Katrine waterworks in 1859, which supplied Glasgow's population with clean water.[7] This civic initiative offered one of the solutions to improving the squalid conditions depicted in *Old Closes and Streets*.

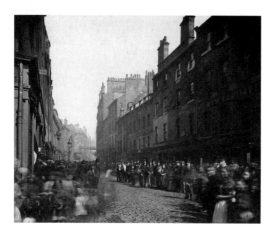

Fig. 2.1 Thomas Annan, *Saltmarket, from Bridgegate*, 1868, printed c. 1878–79, carbon print. National Galllery of Canada, Ottawa (26750)

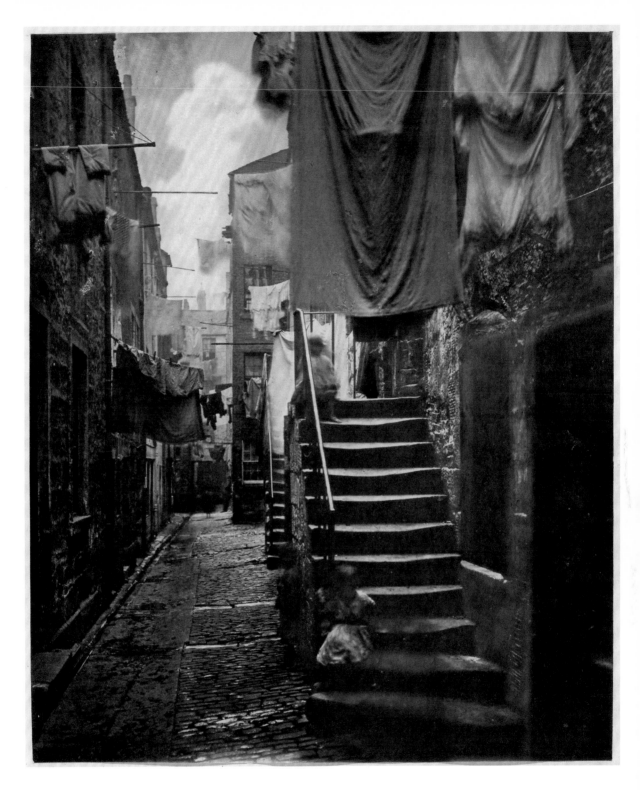

Tonbridge, Kent 16 March 1799–9 June 1871 Halstead Place, Kent

Polypodium crenatum, Norway 1854

From Cyanotypes of British and Foreign Flowering Plants and Ferns, 1854

Cyanotype, 32.9 × 23.6 cm

19712

Inscriptions l.c., in negative, *Polypodium crenatum / Norway*; secondary support, u.r., graphite, partially cut off at right edge *33* (or *38* [?])

Provenance purchased from Robert Hershkowitz, London, 1983

Ancient Celts endowed ferns with special properties, marvelling that they reproduced magically without seeds. Conjuring up the magic of photography, Anna Atkins harnessed the hidden reproductive powers of Nature. A skilled draftswoman, her dynamically composed fern commands our attention from a distance while still rewarding minute inspection. Botanists were one of the first scientific groups to embrace photography, for the early promise was of exacting reproduction of detailed forms, accomplished quickly and inexpensively. Atkins was justly celebrated for her pioneering photographically illustrated book, *British Algae: Cyanotype Impressions*.[1] Issued in parts from 1843 to 1853, each copy included more than four hundred plates, each plate an original photograph executed on a sheet of hand-coated paper. Atkins knew fellow botanist William Henry Fox Talbot and experimented with his silver-based photographic process. But for her book, she turned to the 1842 invention of another friend, Sir John Herschel, whose cyanotype, or blueprint process employed the light sensitivity of iron salts. Atkins positioned her dried seaweed on the coated paper and placed this under glass in the sunlight. Within minutes, solar energy had worked its sleight of hand and a trace image became visible. Plunged into plain water, the affected iron compounds formed the familiar pigment Prussian blue. Acting the role of photographic "negative," the specimen was used to make additional copies of that plate, each a faithful translation of the original plant.

The attractive blue colour of the cyanotype was its natural state. Although nothing could have been more appropriate for "the flowers of the sea," the process resulted in portraits suggestive of melancholy and landscapes of moonlight, limiting its use. For botanists, the colour was not a drawback, but Nature's plant modulated the light passing through it to the paper, leaving behind an unfamiliar shadow of itself – a silhouette or photogram. Ironically, the veracity of photography also proved to be a drawback, for the image was tied to a specific specimen, not necessarily typical in all its parts. Expensive hand-drawn engravings continued to be the mainstay of botanical illustration (see fig. 3.2).

Atkins was an accomplished watercolourist and lithographer. In the decade of publishing *British Algae*, she had come to appreciate the cyanotype's expressive powers. Completing her monumental book, she turned to feathers and various botanical subjects, seemingly for their sheer visual pleasure. A close childhood friend and sometimes collaborator was Anne Dixon (a distant relation of Jane Austen). In 1854 Atkins presented her with a unique album, *Cyanotypes of British and Foreign Flowering Plants and Ferns*, its photographs larger than those of the algae, perhaps to accommodate the typically larger sizes of the ferns. *Polypodium crenatum* is one of its 160 plates.

Fig. 3.1 Anna Atkins, title page, *Cyanotypes of British and Foreign Flowering Plants and Ferns*, c. 1854, cyanotype. Victoria and Albert Museum, London (Ph.379-1981)

Fig. 3.2 *Athyrium filix-femina*, coloured engraving of a fern, 19th century. From Prof. Dr. Otto Wilhelm Thomé, *Flora von Deutschland, Österreich unde der Schweiz* (Gera, Germany, 1885).

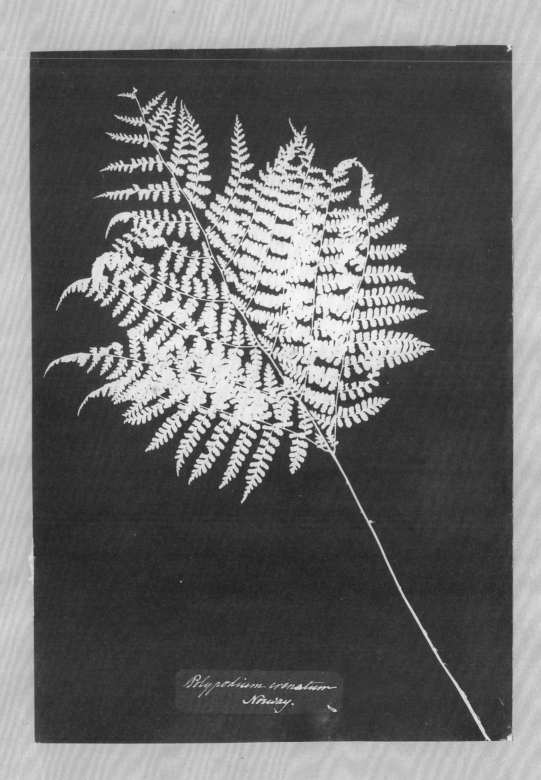

Polypodium crenatum
Norway.

London 1816–May 1894 London
The Waterslide, Badgworthy 1870s
Albumen silver print, 19.7 × 28.6 cm
20789

Annotations l.l., in negative, *Bedford, 2047.*, l.r., *The Waterslide, Badgworthy.*

Provenance purchased from George Eastman House, Rochester, New York, 1972

Following a tradition that began in the eighteenth century, Francis Bedford chose to depict parts of Britain that were rich in historical connotations. The waterslide at Badgworthy (see fig. 4.1) would have been of interest to anyone familiar with R. D. Blackmore's romance novel *Lorna Doone* (1869), and it is probable that Bedford decided to photograph this site because of the book's popularity. The so-called waterslide at Badgworthy (the rock structure provides a series of small steps over which the water cascades until it reaches a still pool at the bottom) was the site where John Ridd, the hero of the novel, first meets Lorna Doone, the eponymous heroine.

Bedford began his career in the office of his father's architectural firm and had established himself in the field of architectural drawing and as a lithographer before taking up photography in 1851. His father, Francis Octavius Bedford, was known for his essays in Greek Revival architecture and for the design of at least six churches in England.

The younger Francis Bedford worked as a lithographer on several commissioned projects, including *A Chart Illustrating the Architecture of Westminster Abbey* (1840), *A Chart of Anglican Church Architecture Arranged Chronologically with Examples of Different Styles* (1843), and *The Church of York* (1843). Bedford was also responsible for the chromolithographs that were used to illustrate Owen Jones's *The Grammar of Ornament* (1856). The author's acknowledgements praised Bedford for the fine work that he managed to complete in less than a year. Among his other accomplishments, he exhibited watercolours and drawings at the Royal Academy between 1833 and 1849.

In 1854 Queen Victoria invited Bedford to photograph several objects from the royal collection.[1] Eight years later, he was asked to accompany the Prince of Wales on a royal tour of Egypt and the Holy Land, where Bedford completed a series of photographs about the places the prince visited.

Bedford became well known for his photographic views of the English countryside. His photography business flourished, and from 1867 until 1893, it was operated by Bedford's son, William. Francis Bedford retired from photography before 1880; he deposited two thousand of his negatives with the firm of Frith & Co. (see cat. 25), who printed and published them.

24 Catalogue

Fig. 4.1 *Badgworthy Waterslide*, tinted postcard, Frith series (2047B), Frith & Co.

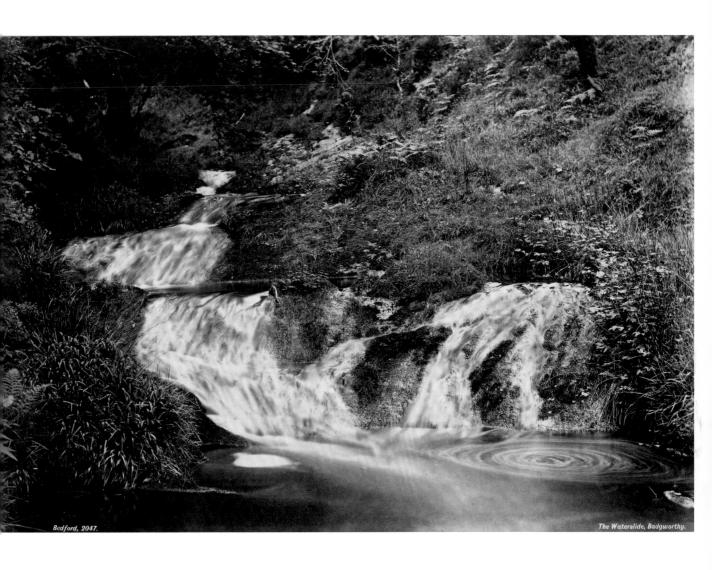

Bedford, 2047.

The Waterslide, Badgworthy.

5 A. & J. Bool

Alfred Henry Bool
1844–8 December 1926 Wimbledon
John James Bool
1850–14 December 1933 Pimlico, London
***The Oxford Arms, Warwick Lane* 1875**
Carbon print, 23.6 × 18.6 cm
20929

Annotations secondary support, l.c., letterpress, *THE OXFORD ARMS, WARWICK LANE, 1875*, l.r., letterpress, *THE SOCIETY FOR PHOTOGRAPHING RELICS OF OLD LONDON. / PHOTOGRAPHED BY A & J BOOL, 86 WARWICK STREET. PIMLICO. S. W*

Provenance purchased from Howard Ricketts Ltd., London, 1977

Threatened with demolition in 1873, the Oxford Arms Inn, originally constructed in the seventeenth century, was used as a "coaching inn" by visitors arriving by carriage to visit the Newgate Market. A group of concerned Londoners came together in 1875 under the name of the Society for Photographing Relics of Old London in order to record through photographs some of the city's disappearing buildings. Located near St. Paul's Cathedral, the Oxford Arms Inn was to be taken down in 1875 to make room for the additions that were planned for the Old Bailey courthouse. The inn had been demolished by the end of 1877, and the site eventually became filled with warehouses.

The project of photographing some of London's historic buildings was a successful one, and the initial series sold to a large number of subscribers. Each of the photographs was accompanied by a text that gave a brief description of the structure and its historical importance, written by the Society's Honorary Secretary, Alfred Marks. The series of photographs was intended to be of interest, not only to those involved with architectural preservation, but also to working architects and artists. The brothers Alfred and John Bool were replaced as photographers in 1879 by Henry Dixon (see cat. 16), who is also credited with making the carbon prints from many of the Bools' earlier negatives. The photographic series was completed in April of 1886 and resulted in a total of 120 images.

The Oxford Arms Inn was photographed from several vantage points (see figs. 5.1 and 5.2), and this particular one was probably taken from a window of the Old Bailey. Although most views of the inn rarely contain people, when they do, as is the case in this image, the aim is to impart a sense of scale. Here, the solitary figure lit from behind adds a picturesque quality, giving the viewer an idea of the complex spaces that were a part of this piece of old London.

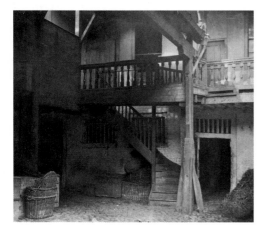

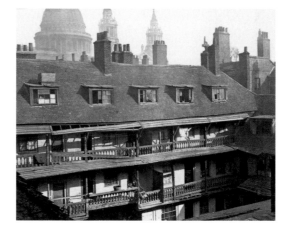

Fig. 5.1 A. & J. Bool, *The Oxford Arms, Warwick Lane*, 1875, carbon print. Boston Museum of Fine Arts, Gift of Richard Germann, 2001 (2001.293)

Fig. 5.2 A. & J. Bool, *The Oxford Arms, Warwick Lane, 1875*, 1875, carbon print. National Gallery of Canada, Ottawa (20930)

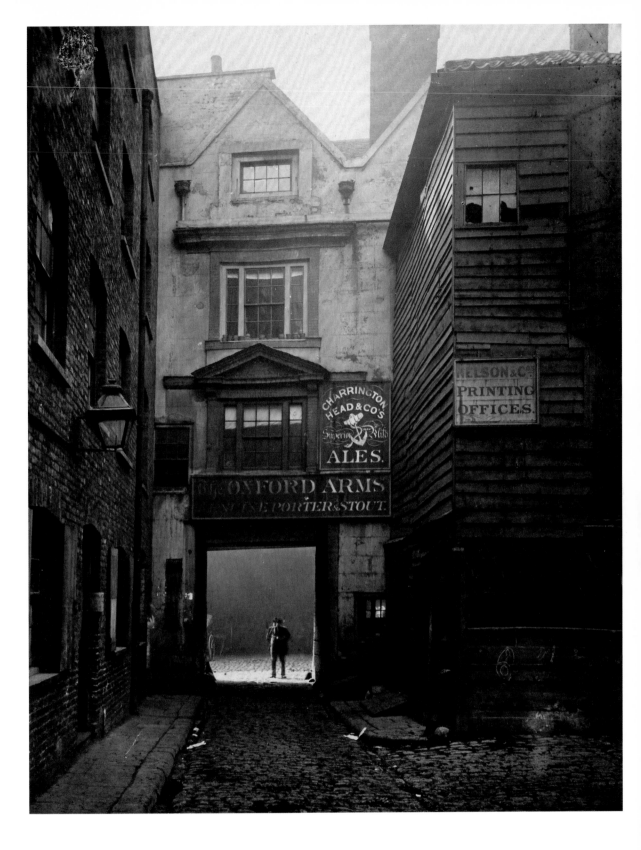

6 Samuel Bourne

Mucklestone, Shropshire 30 October 1834–24 April 1912 Nottingham

The Fort, Deeg c. 1865–June 1866

From *India*, c. 1863–70

Albumen silver print, 22.8 × 28.8 cm

21044.4

Inscriptions l.r., in negative, *Bourne 1315*

Annotations l.l., in negative, letterpress, *THE FORT. DEIG. 1315*, secondary support, verso, l.l., graphite, *4*

Provenance purchased from Daguerreian Era, Pawlet, Vermont, 1972

Built in 1730, the fort at Deeg is located near the city of Bharatpur in Rajasthan, India. The entire fortification was surrounded by a moat, with seventy-two bastions dotted around the perimeter. In 1865 Fort Deeg was already starting to show signs of its age, when Samuel Bourne, a British banker turned photographer, came to record part of its massive stone wall. The simple form of the bastion is echoed in the gently curving line of the water's edge in the moat below, adding an element of the picturesque to the otherwise starkly isolated and decontextualized architectural forms.

Bourne, the son of Thomas and Harriet Bourne, grew up in a Shropshire farming family. As a young man, he was employed at the Moore and Robinson's bank in Nottingham. His interest in photography began in the mid-1850s after having seen a daguerreotype portrait of his uncle made by Richard Beard.[1] Soon afterwards, Bourne himself was making photographic excursions throughout the Lake District, where he sought out picturesque landscapes in addition to making photographic studies closer to home, such as the construction of the Great Northern Station in Nottingham. He became one of the founding members of the Nottingham Photographic Society and exhibited his photographs there in 1859.

Bourne made his first trip to India in 1863, travelling to Calcutta, where he established a photographic partnership with another photographer, William Howard (the firm, which later included Charles Shepherd, became known as Bourne and Shepherd). While in India, Bourne photographed the Himalaya mountain range, and various other landscapes and views of historically significant sites and architecture. He also photographed groups of local people, including a portrait of three Kashmiri women posed in front of a large curtain presumably set up out of doors (see fig. 6.1). Bourne made at least two photographs of men in the Kulu valley using inflated animal skins, or "mussacks," as floating devices for crossing rivers when bridges had been washed out in the monsoon season. In one of these images, Bourne has included a view of the tent that he would have used for developing his photographic plates (see fig. 6.2).

Bourne made one trip back to England for a short time in 1867 in order to marry his fiancée, Mary Tolley. The couple returned to India, where Bourne continued to work as a commercial photographer. He finally completed his work in November of 1870, then settled in Nottingham, where he went into the cotton manufacturing business with his brother-in-law, James Tolley.

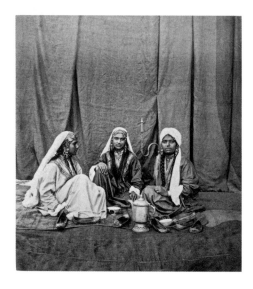

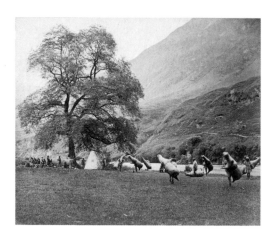

Fig. 6.1 Samuel Bourne, *Women of Kashmir*, c. July–September 1864, albumen silver print. National Gallery of Canada, Ottawa, Gift of Donald C. Thom, Ottawa, 1983 (19829)

Fig. 6.2 Samuel Bourne, *Mussacks for Crossing the Beas River below Bajaura, Kulu Valley*, c. July-August 1866, printed after December 1866, albumen silver print. National Gallery of Canada, Ottawa (21043)

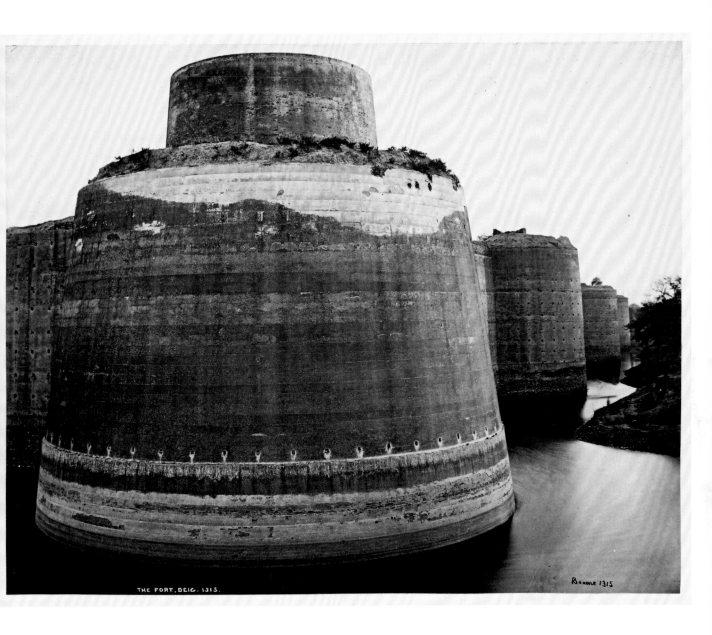

THE FORT, DEIG. 1315.

Bourne 1315

7 Archibald Burns, Attributed to

1831–29 January 1880 Edinburgh
White Horse Close, Edinburgh, No. 1 February 1871?
From ***Views of Old Edinburgh*** album
Albumen silver print, 20.0 × 24.3 cm
21245.20

Inscriptions secondary support, l.r., graphite, *White Horse Close, No 1.*

Provenance purchased from Sotheby's, London, through Daguerreian Era, Pawlet, Vermont, 1975

Archibald Burns was probably practising photography as an amateur about a decade before his name first appeared in the Edinburgh trade directories in 1867. He lived at Rock House, as did another, more famous, Scottish photographer, Thomas Annan. From 1871 to 1880, Burns also used the same photography studio as Robert Adamson and D. O. Hill (1843 to 1847) and Thomas and John Annan (1869 to 1871). Burns exhibited twenty stereographs titled *Views in Scotland* at the Edinburgh Photographic Society of Scotland in 1858, and in 1868 he had fifteen albumen prints published in *"Picturesque Bits" from Old Edinburgh*.[1] In 1867 the Edinburgh Improvement Act was passed and the Edinburgh Improvement Trust commissioned Burns to make photographs of the city's Old Town, which included White Horse Close.

Located near the Palace of Holyroodhouse in the Canongate area, White Horse Close is an Edinburgh historic site that has also been known as Laurence Ord's Close and Davidson's Close.[2] The close dates back to about 1623, but the buildings have been modified at various times, including a renovation by James Jerdan in 1889 to build workers' housing and an extensive redevelopment in the 1960s by Frank Mears & Partners: "The E side very self-consciously picturesque, the N end a Hollywood dream of the [seventeenth century]."[3] It is believed that White Horse Close acquired its name from the fact that Mary, Queen of Scots, kept her favourite saddle-horse in the royal stables that were once located here. In the seventeenth century, the close was the final destination for stagecoaches arriving from London. According to Sir Walter Scott's account in his novel *Waverly,* the buildings at White Horse Close (then known as Boyd's Inn and only later as the White Horse Inn) were also used as lodgings for Jacobite soldiers, supporters of Bonnie Prince Charlie, when they arrived in Edinburgh in 1745.

The significance of this otherwise humble close was recognized by several artists, including the Scottish painter Horatio McCulloch, who produced a watercolour study of the close in 1845 (see fig. 7.1). The subject would have been a familiar one for Burns, who not only lived and worked near this famous site, but who had also been photographing similar places of historic importance around Edinburgh.

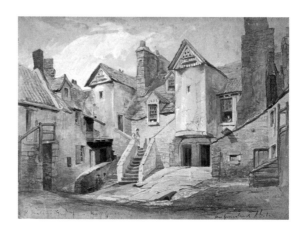

Fig. 7.1 Horatio McCulloch, *White Horse Close, Edinburgh*, 1845, watercolour heightened with white on paper. William Findlay Watson Bequest, 1881, National Gallery of Scotland (D 2652)

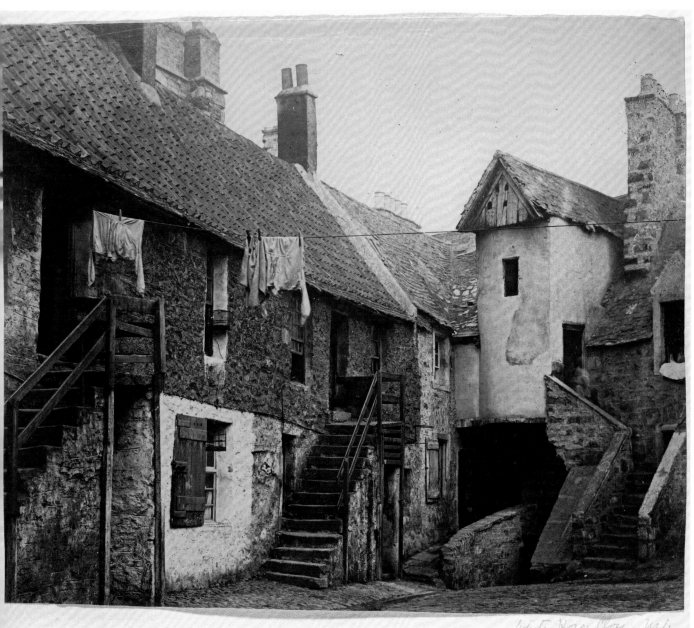

White Horse Close, No 1.

8 Julia Margaret Cameron

Calcutta 20 June 1815–26 January 1879 Kalutara, Ceylon

Allegory: Dejátch Álámáyou and Báshá Félika (Prince Álámáyou, Son of Emperor Theodore of Abyssinia, with Captain Tristram Speedy) 20 July 1868

Albumen silver print, 35.2 × 27.7 cm

21278

Inscriptions secondary support, below image, brown ink, *From Life Registered Photograph Taken at Freshwater 20 July 1868 Julia Margaret Cameron–*, l.c., black ink, *Dejátch Álámáyou / + / Báshá Félíka / – / King Theodore's Son / + / Capt*ⁿ *Speedy*

Annotations secondary support, blind stamp, l.c., *REGISTERED PHOTOGRAPH / SOLD BY / MESS*ᴿˢ *COLNAGHI / 14 PALL MALL EAST / LONDON*, l.l., brown ink, *For the Window immediately orders with be taken Study N*° *2–*

Provenance purchased from André Jammes, Paris, 1967

Julia Margaret Cameron was the fourth of seven daughters born to James Pattle and Adéline de l'Étang. In 1838 she married Charles Hay Cameron, twenty years her senior, who was a British civil servant in India. They returned to England in 1848, and in 1859 bought a home in Freshwater on the Isle of Wight. Julia Cameron received her first camera as a gift from her daughter in 1863, and from then on seems to have devoted her energies to her new hobby.

Although she was known for her portraits of famous Victorians, Cameron's more exotic subjects included a small Abyssinian child named Dejátch Álámáyou and his guardian, Tristram Charles Sawyer Speedy. In the summer of 1868 she made a portrait series of the two figures: in this series, young Dejátch never smiles and Captain Speedy never looks directly at the camera. Cameron often employed this kind of posing direction, which lends her portraits a mood of introspection and an air of Romantic detachment.

Dejátch's presence in Freshwater in 1868 was the result of a series of events that began in his homeland of Abyssinia (present-day Ethiopia). His father, Emperor Tewodros II (Theodore), had written a letter to Queen Victoria requesting her government's assistance. After having received no response after two years, he ordered the imprisonment of the British consul and other British subjects then residing in Ethiopia, an action that led Queen Victoria to dispatch troops led by Sir Robert Napier to ensure the prisoners' release. Sensing defeat, the emperor took his own life on 13 April 1868. His wife and eight-year-old son were to be brought to England, but the empress died en route and the young prince was placed under the guardianship of Captain Speedy, a professional soldier and adventurer who had once worked for Theodore (see fig. 8.1).

News of the orphan's arrival soon reached England and images were quick to follow: an engraving of the child dressed in his native costume was featured on the cover of the *Illustrated London News* on 18 June 1868. Prince Álámáyou went to live with Captain Speedy and his wife on the Isle of Wight, where he was introduced to Queen Victoria and later to Julia Margaret Cameron. Cameron requested the opportunity to photograph Captain Speedy (Báshá Félíka, meaning "speedy" or "lightning," was the name given to him by the emperor), the child, and Casa, an attendant. On at least two occasions in the summer of 1868 (20 July and 21 August),[1] Cameron made some ten photographs of the trio[2] (see fig. 8.2).

Sadly, the life of Dejátch Álámáyou would continue on a tragic course. He was sent to various public schools, but according to at least one commentator, he felt lonely and displaced. When he died of consumption at the age of nineteen, Queen Victoria commented in her diary, "His was no happy life, full of difficulties of every kind, and he was so sensitive, thinking that people stared at him because of his colour, that I fear he would never have been happy."[3]

Fig. 8.1 Julia Margaret Cameron, 'Spear or Spare': Báshá Félíka, Captn. Speedy, 1868, albumen print. Victoria and Albert Museum, London, Gift of Miss Perrin (19-1939)

Fig. 8.2 Julia Margaret Cameron, Dejatch Alamayou and Basha Felika, King Theodore's Son and Captain Speedy, 1868. Royal Photographic Society (2003-5001_2_20853)

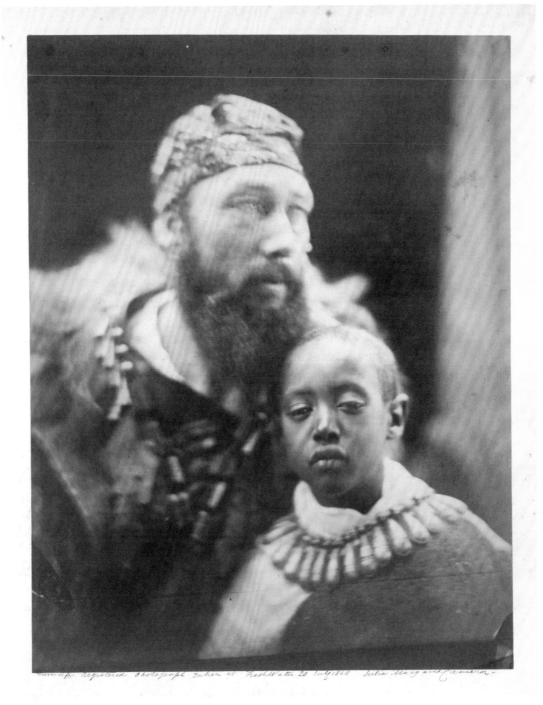

From life Registered Photograph Taken at FreshWater 20 July 1868 Julia Margaret Cameron.

 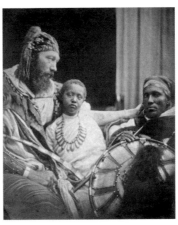

9 Robert Henry Cheney

Newcastle upon Tyne, Northumberland 1800–30 December 1866 Badger Hall, near Shifnal, Shropshire

Guy's Cliffe, Warwickshire c. 1856

Albumen silver print, 18.0 × 21.8 cm

19648

Inscriptions secondary support, l.r., below image, grey ink, *Guyscliffe (Bertie Percy)*

Provenance gift of Irving Taylor, Ottawa, 1981

As the nature of photography became increasingly formalized and structured during the 1850s, the motives that drew photographers into the landscape became increasingly varied. Entrepreneurs believed there was good money to be made from providing the burgeoning tourist market with photographs of popular locations. Hordes of gentlemen amateurs belonging to the newly emergent photographic society used their annual exhibitions as the means of displaying their work collectively and competitively. Finally, there was a small band of photographers for whom photography became the means of private self-expression, a medium much like drawing and watercolour sketching that need never migrate beyond the intimate circle of family and friends. The photographs of Robert Henry Cheney belong firmly to this last category: his work remained unregarded and unknown until 1977, when the first of his prints appeared at Sotheby's in London.

Henry Cheney, as he preferred to be known, was the eldest son of Lieutenant General Cheney, an aide-de-camp to the Duke of York, a position indicative of both the social standing of the Cheney family and the diplomatic aptitude of its most distinguished military officer.[1] When his father died in 1820, Cheney inherited the family estates at Badger Hall, Shropshire, at the tender age of nineteen. For the next thirty years he travelled extensively abroad, taking what can best be described as a latter-day Grand Tour.

In common with others of their class and education, the Cheney family employed a succession of drawing masters to teach them the finer points of drawing and composition. Henry, a pupil of the English painter Peter de Wint, was an accomplished watercolourist (see fig. 9.1), though improving the Badger estate meant he also devoted time to landscape gardening, which he felt was "in its way a sort of painting."[2] The date when he actively took up photography remains unclear, though it seems likely he was influenced by the enthusiasm of his nephew, Alfred Capel Cure, who became a prolific calotypist around 1850 while serving in the army. The pair of them may even have made extensive photographic pilgrimages around Britain, especially after 1855, when Cure was convalescing after injuries received during the Crimean War.[3] There was certainly a close and affectionate bond between the two men, as following Henry's death in 1866, Alfred printed his uncle's surviving negatives, one of which is this study of Guy's Cliffe, Warwickshire.

Never intended for public display, this image assumes the status of a documentary sketch, one of a number made at Guy's Cliffe by both men as they took the equivalent of a British Grand Tour visiting the stately homes and landscaped gardens of the aristocracy and gentry, where as social equals, they would have been welcomed with their cameras and apparatus (see fig. 9.2).

 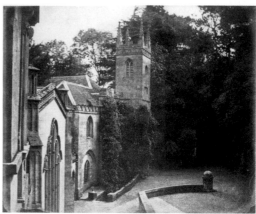

Fig. 9.1 Robert Henry Cheney, *The Old House, Millichope Park, Shropshire*, watercolour over pencil. Guy Peppiatt Fine Art Ltd., London

Fig. 9.2 Robert Henry Cheney, *Guy's Cliff View of House and Chapel, Warwickshire, England*, 1850s, albumen silver print. Collection Centre Canadien d'Architecture/ Canadian Centre for Architecture, Montreal (PH1978:0103:030)

10 Antoine François Jean Claudet
Chateau de Rosay, Lyon 12 August 1797–27 December 1867
Mrs. Hamilton and Frances Mary Hamilton 1856
Daguerreotype with applied colour, 7.8 × 6.6 cm (each of two)
30621

Annotations paper label, letterpress, verso, c., *UNDER THE PATRONAGE OF HER MAJESTY / BY ROYAL LETTERS PATENT. / MR ANTOINE CLAUDET. 107. REGENT STREET. / (QUADRANT, NEAR VICO STREET.) / DAGUERREOTYPE MINIATURES. / PLAIN AND COLOURED STEREOSCOPIC DAGUERREOTYPE PORTRAITS.*, u.r., black ink, *1856 / M^rs Hamilton / Frances Mary Hamilton.* / [arrow], u.r., blue ink [below *M^rs Hamilton*], *grandmother} / Bothamley / on right.*, l.r., black ink, *149b[...]*

Provenance Werner Bokelberg, Hamburg; gift of Phyllis Lambert, 1988

Although Antoine François Jean Claudet was born in France, his major contributions to photography came while he was working as a daguerreotypist in England. In 1818, at the age of twenty-one, he left Lyon for Paris, where he apprenticed as a banker with his uncle Vital Roux and met his future wife, Julie Bourdelain, a Frenchwoman whose family had moved to England. It was through her family connections that in 1828 Claudet secured the position of co-director, along with George Bontemps (his wife's nephew), of a glass-works company in London at 89 High Holborn Street.[1]

Having learned the daguerreotype process in Paris from its inventor in 1839, Claudet purchased a license from Jacques Louis Mandé Daguerre allowing him to make daguerreotypes in England. He then established his first daguerreotype studio in London in 1841, just behind St. Martin's in the Fields. Claudet received honours from both Queen Victoria and Napoleon III for his photographic skills. Although he made some of the first daguerreotype views of London, he soon became regarded as one of the best portrait photographers in England and the first professional to use the stereo daguerreotype.

Many of the fourteen daguerreotypes by Claudet in the National Gallery of Canada collection appear to be connected to one extended family, the Hamiltons and Hoziers, and are likely from the same original source.[2] The NGC collection includes a portrait of Lady Mary Haughton Feilden, wife of William Feilden, Member of Parliament for Blackburn, her daughter Catherine (née Feilden) Hozier, and Catherine's husband, James Hozier, a barrister. Two other stereo daguerreotypes include six of the youngest of the Hamilton children (Frances Eliza Feilden, Catherine's sister, married Andrew Hamilton): Catherine, Emily, and Caroline in one (see fig. 10.1) and Harriet, Edith, and William in the other. The National Gallery also owns a stereo daguerreotype portrait by Claudet of the Hamilton's eldest daughter, Eliza (see fig. 10.2).

In this stereo daguerreotype, we see Frances Eliza (née Feilden), widow of Andrew Hamilton, seated with her second eldest daughter and namesake, Frances Mary Hamilton. This double portrait is representative of Claudet's work in that his sitters are often shown with the same studio props of slightly parted curtains and patterned wallpaper in the background and ornate chairs and table occupying the foreground. Also typical of his daguerreotypes is the delicate hand-colouring of the daguerreotype plates. Claudet was using hand-tinting as early as 1844 and employed Mansion (André Léon Larue) as his colourist during the 1840s and 1850s.[3]

Fig. 10.1 *Catherine Maria, Emily Georgina, and Caroline Charlotte Hamilton*, 1856, daguerreotype with applied colour. National Gallery of Canada, Ottawa, Gift of Phyllis Lambert, Montreal, 1988 (30617)

Fig. 10.2 *Eliza Hamilton*, 1856, daguerreotype with applied colour. National Gallery of Canada, Ottawa, Gift of Phyllis Lambert, Montreal, 1988 (30624)

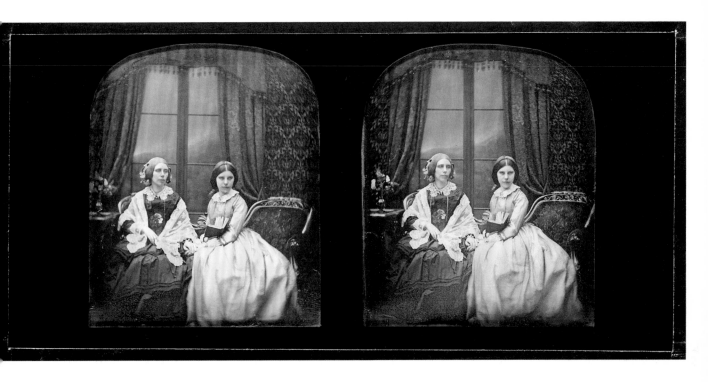

11 Charles Clifford

South Wales 1819–January 1863 Madrid

Statue of Saint Bruno in the Carthusian Monastery of Our Lady of Miraflores, Burgos 1853

Albumen silver print, 35.5 × 31.2 cm

21336

Provenance purchased from the collection of Ralph Greenhill, Toronto, 1972

Little is known about the early life of Charles Clifford, but by about 1850 he was working as a photographer in Spain, calling himself Photografito inglés ("the little English photographer").[1] There is some speculation that he may have gone there to take up a career as an aerial daguerreotypist along with Alfred Guesdon (1808–1876), a lithographer who specialized in aerial views of cities, but to date, only one daguerreotype by him has been identified.

There is also circumstantial evidence that Clifford photographed in the Crimea at an earlier date than Roger Fenton, who made what is widely considered the first significant body of war photographs. Clifford would have used waxed paper negatives, which can withstand higher temperatures than glass plates, but have the disadvantage of needing longer exposure times. Clifford also made photographs in Istanbul.[2]

Clifford gained the support of Queen Isabel II of Spain, and by 1858 was appointed her official photographer, accompanying her on royal tours of the country and photographing the construction projects that were underway, including a magnificent aqueduct and canal system built to supply water to Madrid.

Saint Bruno was the founder of the Carthusian order. In *Statue of Saint Bruno*,[3] we see what appears to be the figure of a man standing in front of the open doors of Burgos cathedral, his right arm extended as he concentrates on the crucifix he holds in his hand. (Clifford made other views of this cathedral; see, for example, fig. 11.1.) In order to make use of the strong sunlight, Clifford had the life-sized statue moved outdoors. The setting, along with the low viewpoint, increases the naturalistic effect of the scene. Clifford's mastery of photographic technique can be seen by comparing it with an image by another photographer working in Spain around the same time, Juan Laurent (1816–1886), whose photograph of this sculpture is more traditional in its format (see fig. 11.2). The National Gallery print of *Saint Bruno* is rare[4] – one of only three or four prints of this work known to exist.[5]

Clifford died suddenly of a cerebral hemorrhage at the age of forty-three.[6] His widow, Jane Clifford, remained in Madrid and seems to have continued Clifford's photographic business.[7]

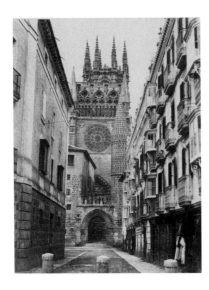

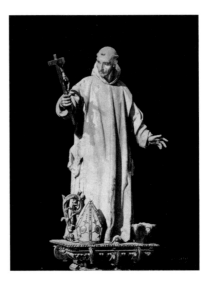

Fig. 11.1 Charles Clifford, *Calle y catedral de Burgos*, 1853, albumen silver print. Photography Collection, Harry Ransom Humanities Research Center, The University of Texas at Austin (979:0091:004)

Fig. 11.2 Juan Laurent, *La Cartuja (Burgos)*, *Statue of Saint Bruno*, 1879, albumen silver print, 1879. Nuno Borges de Araújo Collection, Braga, Portugal

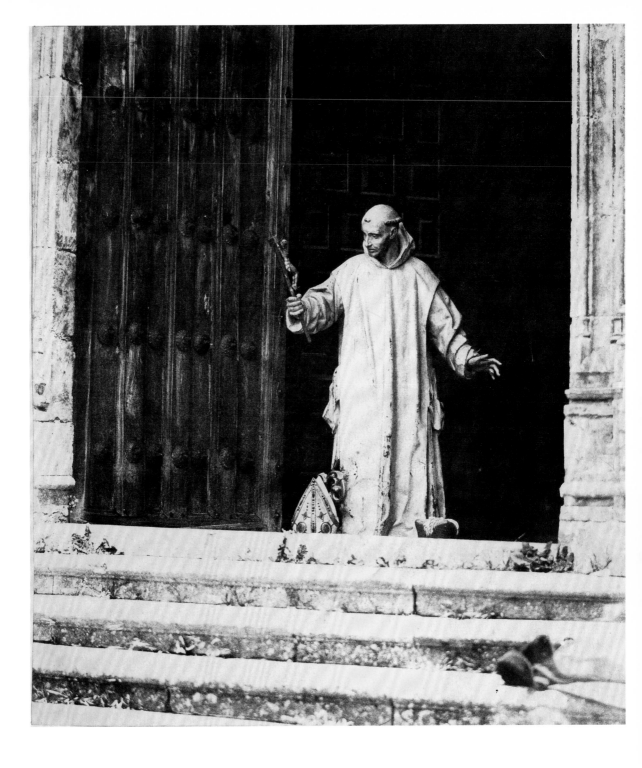

12 Jane Clifford, Attributed to
England? 19th century–19th century? Spain?
The Corselet of Charles V 1866
Albumen silver print, 34.6 × 25.9 cm
43117

Annotations l.c., in negative, *2565*
Provenance **Purchased from Charles Nes Photography, New York, 2010**

The depiction of arms and armour has had a long tradition in the history of art, with artists conveying not only the high craftsmanship of the metalwork itself, but also portraying these objects as symbols of power and status. By the middle of the nineteenth century this convention had run its course, with armour relegated to the role of a prop in narrative painting or staged photographs.

The ability to capture and transmit the volumes and sheen of the metal in *The Corselet of Charles V* and its companion regalia suggests that the maker of these images was an experienced and inventive photographer. In these prints, the suits of armour and helmets are isolated and removed from their contexts of rooms in the Royal Palace in Madrid.[1] This sophisticated method of presenting objects is very different from those of other Victorian photographers such as Roger Fenton, who adopted a more documentary approach to photographing objects from a museum collection.

Made in the mid-1860s, these photographic prints (see also figs. 12.1 and 12.2) are generally acknowledged to be the work of Jane Clifford, the wife of Charles Clifford, who was arguably the most prominent photographer working in nineteenth-century Spain (see cat. 13). Unfortunately, we have little information about her except that she arrived in Madrid in about 1850 with her husband and worked with him in his studio. We do know that she made a series of still-life photographs of the decorative art objects that make up the so-called Treasures of the Dauphin, now in the collection of the Prado Art Museum. There are also letters from Jane Clifford to officials at the Victoria and Albert Museum offering to send the museum prints of the Armoury in Madrid.[2] More research into the life and work of Jane Clifford will possibly reveal her role in the Clifford photographic studio.

Charles Clifford supplied photographs to the royal families of both Spain and England. In his most ambitious project, he photographically recorded for Queen Isabel II the construction of the aqueduct system that was spread across Spain. The photographs of the Royal Amoury would have been of great interest for the Spanish queen, who had re-installed the collection in the Armoury Hall and had a catalogue/inventory published in 1849.[3]

Several of the Armoury photographs, including all three of the works depicted here, were included in the 1907 publication *Spanish Arms and Armour, Being a Historical and Descriptive Account of the Royal Armoury of Madrid*.[4]

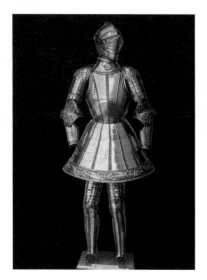 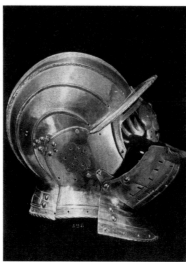

Fig. 12.1 Attributed to Jane Clifford, *Oak Leaf Suit with Lamboys of Charles V*, mid-1860s, albumen silver print. National Gallery of Canada, Ottawa (43118)

Fig. 12.2 Attributed to Jane Clifford, *Helmet of Charles V*, mid-1860s, albumen silver print. National Gallery of Canada, Ottawa (43119)

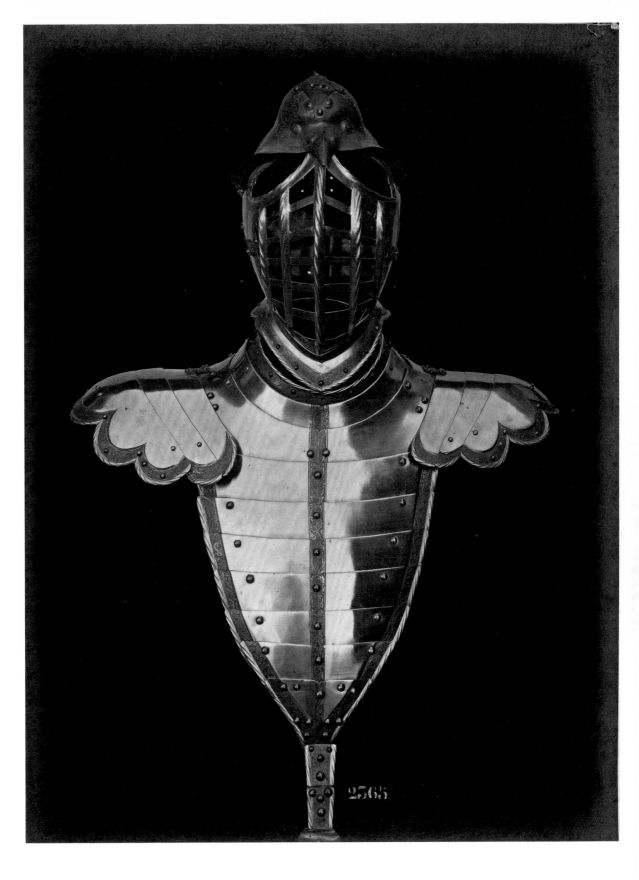

13 Joseph Cundall

Norwich, Norfolk 22 September 1818–10 January 1895 Wallington, Surrey

***The Alms-House* 25 August 1855**

From *The Photographic Album for the Year 1855*, 1855, pl. 32

Albumen silver print, 23.4 × 18.3 cm

20515.30

Provenance purchased from Phillips, Son & Neale, London, 1973

Joseph Cundall was born to Eliza (née Gilman) and Benjamin Cundall, a linen draper. As a young man, he worked as a printer's apprentice in Ipswich and then moved to London at the age of sixteen to work for the publisher and bookseller Charles Tilt (1797–1861). Interested in illustrated children's books, he began working at the publishing house The Juvenile Library in 1841, and seven years later opened a lending library called St. George's Reading Library.

Little is known about Cundall's training as a photographer, but an image of London taken from Blackfriars Bridge is credited to him and shows that he was making photographs as least as early as 1844. In 1847 Cundall, along with Roger Fenton, Philip Henry Delamotte, Robert Hunt, Dr. Hugh Diamond, and Frederick Scott Archer, was a founder and one of the members of the Calotype Club (after 1848 called the Photographic Club) in London.

Although Cundall's publishing business was bankrupt by 1849, he soon entered into another publishing venture with H. M. Addey that ended in 1852. In December of the same year, Cundall and Delamotte organized an exhibition of photographs for the Society of Arts, and the following year, they established the Photographic Institution at Cundall's New Bond Street premises, which housed a photographic studio, a darkroom, and a printing press. Within a few years, Robert Howlett and George Downes would join them. In 1854 Cundall published *The Photographic Primer for Beginners in the Collodion Process*.

During the summer of 1855, Cundall and Delamotte were commissioned to photograph the buildings at Sackville College in East Grinstead in support of the college's title of deeds documentation. One of Cundall's photographs from this group, titled *The Alms-House*, shows the distinctive sandstone brick that was used in much of the Sackville College architecture. The Jacobean-style Alms House was built for Robert Sackville, the Earl of Dorset. Cundall's image includes a figure at the top window, an elderly couple seated on the right-hand side of a doorway, and a young girl sitting on the left. This photograph was Cundall's contribution to *The Photographic Album for the Year 1855*. Another image made during this trip to East Grinstead, *The Old Porch*, was included in the 1856 exhibition of the London Photographic Society (see fig. 13.1). Cundall and Delamotte worked together on other projects, including *A Photographic Tour among the Abbeys of Yorkshire* in 1856. That same year, Cundall and Howlett were commissioned by Queen Victoria to photograph soldiers upon their return to England from the Crimean War.

Cundall continued his work as a photographer into the 1870s, when he was employed as the superintendent of publications, Department of Science and Art, at the South Kensington Museum (now the Victoria and Albert Museum) and commissioned to photograph the Bayeux tapestry for the British Government.

Fig. 13.1 Joseph Cundall or Philip Henry Delamotte, *The Old Porch*, 1855, printed c. 1967. East Grinstead Museum, West Sussex

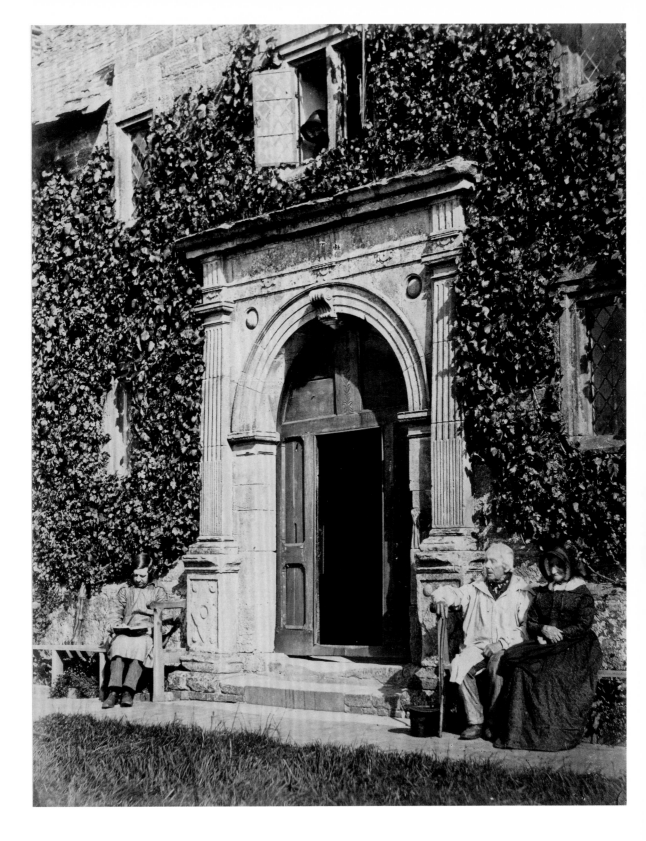

14 John Benjamin Dancer
London 8 October 1812–December 1887 Chorlton, Lancashire
Richard Buxton, Age 64, Botanist and Author, Manchester 1853
Daguerreotype, 6.2 × 5.0 cm

30629

Annotations secondary support, verso, c., brown ink, *Daguerreotype Portrait of the / late Richard Buxton / Botanist and Author one of / the most Eminent of the / Lancashire Botanists in / humble life. Age 64 / Taken by J.B. Dancer / Manchester* [*Manchester* in another hand]. *1851,* l.c., graphite, *50* [encircled], l.l., *No. 14,* paper label, black ink, *Richard Buxton / Botanist / age 64 / Taken by JBDancer / Aug 1851*

Provenance Werner Bokelberg, Hamburg; gift of Phyllis Lambert, Montreal, 1988

Like so many other early photographers, John Benjamin Dancer came to photography through his profession as an optician. He began his career in London, where his father, Josiah, his grandfather Michael, and great-grandfather Daniel had also been employed as opticians and optical instrument makers. Around 1818 Josiah Dancer moved his family and business from London to Liverpool. When he died in 1835, his son took over the business and, like his father, contributed to the intellectual life of the city by delivering lectures on various scientific topics to the Liverpool Literary and Philosophical Society and the Liverpool Mechanics Institute. Six years later, John B. Dancer joined forces with another optician, renamed the company Abraham and Dancer, and moved it to Manchester.

It appears that Dancer had been in contact with William Henry Fox Talbot as early as 1835 (Dancer's father and Talbot shared an interest in Arabic, Hebrew, and cuneiform scripts) and that he made his first daguerreotypes as early as 1839. Dancer recalled that he had experimented with the daguerreotype process using only the "crude and obscure" early descriptions that had been published about Daguerre's methods. He also reported that he had already been making paper photographs before abandoning them in favour of the "beautiful pictures" afforded by the daguerreotype.[1]

Dancer's portrait of the botanist Richard Buxton (1786–1865) shows an older-looking man seated in profile in front of an unadorned background, holding a sprig of white flowers in his left hand, a reference to Buxton's botanical work. It is a portrait infused with a sense of quiet dignity. In a brief autobiography provided in the introduction to the *Botanical Guide to the Flowering Plants, Ferns, Mosses and Algae, found indigenous within sixteen miles of Manchester* (1849), Buxton tells his readers that although he was well educated as a young child, a reversal in his family's fortunes meant that he needed to abandon his formal schooling and learn a trade. He became a cordwainer, or shoemaker, but through acquaintances and long walks through the Manchester countryside, became an expert on the local flora.

Dancer's optical lens and instrument-making business flourished in Manchester, where he and his growing family lived and worked.[2] He is credited with many important inventions, among them microphotography and the binocular stereoscopic camera (both in 1852).[3] He retired in 1878, and the firm moved to Ardwick, a smaller town outside Manchester. His daughters, Eleanor Elizabeth and Catherine Dancer, ran the business as E. E. Dancer & Company until it was sold in 1896.

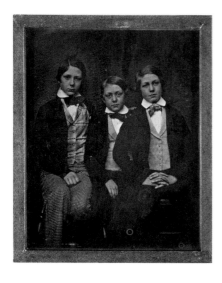

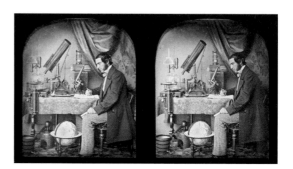

Fig. 14.1 John Benjamin Dancer, *The Artist's Sons: Josiah, William, and John Dancer*, c. 1850, daguerreotype. National Gallery of Canada, Ottawa, Gift of Phyllis Lambert, Montreal, 1988 (30628)

Fig. 14.2 John Benjamin Dancer, *Self-portrait with Scientific Apparatus?*, c. 1853, daguerreotype. National Gallery of Canada, Ottawa, Gift of Phyllis Lambert, Montreal, 1988 (30627)

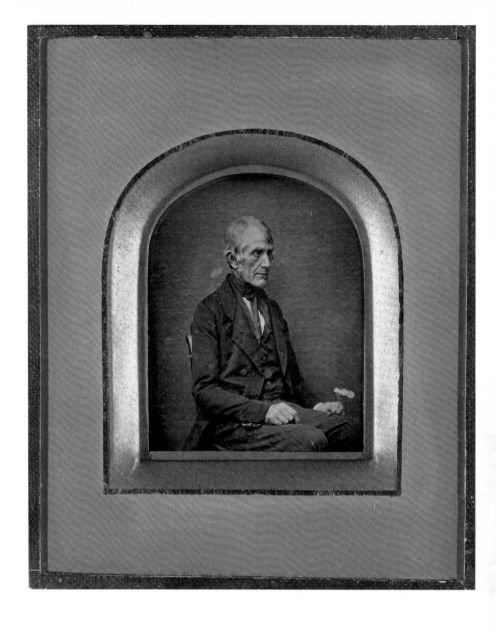

15 Philip Henry Delamotte
Sandhurst, Berkshire 21 August 1821–24 February 1889 Bromley, Kent
Innocence October 1855
From *The Photographic Album for the Year 1855*, 1855, pl. 27
Albumen silver print, 18.7 × 15.6 cm (oval)
20515.25
Provenance purchased from Phillips, Son & Neale, 1973

Innocence, which was included in *The Photographic Album for the Year 1855*,[1] is a slightly unusual image for Philip Henry Delamotte, who is better known for his commissioned photographs of the Crystal Palace reconstruction at Sydenham. Here, a young girl dressed in a tartan skirt and wearing a straw hat with ribbons stands before an open wicker birdcage placed on a draped pedestal. The girl gazes into the bird-cage while inexplicably holding a bird's wing to her chest with her right hand. Her left hand grips the top of a chair on which she is kneeling, probably as a way of ensuring her stability for the pose. The birdcage houses a bird and on the table is a still life, including a halved pomegranate, a knife, a book, and some apples. The combination of the title, the still-life arrangement, and the somewhat eccentric props suggests that Delamotte intended this photograph to convey a symbolic message. Most Victorian viewers would usually read the inclusion of a birdcage in painting as a coded reference to sexuality.[2] Ten years later, the Pre-Raphaelite painter John Everett Millais would depict a similar subject, posing his young daughter as though she had just awoken from a deep sleep. An empty, open birdcage is barely visible in the upper right corner of the picture and what appears to be a dead bird appears in the opposite lower left corner (see fig. 15.1). Delamotte's photograph, like Millais's painting, is meant to remind us of the transient nature of childhood, its fleeting innocence, and the passage into adulthood.

His father, William Delamotte (1775–1863), was the drawing master at Sandhurst Royal Military College when Philip Henry was born, and since Delamotte was himself trained as an artist, he would have been very familiar with the symbolism typically employed by painters. Delamotte married Ellen George in 1846, a union that would eventually produce four daughters and one son. By 1851 he was living in London and listed himself as a "draughtsman and engraver on wood" on the census record for that year. He became inter-ested in photography some time during the late 1840s and learned how to make photographs through the daguerreotype, the calotype, and the wet-plate collodion processes. Delamotte's *The Practice of Photo-graph: A Manual for Students and Amateurs* was published in 1853 by another photographer, Joseph Cundall. That same year Delamotte and Roger Fenton formed the Photographic Society (also known as the Calotype Club),[3] an association of photographers that eventually became known as the Royal Photographic Society. By 1855 Delamotte had been appointed professor of drawing and perspective at King's College, London. In 1861 he closed his studio in Bayswater and moved with his family to Twickenham. Delamotte died at the home of his son-in-law, Henry Charles Bond.

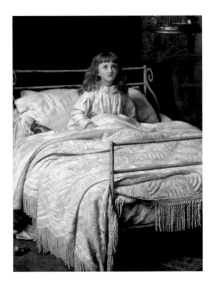

Fig. 15.1 John Everett Millais, *Waking*, oil on canvas, 1865. Perth Museum and Art Gallery, Perth and Kinross Council, Scotland

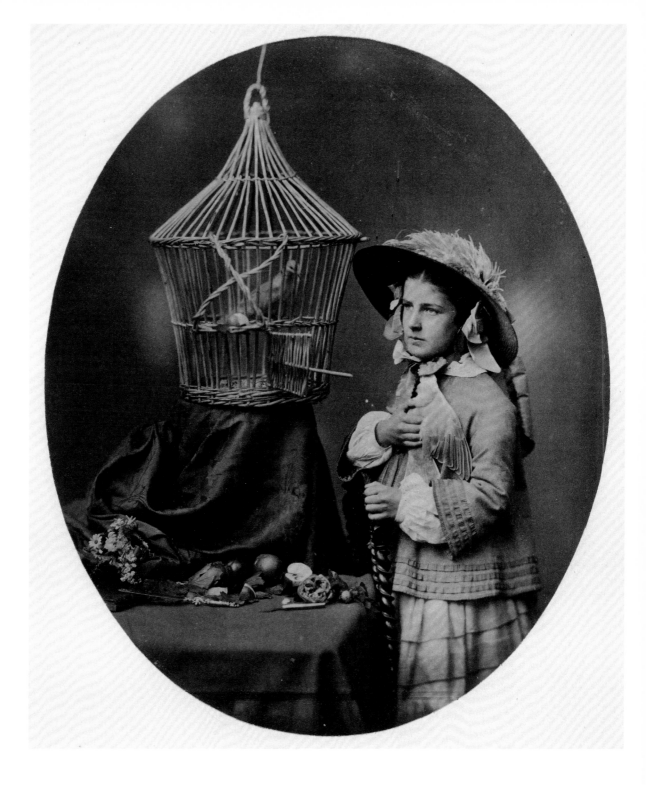

16 Henry Dixon

St. Pancras, London 14 April 1820–20 January 1893 St. Pancras, London
St. Mary Overy's Dock, Southwark 1881?
Carbon print, 22.7 × 18.0 cm

21561

Inscriptions l.r., in negative, *57*

Annotations secondary support, l.c., letterpress, *S^T MARY OVERY'S DOCK, SOUTHWARK*, l.r., letterpress, *THE SOCIETY FOR PHOTOGRAPHING RELICS OF OLD LONDON, 1881. / PHOTOGRAPHED & PRINTED IN PERMANENT CARBON / BY HENRY DIXON, 112, ALBANY S^T LONDON. N.W.*, l.r., black ink, *Am*[?] *75*

Provenance purchased from Howard Ricketts Ltd., London, 1977

Henry Dixon began his working life as an apprentice to his elder brother, Thomas, a copperplate printer. He took up photography as a profession before 1860, and operated his own studio until 1886, when his son Thomas James joined him. Dixon's wife, Sophia (née Cook), and two of their seven daughters, Lucy and Ellen, also worked as photographic assistants for Dixon & Son. An active member of the Photographic Society, Dixon was employed by the Corporation of London from December 1875 to photograph the building of Holborn Viaduct and the City of London sewers. He is also known for his photographs of animals at the London Zoo.

From the late 1860s, Dixon, along with Alfred and John Bool, made and printed photographs for a project commissioned by the Society for Photographing Relics of Old London.[1] The Society was one of the earliest coordinated efforts to document buildings threatened with demolition, and unlike the commissions given to Thomas Annan in Glasgow (1868; see cat. 2) and James Burgoyne in Birmingham (1875), this scheme, formed by friends who wanted to record the Oxford Arms Inn (see cat. 5), was neither municipally funded nor intended to document contemporary living conditions. [2]

Until the mid-twentieth century, Southwark was filled with wharves and warehouses, a place that had been home to trades associated with ship building and noxious industries such as glass-making, leather tanning, and hat manufacturing that were banned from the City of London. But the borough also housed religious institutions such as the Bishop of Winchester's palace and the church of St. Mary Overy (now Southwark Cathedral). In 1984 there was a movement to include St. Mary Overy's wharf (the wharf encompassed the adjacent St. Mary Overy's dock and the buildings around it) in the list of buildings of special architectural or historic interest. The inspector's report described the wharf as "one of a tightly-knit group of Victorian warehouses, and the combination of tall buildings and narrow streets imparts an ambiance to the area which vividly captures the character of the riverside commerce of Victorian London."[3]

The photograph is splendidly atmospheric. The houses show the fine tonal gradation and relief between areas of shadow and light characteristic of carbon prints.[4] In the misty background, ghost-like boats appear cloaked by river fog or perhaps by the city's famous pea-soupers. The three figures in the image – two men leaning on the railings and a man in a bowler hat emerging from a narrow passageway on the left – take second place to the architecture. The Society left social commentary to other photographers like John Thomson (see cat. 59), and focused on recording architectural "relics," with vernacular buildings such as houses and inns (see figs. 16.1 and 16.2) its primary subjects.

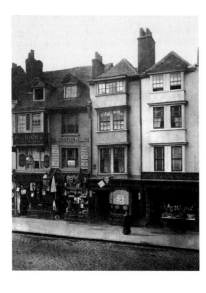

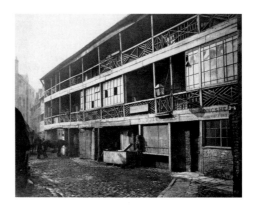

Fig. 16.1 Henry Dixon, *Old Houses in Borough High Street, Southwark*, 1881?, carbon print. National Gallery of Canada, Ottawa (21555)

Fig. 16.2 Henry Dixon, *King's Head Inn Yard, Southwark*, before 1876, carbon print. National Gallery of Canada, Ottawa (21559)

17 Peter Henry Emerson

Sagua-la-Grande, Cuba 13 May 1856–12 May 1936 Falmouth, Cornwall

Gathering Waterlilies 1885, printed 1886

From *Life and Landscape on the Norfolk Broads*, 1886, pl. IX

Platinum print, 19.9 × 29.1 cm

21650.10

Provenance purchased from Howard Ricketts Ltd., London, 1975

Peter Henry Emerson's first book of photographs was devoted to the subject of the countryside and the working people of the Norfolk Broads (a system of interconnecting rivers and lakes and surrounding low lying wetland) in eastern England. During the late nineteenth century, these waterways became a popular spot for tourism and recreational sailing, and it was there that Emerson and the painter Thomas F. Goodall (1856/57–1944) met while on a holiday cruise in 1883 and became friends. Three years later they would collaborate on *Life and Landscape on the Norfolk Broads*. The publication comprises forty photographic plates that were first conceived of as albumen prints, but for the book Emerson made platinum prints, whose gentle tonal gradations were perfectly suited to the atmospheric conditions of the marshlands. *Life and Landscape* later appeared with photogravure plates.

Emerson was born Pedro Enrique Emerson in Cuba to a British mother (Jane Harris Billings) and an American father (Henry Ezekial Emerson), who owned and managed both a sugar and a coffee plantation. Pedro Enrique, his sister, Jane, and brother, Justo William, were all born on the estate at La Palma, the sugar plantation. The family left Cuba for the United States around 1867, where Emerson attended school in Wilmington, Delaware. After his father died, the family moved to England. Emerson completed his education at the Cranleigh School in Surrey, went on to study medicine at Cambridge University, and was accepted into the Royal College of Surgeons in 1879. In 1881 he married Edith Amy Ainsworth, with whom he had five children. He gave up medicine after graduating from Cambridge and began to learn the art of photography under the tutelage of the physicist Ernest Griffiths (1851–1932).

Emerson purchased his first camera in 1882 in order to facilitate his bird-watching hobby. The same year, he had some of his artistic photographs exhibited in Pall Mall through the auspices of the Photographic Society of Great Britain.

All of the photographs in the Norfolk Broads series concentrate on life and work in the marsh (see fig. 17.1). *Gathering Waterlilies* is the ninth in the book and is in many ways a visual demonstration of the photographic style that Emerson promoted in *Naturalistic Photography* (1889). In this handbook, he urged other photographers to abandon the conventional practice of crafting images from more than one negative and to create photographs that employed what he called "differential focusing," a method of photographing where not everything in the image was of equal sharpness. This, Emerson argued, was more true to the way human vision worked. Here, a woman leans over the boat in order to gather the water lilies that will be used as bait by fishermen. Her shadow and those of the oarsman, oars, and boat are mirrored in the still water that surrounds them: a daily act frozen for eternity in an image of quiet harmony between the workers and the landscape in which they toil.

Fig. 17.1 Peter Henry Emerson, *Setting Up the Bow-Net*, 1885, printed 1886, platinum print. National Gallery of Canada, Ottawa (21650.19)

18 William England
Near Trowbridge, Wiltshire 1830–13 August 1896 London
The Railway Suspension Bridge from the "Maid of the Mist" Dock, Niagara 1859
Albumen silver print, 24.0 × 28.3 cm
28823

Provenance purchased from the collection of Ralph Greenhill, Toronto, 1985

William England spent his formative years in a village not far from Lacock Abbey, where William Henry Fox Talbot was then at the forefront of photographic invention. At the age of twelve, England was employed as an assistant in a daguerreotypist's studio.

By 1854 England had married, moved to London, and begun working for the newly formed London Stereoscopic Company.[1] During the mid-1850s and into the 1860s, the company enjoyed unprecedented success, in 1865 declaring itself the biggest supplier of stereo views in Europe. In 1858 the firm had begun producing a "pocket" stereoscopic camera that allowed for a much greater mobility than the larger and heavier traditional apparatus. The following year, the company sent England to North America to obtain photographic views of its many natural wonders.

With the intention of creating a series that would be called *America in the Stereoscope*, England travelled from New York into Canada, eventually making his way to Niagara Falls. Although he photographed a variety of subjects, he was particularly interested in capturing images of engineering and construction alongside landscapes and wilderness scenes. His views of North America are considered to be some of the first photographs to be widely circulated on the other side of the Atlantic. Images of Niagara Falls and the suspension bridge, in particular, a scene of The Great Blondin crossing the Niagara gorge on a tightrope, were hugely successful (the company sold 100,000 copies worldwide).

This spectacular feat of engineering made it the world's first working railway suspension bridge. England photographed it from various vantage points (see fig. 18.1 for a view taken from the American side). In at least two instances, he photographed the entrance to the pedestrian bridge, giving viewers the feeling of anticipatory excitement, as if they were about to cross the bridge themselves. In this view, taken from what would later become the docking point for the *Maid of the Mist* ferry, England has posed his wife, Rosalie, elder son Louis, and daughter, Marie Rose, in the foreground. The roughly hewn logs that would form the base of the dock seem solidly rooted to the ground while the bridge is visible in the background stretching across the gorge like a gauzy strand of spider's silk. Seen from a distance, the structure appears impossibly delicate; it is even difficult to imagine that it had been built from wood. The bridge could accommodate two modes of traffic – locomotives on the upper portion, pedestrians and horse-drawn carriages on the lower part (see fig. 18.2).

By 1863 England had left the London Stereoscopic Company, and in 1867 he established a photographic printing studio in London's Notting Hill neighbourhood.[2] He continued to travel and make photographs, his views of Italy, Switzerland, and France winning him the reputation as "probably the largest Continental publisher of European views and one of the finest landscape photographers."[3]

Fig. 18.1 William England, *Niagara Suspension Bridge*, 1859, albumen silver print. Museum of Modern Art, New York (Purchase 51.1966)

Fig. 18.2 Charles Parsons, *The Niagara Suspension Bridge, showing Niagara Falls in the Background and the Maid of the Mist in the Waters Below*, hand-coloured lithograph, 1856, published 1857. Library of Congress, Prints and Photographs Division (cph 3b51175)

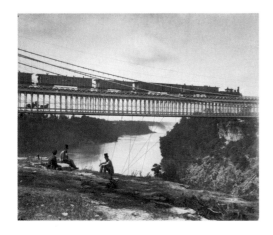

19 Frederick H. Evans

London 26 June 1853–24 June 1943 London

New Forest, A Pre-Raphaelite Study 1894?, printed before 1909

Platinum print, 20.5 × 15.2 cm

21715

Inscriptions secondary support, below image, l.l., graphite, *New Forest*, below image, l.r., graphite, *F.H.E*

Annotations l.l., graphite, *A Pre-Raphaelite Study!*

Provenance purchased from Evan Evans, Fetcham, Surrey, 1967

Frederick Evans found spiritual sustenance in the open soaring expanses of cathedral interiors and in the mysterious depths of the forest. If church interiors invited him to contemplate their overwhelming spaciousness and crystalline light, forests communicated a sense of the intimacy and complexity of nature tinged with melancholy. His friend George Meredith's poems about the natural world served as an inspiration, moving Evans to dedicate at least one of his forest views to Meredith's famous "The Woods of Westermain" and another image in the National Gallery of Canada's collection (see fig. 19.1) to Meredith's memory.

In addition to photographing extensively in Epping, Deerleap, and Redland forests, Evans made a number of views in the New Forest. Located in Hampshire in the southeastern part of England, the New Forest was created around 1079 by William the Conqueror as a hunting reserve for his own use. Other than being accorded statutory rights as a commons in 1698, not much attention was paid to the area until 1877, when the New Forest Act was passed and access rights for commoners[1] confirmed. There is no evidence to suggest that the Pre-Raphaelite Brotherhood enjoyed any particular relationship to these ancient woods, leaving us to conclude that it was the camera's fastidious recording of the details of nature that led Evans to associate his image with this group of artists.

Evans, who had worked as a bookseller in the early 1890s, was surely familiar with *The New Forest: Its History and Its Scenery* (1863), whose author, John Richard Wise, proclaimed that "not in individual trees lies the beauty of the Forest, but in the masses of wood."[2] Taking a different point of view, Evans created a portrait of a single tree, filling the frame with its sturdy but imperfectly textured, lichen-covered trunk and its expressively twisted branches.[3]

Natural history, the landscape, and trees and forests in particular were subjects of great interest to British theorists and artists of the eighteenth and nineteenth centuries. This passion for picturing nature is articulated in the Reverend William Gilpin's eighteenth-century philosophical investigations into the nature of the Picturesque and his *Remarks on Forest Scenery* (Gilpin was the vicar of Boldre, a village in the New Forest), Ruskin's exquisitely detailed descriptions on the rendering of leaves, buds, and clouds, along with the paintings of Constable, Cozens, and the photographs by mid-nineteenth-century British amateurs who published their prints in *The Photographic Album for the Year 1855* and the *Exchange Club Album of 1856*. Indeed, the father of the negative-positive process, William Henry Fox Talbot, made memorable images of two stately trees, an old oak on the grounds of Lacock Abbey and a red cedar on the grounds of Mount Edgcumbe, the estate of a Talbot relative, the Earl of Mount Edgcumbe (see fig. 19.2).

Fig. 19.1 Frederick H. Evans, *In Deerleap Woods, Surrey (in memory of George Meredith)* 1909?, platinum print. National Gallery of Canada, Ottawa (21718)

Fig. 19.2 William Henry Fox Talbot, *An Aged Red Cedar Tree in the Grounds of Mount Edgcumbe*, before 1845, salted paper print. National Gallery of Canada, Ottawa (33487.8)

20 Frederick H. Evans

London 26 June 1853–24 June 1943 London

Wells Cathedral: A Sea of Steps (Stairs to the Chapter House and Bridge to the Vicar's Close) 1903

Platinum print, 23.4 × 19.1 cm

42874

Inscriptions verso, c., graphite [...], secondary support, b.l.c., graphite, *Wells Cathedral: A Sea of Steps*, verso, l.l., graphite, *300648*, backing paper, black ink, *A Sea of Steps / – Stairs to Chapter House – / Wells Cathedral / by / Frederick H. Evans*

Annotations secondary support, b.c.r., blind stamp, *FHE*, backing paper, l.r., graphite, *W5*

Provenance Sotheby's, 2005; purchased from Hans P. Kraus, Jr., Inc., New York, New York, 2009

If a masterpiece represents the consummate achievement of an artist and surpasses all other like works, there is no doubt that Frederick Evans's *Wells Cathedral: A Sea of Steps* qualifies as such. A knowledgeable and devoted student of English and French cathedrals and abbeys, Evans would often spend days in cathedral towns familiarizing himself with the structural forms and intricacies of the ecclesiological architecture, studying the ways in which light illuminated and clarified the vaults, arches, stairs, and pillars and also lent a spiritual quality to the interiors. He captured these moments with a secure knowledge of these spaces, allowing the eye to travel easily from element to element.

Evans first photographed in Wells cathedral in 1894, exhibiting fifty of the resulting lantern slides at the Camera Club in the same year. If this was indeed his earliest attempt, it took him nine years of returning frequently to the site in order to obtain the image that he felt did justice to the "strange impressive beauty" of the staircase.[1] There were elements of opposites – light and darkness, height and depth – that he sought to reconcile both literally and metaphorically and that he seemed to have come close to achieving in variant views (see fig. 20.1). But he did not manage to realize his vision as he finally did in this iconic view of the *Sea of Steps*. Evans's fastidiousness and persistence were eventually rewarded and he was able to write that "getting a negative of this not-too-easy subject ... has contented me more than I thought possible."[2]

Evans and his work represent the conjunction of several streams of philosophical inquiry dear to Victorians: the conundrum of natural laws and their relevance to and manifestation in the physical world, the striving after spiritual harmony, and the connections between the various branches of scientific and artistic expression.

Once described as the "last great idealist,"[3] Evans patiently studied his interiors over prolonged periods of time before setting up his camera. He even asked church deacons to remove the pews and the gas fittings so that he would have an unobstructed view of the space and its architectural configuration. This elimination of anything extraneous resulted in images of crystalline purity as seen in his interior of Reims cathedral (see fig. 20.2).

Perhaps the last words on Evans and the special fascination that Wells cathedral exercised over his imagination belong to the photographer himself:

> The steps now rise steeply before one, and the extraordinary wear in the top portions leading to the corridor, is now shown just as it appeals to the eye in the original subject, a veritable sea of steps. The passing over them of hundreds of footsteps during the many years the stair has served its purpose have worn them into a semblance of broken waves, low-beating on a placid shore. The beautiful curve of the steps on the right as they rise to the height of the Chapter House floor, is for all the world like the surge of a great wave that will presently break and subside into smaller ones like those at the top of the picture.[4]

Fig. 20.1 Frederick H. Evans, *Steps into Chapter House, Wells Cathedral*, 1903, platinum print. Museum of Fine Arts, Houston, Gift of Manfred Heiting, the Manfred Heiting Collection

Fig. 20.2 Frederick H. Evans, *Reims Cathedral*, 1905, platinum print. National Gallery of Canada, Ottawa (21708)

21 Frederick H. Evans
London 26 June 1853–24 June 1943 London
A Pillar of Chartres 1906?
Platinum print, 25.1 × 11.6 cm
21717

Inscriptions secondary support, below image, l.l., graphite, *A Pillar of Chartres*, l.r., graphite, *Frederick H. Evans*
Annotations verso, c., coloured pencil, *FHE*, u.l., graphite, *FHE*
Provenance purchased from Evan Evans, Fetcham, Surrey, 1967

Highly regarded as a photographer in his time, Frederick H. Evans was described by Alfred Stieglitz as standing alone in architectural photography, "able to instill into pictures of this kind so much feeling, beauty and poetry."[1] Apart from being gifted with a refined sense of aesthetic judgment, Evans's inspiration to photograph a lone pillar bathed in a subtle light shows a unique vision defined by rigour and a willingness to defy the conventions that prevailed in the turn-of-the-century Pictorialist movement.

For reasons that were both technical and cultural, architectural monuments of all kinds, including cathedrals, were highly popular subject matter for nineteenth-century British photographers. First, the immobility of buildings permitted long exposures that resulted in the production of consistently legible prints for which there was a ready market, particularly among tourists, and second, in the face of rapid urban expansion, the nineteenth century witnessed increased awareness of architectural preservation, particularly in France and England.

Chartres cathedral was recognized by other nineteenth-century photographers for the consummate expression of the early Gothic ideal in its facade, among them the French practitioners Charles Nègre and Henri Le Secq (see figs. 21.1 and 21.2). Evans took the opportunity to photograph its interior when he and his friend and collaborator, Theodore Andrea Cook, received an assignment in 1905 to photograph French châteaux for *Country Life*.

We might wonder what motivated Evans to condense his experience of the richly detailed interior of this cathedral, renowned for its splendid stained-glass windows and intricately carved choir screen, to this one soaring column. Made during a trying period in the photographer's life when his health was poor and he was having trouble making ends meet, this single pillar reflects the peace and strength that he clearly continued to find in such structures and spaces despite the adversity he was facing.

Evans's extraordinary achievements as an architectural photographer can be partly ascribed to the importance he attributed to the act of pre-visualization and the precise preparation that preceded the making of the image. Most significant, however, was his inherent grasp of the fundamental language of architectural form and the awe-inspiring simplicity and elegance with which he was able to express his sense of spiritual quest.

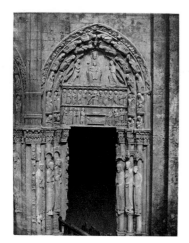
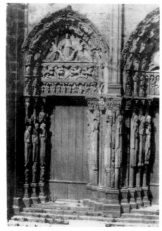

Fig. 21.1 Charles Nègre, *Chartres Cathedral, Right Door of the Royal Portal, West Side, XII Century*, 1857, photogravure. National Gallery of Canada, Ottawa (26558)

Fig. 21.2 Henri Le Secq, *Chartres*, before 1853, photolithograph with beige tint stone. National Gallery of Canada, Ottawa (31451)

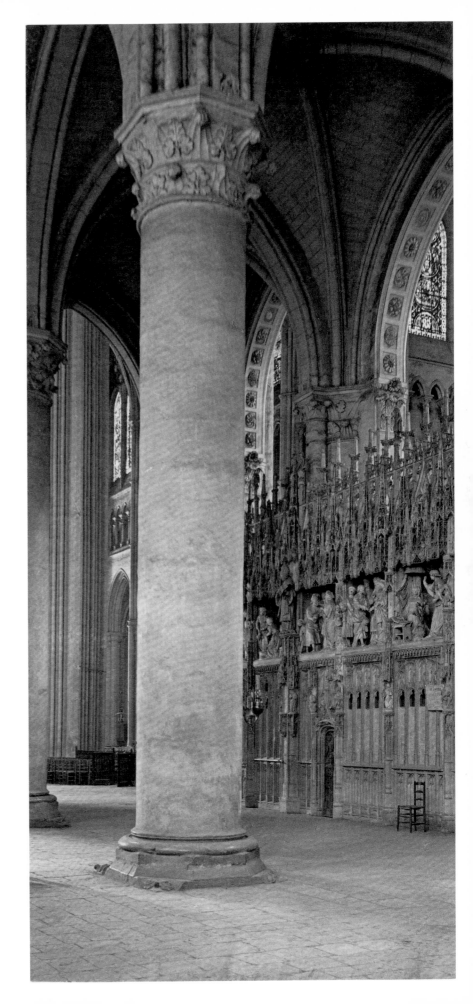

22 Roger Fenton
Heywood, Lancashire 20 March 1819–8 August 1869 London
Russia **October 1852**
Albumen silver print, 17.5 × 21.0 cm
21822

Inscriptions **verso, u.r., graphite, #4216, l.r., graphite, I[?]M39[?]8 / S [encircled], watermark, l. edge, *CANSON***
[partially trimmed]

Provenance **purchased from Daniel Wolf Inc., New York, 1978**

Roger Fenton was just beginning to carve out a career as a photographer when he made this enigmatic image of a cottage and shed on the banks of the Dnieper River near Kiev, having been invited by his friend the engineer Charles Blacker Vignoles to record the building of the world's largest suspension bridge.

Although trained as a lawyer, Fenton was a keen student of the new art of photography. His earliest experiments included working with Charles Wheatstone's reflecting stereoscope camera to photograph animals at London's Zoological Gardens during the summer of 1852. In August Fenton left England for Russia with Vignoles, who had engaged John Cooke Bourne in March 1848 as "resident artist" to photograph the Nicholas Bridge (named after Czar Nicholas I).[1] Remarkably, Fenton seems to have had only two days to make photographs – and even the surviving output of seven negatives is an astonishing production given his lack of experience with the time-consuming process of producing photographic prints on paper.

Fenton photographed this wooden house from at least two other vantage points (see figs. 22.1 and 22.2). His interest in this particular dwelling may be attributed to the fact that he and Bourne were living there while working on their documentation of the bridge.[2] But even if this were true, why did Fenton seem intent on capturing the cottage from various angles? The work here is particularly mysterious, for we are provided with only a close-up of the lean-to addition at the rear of the building; the river is merely glimpsed as a small patch of water toward the top of the image. There is at least one explanation for Fenton to have photographed this unassuming building from different perspectives. Since we know that he was brought to Russia to produce photographs that could be used in a stereoscope, he may have been continuing to refine his skills at creating images for Wheatstone's reflecting stereoscope.[3] In at least two cases of the surviving images from this period, there are two very similar but "variant" images of the same scene.[4]

Compared to Fenton's other bodies of work, there are relatively few examples of his work done in Russia. One reason is that Fenton appears to have been slow in submitting his prints to Vignoles, who in frustration ordered that Fenton submit all of his images and waxed paper negatives to him in 1853.[5] It is clear that Fenton had been sending his prints to fellow photography enthusiasts, including Paul Jeuffrain and Charles Wheatstone.[6] Fenton's early Russian photographs were included in an exhibition held in Russia and also in a December 1852 exhibition organized by the bookseller and amateur photographer Joseph Cundall for the London Society of Arts.

Fenton's next major photographic project would come three years later, in 1855, when he was hired to make photographs in the Crimea. Probably his best-known body of work, the photographs made during the Crimean War afforded Fenton the title of the first war photographer (see cat. 23).

 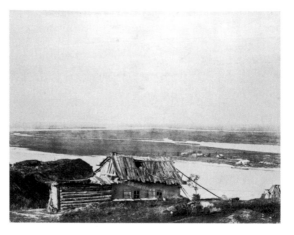

Fig. 22.1 Roger Fenton, *Cottage overlooking the Dnieper, Kiev,* 1852, salted paper print. Courtesy of Robert Hershkowitz

Fig. 22.2 Roger Fenton, *Russian Cottage overlooking the Dnieper, Kiev,* c. October 1852, salted paper print mounted on card. Courtesy of Robert Hershkowitz

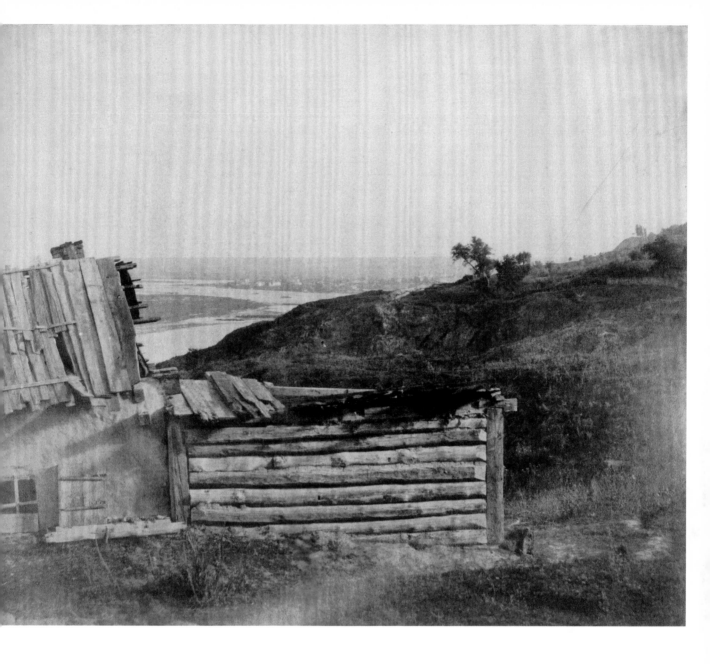

23 Roger Fenton
Heywood, Lancashire, 20 March 1819–8 August 1869 London
Railway Sheds and Workshops, Balaklava March–June 1855, printed 5 April 1856
Salted paper print, 20.7 × 24.9 cm

21811

Inscriptions **secondary support, verso, l.l., graphite,** *Fenton*

Annotations **secondary support, l.r., letterpress,** *Railway Sheds & Workshops, Balaklava,* **l.c.,** *Photographed by R. Fenton. / Manchester, Published by T. Agnew & Sons, April 5th 1856 / London, P.&D. Colnaghi + C° Paris, Moulin, 23, Rue Richer. New York, Williams + C°,* **l.l.,** *Deposé.,* **l.c., raised stamp,** *T Agnew & Son Publishers / Manchester*

Provenance **purchased from Lucien Goldschmidt Gallery, New York, 1972**

Although Roger Fenton's photographic career lasted little more than a decade, his name dominated the 1850s, initially as an advocate for the formation of a Photographic Society in London, and latterly as the most prolific exhibitor of the period.[1] It was his photographs of the Crimea that attracted the most widespread public attention when they were shown in venues throughout Britain from 1853 to 1856, making him the most admired and widely publicized photographer in Britain.[2]

Fenton was born into a prosperous Lancashire family whose banking and mercantile interests gave him the financial independence to pursue a career in law. But it was a bequest from his grandfather that allowed him to spend several years fulfilling his creative ambitions.[3] Like many of that generation, he became interested in photography sometime around 1850, and by 1852 had become a proficient artist of the camera.

After forty years of peace, the British Army was ill prepared to engage with a numerically superior army in a hostile terrain three thousand miles from home in the Crimea. War was declared against Russia in March 1854, and when Lord Raglan landed at Varna with an army of 28,000 two months later, the logistical nightmare of maintaining that many soldiers soon became apparent. With everything in short supply, the greatest threat to life came, not from the enemy, but from infected water supplies and insanitary conditions, which hospitalized a quarter of the army within a matter of months.[4]

The idea of sending Fenton to the Crimea came from Thomas Agnew & Sons, the respected fine art publishers and print sellers. The commission was unprecedented: nothing of this scale or ambition had been attempted by a photographer before. Fenton departed from London in February 1855, with two assistants, a photographic van, seven hundred glass plates, and six large chests of equipment and personal effects[5] (see fig. 23.1).

When Fenton sailed into the narrow inlet that was Balaklava, the whole harbour would have been clogged with shipping, each vessel jostling for space in its anxiety to unload men, ordnance, and essential supplies. Rather than rely on horses and wagons, the army decided to build a railway to move everything to the front, sending out six thousand sleepers, six hundred loads of timber, and about three thousand tons of other material and machinery, along with parties of several hundred "navvies," to construct the line that runs across the foreground of Fenton's study of the harbour[6] (see fig. 23.2).

The wisps of smoke and steam that permeate the scene indicate the hidden activity of ships discharging their cargoes, unrecorded by the long exposure time. Running between ship and shore were boats and barges laden with "biscuit, barrels of beef, pork, rum, bales of winter clothing, siege guns, boxes of Minié ammunition, piles of shell, trusses of hay, and sacks of barley and potato."[7] Also invisible to the eye, but apparent to other senses, hung the pervading stench of death and decomposition. Despite the benign appearance of this image, Balaklava was not a place for the faint-hearted in the summer of 1855.

Fig. 23.1 Roger Fenton, *The Artist's Van, with Marcus Sparling in the Crimea*, 1855, salted paper print. Library of Congress, Prints and Photographs Division (LC-USZ)

Fig. 23.2 Roger Fenton, *Head of Harbour, Balaklava*, c. 8 March–26 June 1855, printed 5 April 1856, salted paper print. National Gallery of Canada, Ottawa (21809)

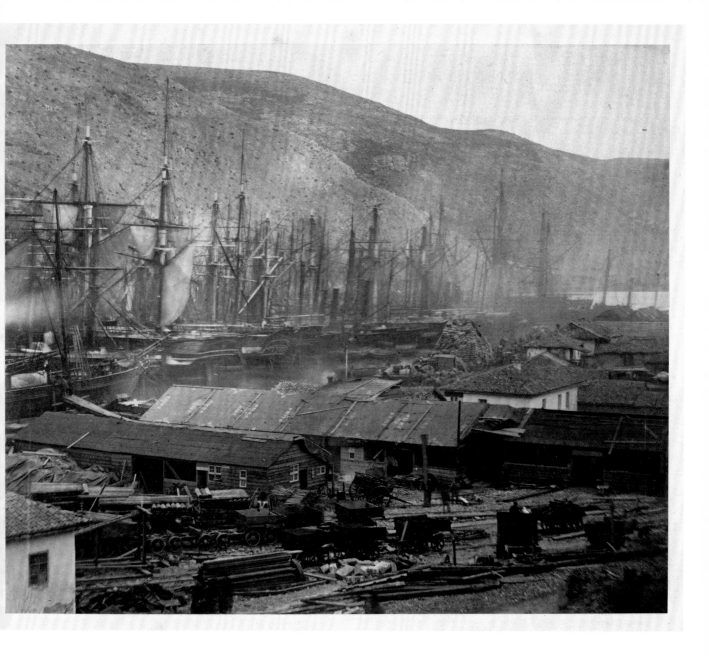

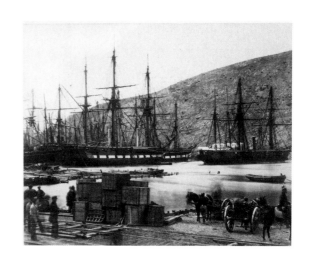

24 Roger Fenton
Heywood, Lancashire 20 March 1819–8 August 1869 London

Highland Gillies, Balmoral September 1856
Salted paper print, 31.4 × 44.2 cm
19520

Inscriptions l.c., in negative, *H.68*, verso, u.c., graphite, *The Queens Gillees*
Provenance purchased from the Phyllis Lambert Fund, 1983

Roger Fenton first met Queen Victoria and Prince Albert in January 1854 during a private visit to the First Annual Exhibition of the Photographic Society. Delighted by the experience, the Queen noted in her journal, "It was most interesting & there are three rooms full of the most beautiful specimens, some, from France, & Germany, & many by amateurs. Mr. Fenton, who belongs to the society, explained everything & there are many beautiful photographs done by him."[1]

Having won royal favour, Fenton received a number of portrait commissions during 1854.[2] That same year he began preparing for his photographic expedition to the Crimea, furnished with a letter of introduction from Prince Albert.[3] A further sign of approval came with the publication of Fenton's portfolio of Crimean studies "Under the Especial Patronage of Her Most Gracious Majesty."[4]

It was against this background that Fenton headed for Balmoral in the late summer of 1856, where he had most likely been summoned by Queen Victoria.[5] Travelling north, he photographed extensively en route before arriving sometime during the second week of September.[6]

The royal couple had made their own way north some two weeks earlier, but with a great deal more pomp and ceremony.[7] Balmoral held a special place in their hearts, its very remoteness offering welcome relief from the rigid formalities of court life in London. On their first visit to Scotland in 1842, Queen Victoria presciently noted how the place had made "a highly favourable impression on us both. The country is really very beautiful … perfect for sport of all kinds, the air remarkably pure and light.[8]

Further visits followed, and in 1848 Prince Albert acquired the lease of Balmoral. Four years later he purchased the estate and immediately began working on its transformation. Their arrival in 1856 coincided with the completion of all major building work. In Fenton's study, the brilliance of the unweathered granite gives the building the appearance of Parian china, or icing sugar (see fig. 24.1).

Nothing pleased the prince more than stalking deer attended by his loyal band of ghillies. A favourite was Macdonald, who stands proudly to the left of this group study.[9] *Highland Gillies* belongs to a series Fenton made of these men in the grounds of Balmoral when every image was anchored by the presence of the large white rock we see here (see fig. 24.2).

The carefully studied composition reveals Fenton's formal training as a history painter in Paris, a skill he brought to perfection during his time in the Crimea, where posing groups of soldiers became second nature. The subject matter belongs to the tradition of Edwin Landseer, whose studies of stag hunting and noble highlanders were part of the visual trappings of life at Balmoral. For the Queen and prince, however, Fenton's group portrait was a *tableau vivant* showing an aspect of daily life on their estate, with a group of ghillies resting after yet another hard day among the heather, their handsome and dignified features perfectly delineated in the chiaroscuro of the evening sun.[10]

Catalogue

64

Fig. 24.1 Roger Fenton, *Balmoral Castle*, 1856, salted paper print. The Royal Collection, Windsor Castle (RCIN 2160040)

Fig. 24.2 Roger Fenton, *Archibald Fraser Macdonald, Ghillie at Balmoral*, after 1856, before 1861, salted paper print. University Eötvös Loránd, Budapest, University Library, Fenykep 4

25 Francis Frith

Chesterfield, Derbyshire 1822–1898 Cannes, France

Sculptures in the Great Temple, Philae 1857
From *Upper Egypt and Ethiopia*, 1862, pl. 13

Albumen silver print, 21.9 × 15.6 cm

21900.14

Annotations secondary support, l.c., letterpress, *SCULPTURES IN THE GREAT TEMPLE. / Philæ.*

Provenance purchased from Hugh Anson-Cartwright, Toronto, 1972

Francis Frith is considered by some to be the first photographer in the United Kingdom to produce and distribute photographs on a large scale. His firm of Frith & Co. generated thousands of photographic images in various forms, including stereographs, postcards, lantern slides, and albums.

Born to a middle-class Quaker family, Frith attended Quaker schools at Ackworth from the ages of about six to sixteen. As a young man, he worked in the cutlery business until he suffered what seems to have been a nervous breakdown. Following two years of convalescence and travel, Frith became a partner in a wholesale grocery enterprise, which he eventually sold, then opened a printing company. Somewhere along the way he also learned the skills needed to become a photographer: in 1853 he became one of the founding members of the Liverpool Photographic Society, and by 1856 he had taken his first trip to Egypt, where he would photograph the landscape and archaeological sites.

Frith ventured up the Nile (on a traditional sailing vessel known as a *dahabieh*) in order to photograph the temple of Isis on the island of Philae. The temple of Isis (c. 370 BC) was a favorite tourist destination and the subject of study since the eighteenth century, when artists such as David Roberts made illustrations of various sites and brought them back to a public hungry for information about ancient and exotic places (see fig. 25.1). The temple was also a very popular subject for other nineteenth-century photographers, including Maxime Du Camp (see fig. 25.2).

In this photograph (which appeared as plate 13 in the published album), Frith has concentrated on the relief sculptures of the Egyptian goddess Isis and her son, Horus, that adorn the first pylons flanking the entrance to the inner temple. The slope of the jutting wall casts a deep shadow through the centre of the image; dark shadows also outline the shapes of the three figures in front of the pylon. The view represented in the National Gallery of Canada's collection shows the reliefs on the right-hand side of the portal to the inner temple. But Frith made other views, including one that shows a different set of relief sculptures with strong slanting shadows falling across the front of the wall from another part of the temple structure.

Given the volume of his output, it is remarkable that Frith made these photographs using a large-format camera and wet-plate collodion on glass negatives, a delicate process even in ideal conditions, but a close-to-impossible task in the climatic conditions and challenging terrain he encountered.

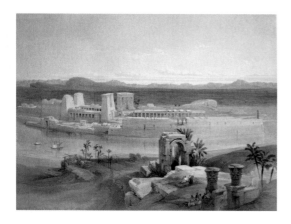

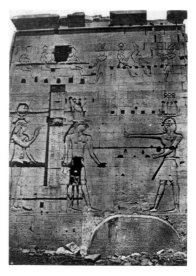

Fig. 25.1 David Roberts, *General View of the Island of Philae, Nubia*, 1838, from *Egypt and Nubia*, vol. 1. London: F. G. Moon, 1846.

Fig. 25.2 Maxime Du Camp, *Second Pylon, Grand Temple of Isis at Philae, Nubia*, after 1849, printed 1852, salted paper print. National Gallery of Canada, Ottawa (21569.72)

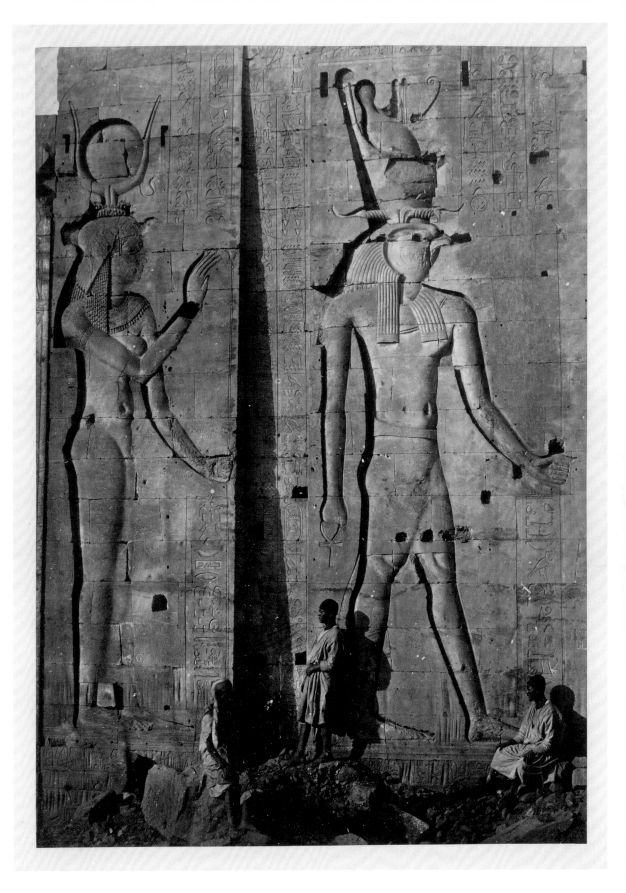

26 David Octavius Hill and Robert Adamson

David Octavius Hill
Perth 20 May 1802–17 May 1870 Newington
Robert Adamson
Burnside 26 April 1821–14 January 1848 St. Andrews
Newhaven Fishwives ("To Hail the Bark that Never can Return") c. 1843–47
Salted paper print, 19.9 × 14.4 cm
31162

Inscriptions secondary support, u.r., *B / 3 / 103*
Annotations l.r., chop mark, *RA* [looped]
Provenance Thackrey & Robertson, San Francisco; purchased from Howard Ricketts Ltd., London, 1977

If some future civilization traced no photographs later than the mid-1840s, it would still understand their expressive power in portraiture through the work of Hill and Adamson. D. O. Hill was an accomplished painter and a powerful voice in Edinburgh's artistic community. Robert Adamson was a young engineer, trained in photography by the circle around Sir David Brewster in St. Andrews. It was through Brewster that Adamson secured the encouragement of Henry Talbot to open a calotype studio in Edinburgh in 1843, an untested prospect in a new form of art. Hill and Adamson were initially thrown together to make working studies of the more than four hundred ministers who broke off to form the Free Church of Scotland. Hill anticipated painting a group portrait. The vigour of their photographs soon overshadowed the potential of the painting, and in a period of four years – very early years in the history of photography – they produced an astonishing three thousand calotype negatives, each on a hand-coated sheet of paper, with each print also made by hand.

Their best known accomplishments were in portraiture, with one of their most significant bodies of work the documentation of the inhabitants of Newhaven, a nearby fishing port[1] (see fig. 26.1). This print's title, drawn from the James Wilson Album at the Scottish National Portrait Gallery, reflects the harsh realities of Newhaven life, for the tempestuous waters of the Firth of Forth claimed their share of the men who ventured out in the boats. "It's no fish ye're buying, it's men's lives" was one contemporary observation.[2]

We do not know for certain the identity of these fishwives. They may be Jeannie Wilson and Annie Linton, but with their handmade creels and characteristic striped garb, they are "types" of the sort one would expect from genre paintings. Yet the truthfulness and specificity of photography preserves the fact that they are real individuals. Their faces express their concern, collectively but individually. The shallow depth of field throws the background out of focus and the long exposure time (perhaps a minute or so) blurs the trees, depicting a world of turmoil surrounding their private strength. These are effects inherent in the photograph and equally natural to our imagination. Hill explained to a new collector of their photographs: "The rough surface & unequal texture throughout the paper is the main cause of the calotype failing in details, before the process of Daguerreotypy – & this is the very life of it. They look like the imperfect work of man – and not the much diminished perfect work of God. Hence I think one great charm Sir I think you will find that the Calotypes like fine pictures, will be always giving out new lights of themselves."[3] The more one examines this photographic image, the more it gains in strength.

 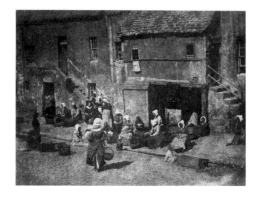

Fig. 26.1 David Octavius Hill and Robert Adamson, *Newhaven Fisher Lassies at Rock House, Edinburgh*, c. 1843–47, salted paper print. National Gallery of Canada, Ottawa (31218)

Fig. 26.2 Circle of David Octavius Hill and Robert Adamson, *Baiting the Lines, North Street, Fishergate, St. Andrews*, c. 1843–47, printed posthumously 1916, carbon print. National Gallery of Canada, Ottawa (31134.6)

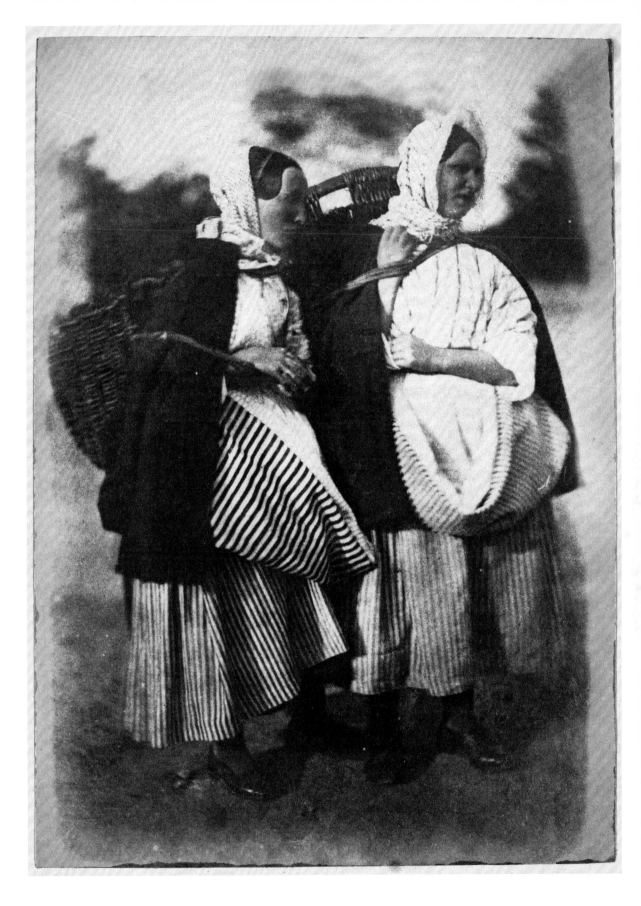

27 David Octavius Hill and Robert Adamson

David Octavius Hill
Perth 20 May 1802–17 May 1870 Newington
Robert Adamson
Burnside 26 April 1821–14 January 1848 St. Andrews

The Reverend Dr. Abraham Capadose (1795–1874), Physician and Calvinist Writer of The Hague c. 1843–47

Salted paper print, 20.4 × 15.6 cm
31204

Inscriptions secondary support, l.l., graphite, *Dr Capadose (The Hague)*, u.r., graphite, *5154, B / 2 / 37*

Annotations secondary support, l.r., black ink, chop mark, *RA* [looped]

Provenance Thackrey & Robertson, San Francisco; purchased from Howard Ricketts Ltd., London, 1977

When the Scottish landscape painter David Octavius Hill announced that he was planning to produce a painting commemorating the founding of the Free Church of Scotland, he was advised by Sir David Brewster, a physicist and the principal of Edinburgh University, to engage Robert Adamson as his assistant. Together, with the aid of the newly invented art of photography, they would undertake the onerous task of representing each of the 474 delegates who were to be included in the final painting. It is believed that Adamson provided the technical support, stood behind the camera, and actually printed the photographs, while Hill arranged the poses and overall composition of the images. The collaboration between Hill and Adamson resulted in a body of work that set the standard for nineteenth-century photographic portraiture and provided a unique record of some of the famous and influential people of the day.

The subject of this portrait is the Reverend Dr. Abraham Capadose, a physician and Calvinist writer from The Hague. Capadose had been one of the delegates to attend the historically important Disruption meeting held on 18 May 1843, which resulted in the formulation of the Deed of Demission and the founding of the Free Church of Scotland. Born into a Sephardic Jewish family and baptized at the age of twenty-seven, Capadose was a central figure in the nineteenth-century Jewish Awakening movement in the Netherlands and actively promoted outreach efforts and prayer services for the "salvation" of Jews.

Here, Capadose is shown with a Bible, an allusion to his prominence within the church hierarchy and his status as a devout thinker and writer. Depicted in three-quarter length profile, he clasps the spine of the large book with both hands. Because of the constraints of the calotype process used by the photographer, the print had to be made out of doors; the strong sunlight causes the sitter's forehead and hands to stand out dramatically from the swag of dark brocade in the background and pulls the eye to the brilliant white of his high-collared shirt. Capadose stares intently at something outside the frame of the image, and his expression is serious – suggesting the solemnity and nobility of his reasons for being in Scotland. At least one other portrait of Capadose was made during this sitting, which shows him in a slightly more relaxed pose, his left hand resting on his thigh (see fig. 27.1). The bold shadows and simple, straightforward composition of Hill and Adamson's photographs link their work to that of the popular Scottish portraitist Sir Henry Raeburn (see fig. 27.2).

Fig. 27.1 David Octavius Hill and Robert Adamson, *Rev. Dr. Abraham Capadose (1795–1874)*, 1843–47, calotype. Private collection, New York

Fig. 27.2 Henry Raeburn, *Jacobina Copland*, c. 1794–98, oil on canvas. National Gallery of Canada, Ottawa (9928)

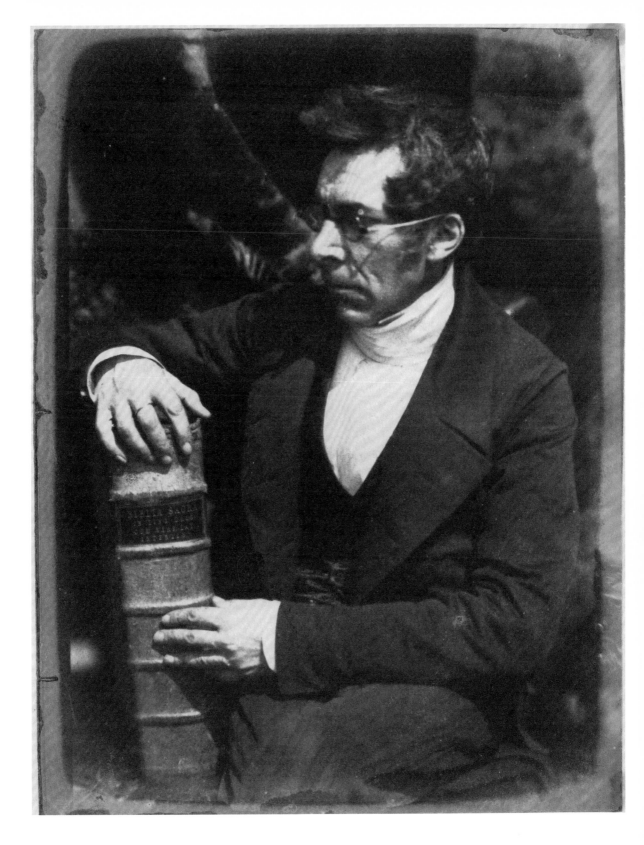

David Octavius Hill
Perth 20 May 1802–17 May 1870 Newington
Robert Adamson
Burnside 26 April 1821–14 January 1848 St. Andrews
Miss Elizabeth (Betsy) Etty, Daughter of John Etty 16 October 1844?,
printed posthumously 1916
Carbon print, 20.2 × 14.9 cm
31134.12

Inscriptions secondary support, verso, u.r., graphite, *Miss Etty*, l.r., graphite, *11*
Provenance purchased from Sotheby's, London, lot 87, 8 March 1974

This portrait of Miss Elizabeth (Betsy) Etty[1] was probably made on the same day that she and two of her uncles, the famous painter William Etty and his elder brother, Charles, also sat for portraits by the Scottish photographic team of David Octavius Hill and Robert Adamson. Etty and Hill knew each other through the Royal Society of Artists, having been correspondents since at least 1830. William Etty and his niece happened to be in Edinburgh on 16 and 17 October in 1844, and it was then that they and Captain Charles Etty had their portraits made by Hill and Adamson.

Betsy, the fifth child of William's younger brother, John, and his wife, Susannah, was born on 21 November in 1801 in the city of York. She, along with her sisters and brother, would often visit their uncle William, who also lived in York and frequently took them to view paintings at the National Gallery in London.[2] He grew quite fond of Betsy, and eventually she came to live with him for long periods of time as his house-keeper and assistant – sometimes travelling with her uncle Charles on trips abroad.

Hill and Adamson's portrait of Betsy shows us a seemingly demure woman, her head slightly turned and eyes downcast. She holds what looks to be a small telescope in her right hand and her elbow rests on a large book. In the portrait of Charles Etty, a merchant seaman and sugar planter who lived in Java, he is holding the same telescope, his right arm leaning on the same large book (see fig. 28.1). This book, and the table upon which it rests, can also be seen in Hill and Adamson's portrait of William Etty, who poses with a paint brush and palette in his hands (see fig. 28.2). As William Etty's biographer, Leonard Robinson, pointed out, Betsy was a kind and devoted niece to both uncles. There is little else known about her other than the fact that she later married Stephen Binnington, a chemist, in May of 1850, and following his death, she married a Mr. Ince. Betsy Etty died in 1888 in London.

The National Gallery of Canada's photograph is a carbon print made by Jessie Bertram in the 1920s using Hill and Adamson's original calotype negative. The carbon prints by Bertram are typically denser in tone and glossier than the original salted paper prints made by Hill and Adamson.

Fig. 28.1 David Octavius Hill and Robert Adamson, *Captain Charles Etty*, 16 October 1844, salted paper print. Purchase, Horace H. Goldsmith and Art Purchase Fund. Chrysler Museum of Art, Norfolk, Virginia (91.28)

Fig. 28.2 David Octavius Hill and Robert Adamson, *William Etty, R.S.A. (1787–1849)*, 16 October 1844, salted paper print. National Gallery of Canada, Ottawa (31200)

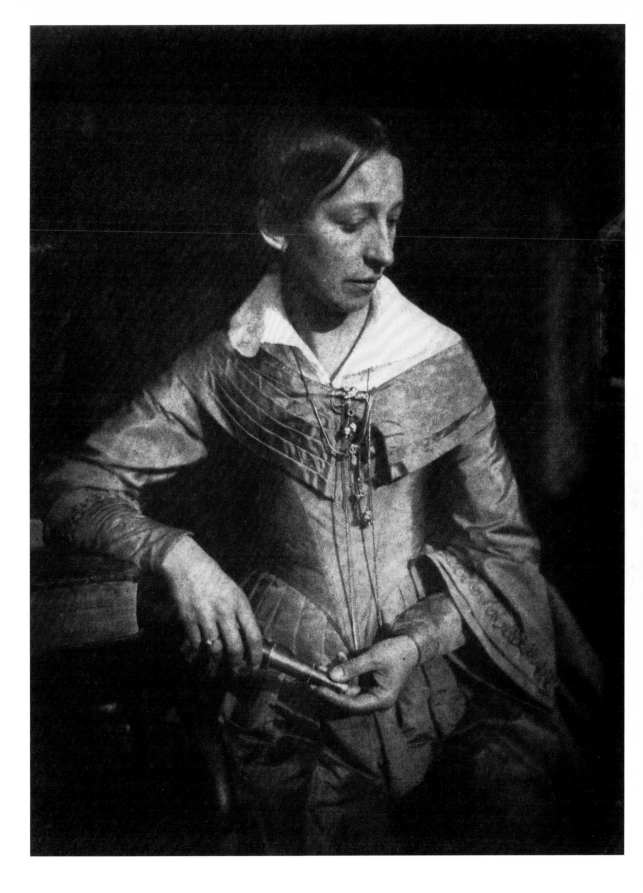

29 Jabez Hogg
Chatham, Kent 27 April 1817–23 April 1899 London
Joseph Andrew and Jabez Hogg Playing Chess c. 1843
Daguerreotype, 10.1 × 7.5 cm
30643

Inscriptions label, verso, u.r., graphite, 22, c., ink, *J. Hogg + Joseph Andrew M.R.C.S.E. / 183[...] / playing Chess / Taken by the Voightlander Lens / 1839.*

Annotations plate, verso, l.r., inverted, stamped, 3, scratched [...]

Provenance Werner Bokelberg, Hamburg; gift of Phyllis Lambert, Montreal, 1988

In 1843 a photographer working in Richard Beard's photography studio at the Royal Polytechnic Institution in London[1] made what is considered to be the first daguerreotype to show a daguerreotypist at work (see fig. 29.1). In this image, we see Hogg standing behind the camera looking at the pocket watch in his left hand while preparing to cover the lens with the cap he holds in his right hand, once the plate has had the right amount of exposure to light. An older man sits stiffly in front of the camera, his top hat placed upside down on the floor in front of him.

Joseph Andrew and Jabez Hogg Playing Chess has much in common with the daguerreotype *Jabez Hogg and Mr Johnson.*[2] Probably made at about the same time, both photographs include a similar swag of drapery in the background on the right. An unidentified portrait bust can be seen in the centre of the National Gallery photograph, between Andrew and Hogg, and on the right in the double portrait of Hogg and Mr. Johnson. The portrait bust would eventually become a standard prop in photography studio portraits and acted both as a sign of the sitter's cultivated tastes and possibly as a way to show how much more lifelike the photograph was compared to the traditional art of sculpture. Posing two figures playing a game like chess also became a photography studio convention during the nineteenth century. Known as a conversation piece, this class of portrait was a way to create a naturalistic, engaging scene while still allowing for the immobility required in long exposure times.[3]

Jabez Hogg was born in Chatham, the youngest son of John Hogg and his wife, Martha. He attended Rochester Grammar School and pursued his interests in literature and photography. By 1841 he was employed as a surgeon's assistant to Dr. Hugh Welch Diamond and living with Diamond and his family in London. Diamond had been interested in photography since 1839 and the two medical men may have experimented with the art together. In 1854 both Hogg and Diamond submitted photographs for the Dundee Royal Infirmary Fund exhibition. In 1843 Hogg began working as a writer and editor for the newly established *Illustrated London News*. Two years later, he took up the study of medicine at London's Hunterian School of Medicine, and that same year published *A Practical Manual of Photography*. Hogg practised medicine, specializing in ophthalmology, dentistry, and diseases of the skin, until at least 1891, and in 1894 or 1895 donated several daguerreotype portraits to the Royal College of Surgeons, whose ranks he had joined in 1850 (see fig. 29.2). Hogg was also the author of several books and articles on various medical and scientific subjects, the best known being *The Microscope: Its History, Construction and Application* (1854).

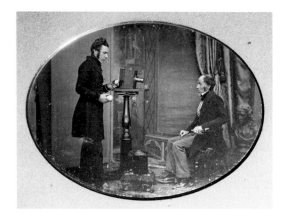

Fig. 29.1 *Jabez Hogg and Mr Johnson*, 1843, daguerreotype. National Media Museum, Bradford (10328383)

Fig. 29.2 Jabez Hogg, *Portrait of Michael Faraday*, 1842, daguerreotype. Gift of Jabez Hogg, 1895, The Royal College of Surgeons of England, London (RCSSC/P 3257)

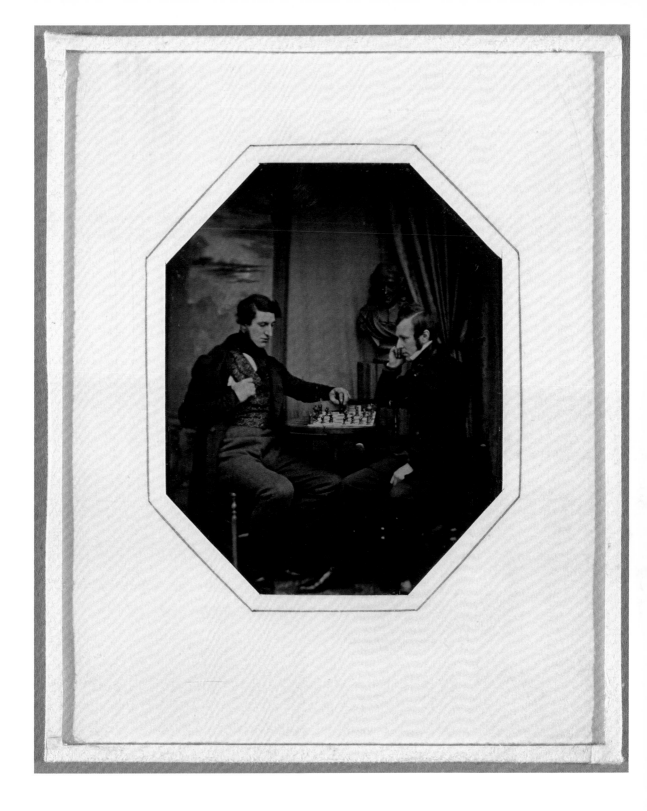

30 Fallon Horne
Monkton, Isle of Thanet, Kent 1814–1858, Margate, Isle of Thanet
Youth and Age before 1855
From *The Photographic Album for the Year 1855*, 1855, pl. 17
Salted paper print, 17.0 × 13.3 cm
20515.16

Provenance purchased from Phillips, Son & Neale, London, 1973

As one of the founders and partners of Horne, Thornthwaite (opticians and manufacturers of scientific instruments) of London, Fallon Horne would have been acquainted with many photographers working or visiting Britain in the 1840s and 1850s. Horne and his business partner, William Henry Emilien Thornthwaite (1819–1894), purchased Edward Palmer's instrument company located at 103 Newgate Street in London in the 1840s. In 1846 Edward Wood joined the company, which then became known as Horne, Thornthwaite and Wood. Although Wood left to start his own business in 1855, he returned in 1886, and the company continued until 1912.

Horne, whose self-portrait (see fig. 30.1) was included in an album put together by another London optician, Richard Willats,[1] was known for his calotypes as well as for his amiability and practical nature.[2] Along with Peter Wickens Fry, founder of the Calotype Club and an early promoter of photography, Horne "was the chief person who aided Mr. Archer[3] to bring his collodion process into general use."[4]

Youth and Age was published in *The Photographic Album for the Year 1855*, and, like Philip Delamotte's *Innocence* (cat. 15) is rich in visual metaphor. His photograph of the boy and man is meant to represent the stages of life rather than the actual people who posed for the portrait. The boy kneels before his elder, looking up to him as if for guidance, his hand covering the open pages of a book he has been reading – as if to suggest the older man is the better choice as a source of wisdom and learning. The text that accompanied Horne's photograph was the third stanza from a poem by Samuel Taylor Coleridge, also titled "Youth and Age" (1834). His technical notes indicate that the negative was made with collodion on glass in August of 1855 when the weather was "very fine." Horne also records that the print was developed using pyrogallic acid and that the camera's lens was manufactured by his own company, Horne and Thornthwaite.[5]

Horne died in Margate (Isle of Thanet) after a long illness.

Fig. 30.1 Fallon Horne, self-portrait, from Richard Willats's album, Graphic Arts Collection, Department of Rare Books and Special Collections, Princeton University Library

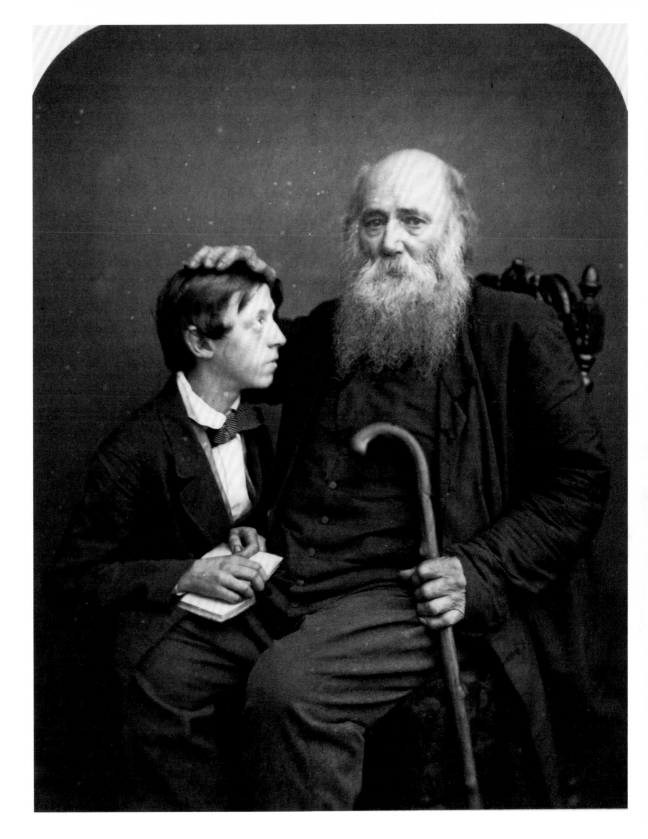

31 Robert Howlett

Theberton, Suffolk 3 July 1831– 2 December 1858 Kensington, London

***The Valley of the Mole* 3 September 1855**

From *The Photographic Album for the Year 1855*, 1855, pl. 13

Albumen silver print?, waxed, 20.5 × 25.6 cm

20515.12

Provenance **purchased from Phillips, Son & Neale, London, 1973**

Although Robert Howlett died at the tragically young age of twenty-seven, he managed to carve out a name for himself in the history of photography. He is highly regarded for his series of photographs documenting the construction of the steamship the *Great Eastern* (originally known as the *Leviathan*), which he produced for the *Illustrated Times* of London, and in particular for his iconic portrait of the ship's builder, Isambard Kingdom Brunel, an early example of environmental portraiture (see fig. 31.1).

Robert Howlett was the second of four sons born to Harriet (née Harsant) and the Reverend Robert Howlett. The younger Howlett's interest in photography was part of a love of science, a passion that may have been inherited from his maternal grandfather, Thomas Harsant, a surgeon from Wickham Market who was remembered for his "mechanical attainments."[1] A financial inheritance from this grandfather allowed Howlett to move from Norfolk to London, where he began an association with Joseph Cundall, another Norfolk native. In London, Howlett worked with Cundall and Philip Henry Delamotte at the Photographic Institution at 168 New Bond Street in Westminster. Howlett took on mainly commercial assignments, including images of the murals of Buckingham Palace for Queen Victoria and Prince Albert as well as a series of views of the crowds at Epsom Downs during a race day for the painter William Powell Frith (who used them in preparation for his 1858 painting *The Derby Day*).[2] Howlett collaborated with Cundall in 1856 on a second commission for the Queen, who had requested a series of photographic portraits of soldiers returning from the Crimean War, and in 1859 he also completed a series of photographs on the architecture of Rouen.

The Valley of the Mole was included in *The Photographic Album for the Year 1855*, accompanied by a stanza from a poem by Percy Bysshe Shelley.[3] In this image we see a haywagon, tilted so that the back of the wagon lies in the water, while the two long handles rest on the land at the river bank's gently curving edge. It is an idyllic scene, the rustic cart evoking ideas about labour and the use of the land for physical and spiritual sustenance. The infusion of Romantic symbolism is in keeping with other images from this album – see, for example, Philip Delamotte's *Innocence* (cat. 15) – but it is also typical of the pastoral landscape paintings done by many Victorian artists.[4] Howlett's photograph was one of several landscapes he made, including an image depicting another tilted wagon, *Barn at the Beehive* (fig. 31.2), in the area of the river Mole near Mickleham and Dorking in Surrey.

Fig. 31.1 Robert Howlett, [*Isambard Kingdom Brunel Standing before the Launching Chains of the Great Eastern*], 1857, printed 1863–64, albumen silver print. Metropolitan Museum of Art, New York, Gilman Collection, Gift of Harriette and Noel Levine, 2005 (2005.100.11)

Fig. 31.2 Robert Howlett, *Barn at the Beehive, Mickleham*, c. 1855, albumen silver print. Victoria and Albert Museum, London (36:369)

32 Calvert Richard Jones
Swansea 4 December 1802–7 December 1877 Bath
Colosseum, Rome, 2nd View May 1846
Salted paper print, 18.6 × 22.4 cm, sheet 19.7 × 24.7 cm
33488

Inscriptions l.l. to l.c., in negative, *67. Colosseum Rome, 2ⁿᵈ view*

Provenance purchased from the estate of William Henry Fox Talbot, through Caroline Ostroff, Silver Spring, Maryland, 1967

William Henry Fox Talbot hoped for others to take up his new art, and no one met these hopes quite so perfectly as did the Reverend Calvert R. Jones. More inclined towards being an artist than a minister, Jones was a close friend and travelling companion of Christopher "Kit" Rice Mansell Talbot, Henry Talbot's cousin and the wealthiest commoner in Britain. While Kit's yacht expanded Jones's range of subject matter, Talbot's calotype process made it possible for him to produce photographs evolving from the style of his previous watercolours. Talbot began purchasing Jones's negatives in order to provide Nicolaas Henneman with subjects for sale. Jones, always in need of funding, lamented to Talbot: "I only wish I knew whether I shᵈ be likely to put my negatives to a mercantile account, as the subjects I shᵈ choose for that purpose wᵈ be different from what I shᵈ select for a private collection of my own."[1] In contrast to the more introspective view that Jones took for himself (see fig. 32.1), this is the perfect tourist memento.

It is possibly Jones himself and almost certainly his wife, Anne, in the foreground, with a mysterious figure closer to the Colosseum providing scale, but otherwise the scene allows the viewer to contemplate the great building, almost as if he were there in person. In comparison with the idealized settings of the majority of hand-engraved prints, the truthfulness of photography shows just how tranquil, indeed almost abandoned, this area of Rome was at the time of Jones's visit. Today, surrounded by urban bustle and choked by long queues of tourists, we need the testimony of photography to believe that it could ever have been different.

This is both a masterful composition and a masterful exposure, belonging to what Jones called his "second series" of negatives, which he felt "will in general yield much finer copies than the 1st set: as the negatives have been left a much longer time in the Camera."[2] Talbot had given him the very modern photographic advice to "expose for the shadows, and develop for the highlights," perfect for the brilliant Italian sunlight. It is the calotype negative at its best. This exceptionally fine print came in the 1960s from the archive preserved at Talbot's home of Lacock Abbey. Unmounted and untrimmed, it brings out all of the potential of the fine negative.[3]

Fig. 32.1 Calvert R. Jones, *Colosseum, Rome*, c. February–May 1846, salted paper print. National Gallery of Canada, Ottawa (33555)

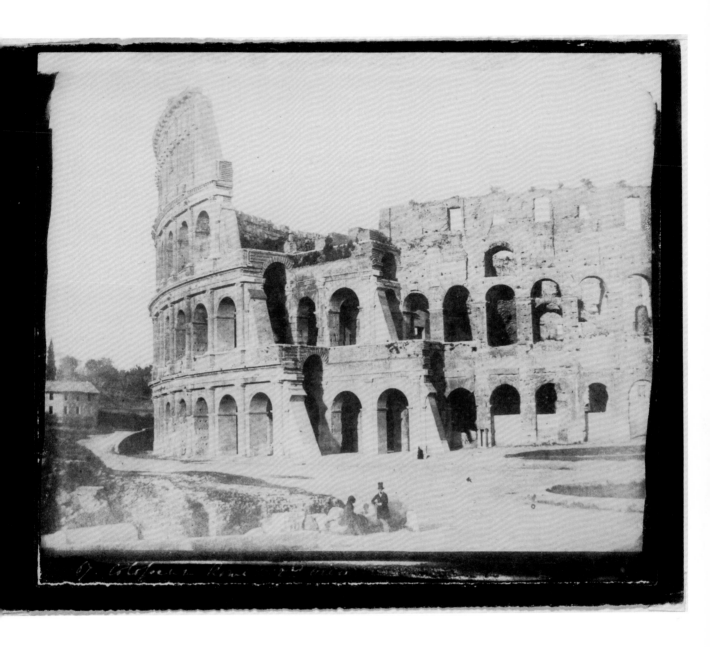
Colosseum, Rome

33 William Edward Kilburn

London 28 November 1818–11 December 1891 Whitwell, Isle of Wight

Mrs. Jane Hamilton with Daughters Rose and Eliza c. 1850

Daguerreotype with applied colour, 12.6 × 10.1 cm

30646

Annotations paper label on cover glass, u.l., black ink, *Mrs Jane Hamilton & Daughters Rose & Eliza c 1851*

Provenance Werner Bokelberg, Hamburg; gift of Phyllis Lambert, Montreal, 1988

The family portrait of Mrs. Jane Hamilton and her daughters Rose and Eliza, with its painted backdrop of clouds and delicate hand-colouring, is typical of the daguerreotype portraits made by William Edward Kilburn during the late 1840s and early 1850s (see fig. 33.1). Mrs. Hamilton and her daughters would have visited Kilburn's photographic studio at 234 Regent Street in London, travelling there from their home in Kirkcudbright, Scotland.

Kilburn's expertise in grouping the three women is evidenced by the pyramidal formation of the figures: Jane Hamilton, the mother, seated on the left, her eldest daughter, Rose, standing behind her, and Eliza, the youngest daughter, seated on the right. The blue sky of the background contrasts with the pink of Rose's dress and is echoed by Eliza's blue collar. Jane and Eliza look off into the distance, their heads turned away from the photographer, while Rose, in the centre, gazes evenly into the daguerreotypist's lens.

William Edward Kilburn may have inherited some of his artistic talent from his grandfather, also named William Kilburn (1745–1818), a botanical illustrator and textile designer who died the same year his grandson was born. The younger Kilburn was the fifth of ten children born between 1814 and 1831 to Thomas, a London warehouseman, and his wife, Catherine Ward. William and his brothers Edward, Frederick, and Charles worked as merchants for the East India Company in the late 1830s and into the 1840s, William and Frederick as accountants and Edward and Charles as traders. But by the mid-1840s, William had taken up photography and learned the daguerreotype process well enough to send instructions to his elder brother Douglas, who had moved to Australia and established Melbourne's first professional photography studio. In 1854 William married a native of Manchester, Louisa Ludlum Tootal; the couple had two daughters and a son. Kilburn is best known for his photographs of the crowds that gathered at Kennington Common on 10 April 1848 for a rally as part of the Chartist Movement[1] (see fig. 33.2). His work was also favoured by Queen Victoria, and he described himself as "Photographer to Her Majesty and His Royal Highness Prince Albert."

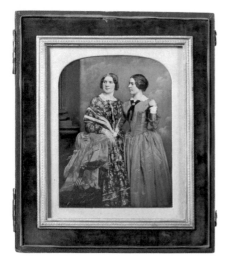

Fig. 33.1 William Edward Kilburn, *Johanna Maria ("Jenny") Lind; Marietta Alboni, Countess Pepoli (née Maria Anna Marzia)*, hand-coloured, half-plate daguerreotype, arched top, 1848. National Portrait Gallery, London (NPG P956)

Fig. 33.2 William Edward Kilburn, *View of the Great Chartist Meeting on Kennington Common*, 10 April 1848, daguerreotype. The Royal Collection, Windsor Castle (RCIN 2932484)

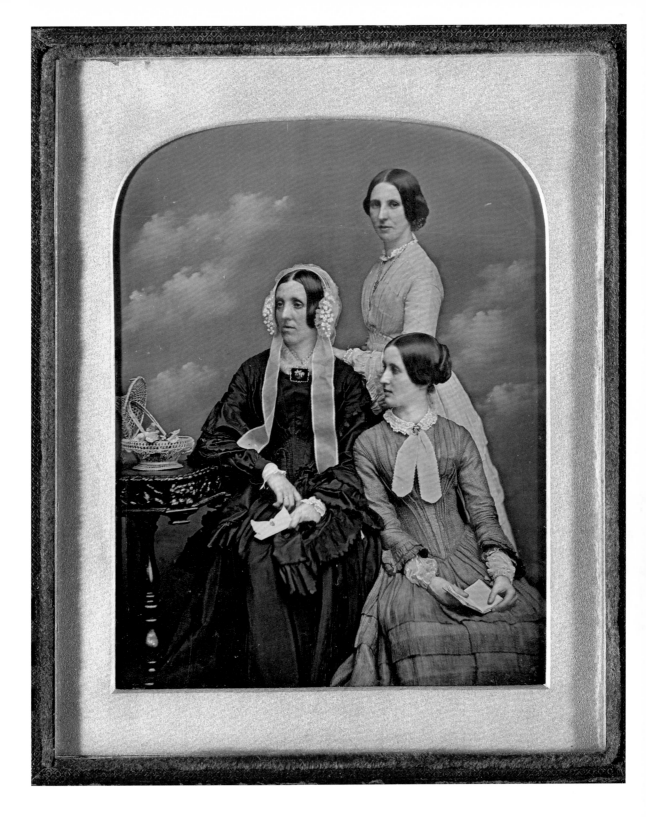

Swansea 12 January 1810–August 1882 Wimbledon, Surrey
Ferns c. 1848–52
Albumen silver print, 20.1 × 24.2 cm
41027

Inscriptions verso, u.l., graphite, *wrong*, l.l., graphite, *X1712.05*, watermark, *[M]ARION*
Provenance purchased from Hans. P. Kraus, Jr., Inc., New York, 2004

> The bright colours of flowers are admired by the least intellectual but the beauty of form and texture of ferns requires a higher degree of mental perception and a more cultivated intellect for its proper appreciation. Hence we regard the growing taste for the cultivation of ferns as proof of mental advancement.
>
> Abraham Stansfield, 1858

The appreciation of ferns reached a highpoint in mid-nineteenth-century Britain, when refinements in the technology of the microscope meant that the plant's spore germination, and hence its reproductive strategies, could be examined more closely. This fascination with ferns and other plant life coincided with the early development of photography; William Henry Fox Talbot, the inventor of photography on paper, was also an avid botanist who used ferns as subjects for his experiments. In 1865, when writing about photoglyphic engravings, Talbot asserted that his invention could greatly facilitate the scientific study of plants, arguing that "it would have greatly aided modern botanists in determining the plants intended by these authors, whose descriptions are frequently so incorrect that they are like so many enigmas, and have proved a hindrance, and not an advantage to science."[1]

Other amateur photographers in Britain were quick to learn photogenic drawing, and as early as 1839, the year that Talbot announced his invention, John Thomas Cooper, Jr. presented photogenic drawings of mosses and ferns to the March meeting of the Botanical Society. By 1853 Anna Atkins (see cat. 3) had completed her book, *Cyanotypes of British and Foreign Flowering Plants and Ferns*.

The son of an acclaimed Welsh botanist, John Dillwyn Llewelyn was himself keenly interested in horticulture and other scientific pursuits, including photography. Llewelyn was married to William Henry Fox Talbot's first cousin Emma, and it was through Talbot that the Llewelyn family was kept informed of new advancements in photography. This photographic study presents the viewer with several different types of ferns carefully arranged on a page. The process used was Talbot's "photogenic drawing," today called a photogram. The ferns were arranged on a piece of paper that had been prepared with a light-sensitive coating and then the entire page was exposed to sunlight. After several minutes, the ferns were removed and the coating washed off the paper. The areas of the paper that had been covered by the fronds remained light whereas those parts of the paper exposed to the sunshine became dark, giving the image the appearance of an early negative (see figs. 34.1 and 34.2).

Fern cultivation, collection, and classification were popular pastimes in Britain during the middle part of the nineteenth century. In his *Glacus or the Wonders of the Shore* (1855), Charles Kingsley coined the term pteridomania in reference to the fern-loving phenomenon. At the same time, ferns became a fashionable motif for the decoration of many household items, including pottery, furniture, glassware, and fabrics.

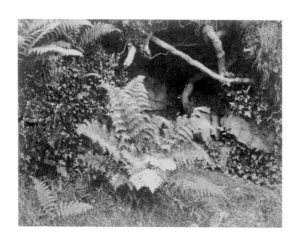

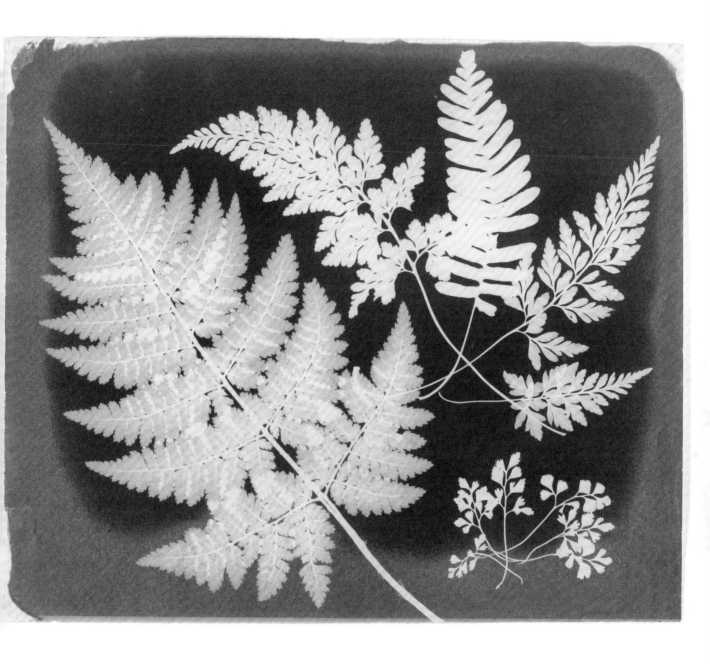

Fig. 34.1 John Dillwyn Llewelyn, *Ferns in a Grotto at Penllergare*, c. 1853, salted paper print. George Eastman House, Rochester, New York (74:0045:0007)

Fig. 34.2 John Dillwyn Llewelyn, *Stoat & Fern Study*, c. 1856, Oxymel negative. City and County of Swansea, Swansea Museum Collection (SWASM: SM1987.846.99)

35 Farnham Maxwell Lyte

Brixham, Devon 10 January 1828–4 March 1906 London

Untitled (Study of Trees and Figures, Park in Pau, France) c. 1853

Salted paper print, 20.7 × 16.9 cm

39630

Inscriptions l.l., in negative [mirror image], *Lux Feci[t]*

Provenance Lot 68, Christies, South Kensington, Wednesday 19 and Thursday 20 November 1997; purchased from
Robert Hershkowitz, Lindfield, Sussex, 1998

Farnham Maxwell Lyte (see fig. 35.1) is an enigmatic figure in the history of early European photography. Trained as a chemical engineer, he left London for the south of France around 1852 in an effort to over- come health problems. While in Pau, he experimented with photographic processes in collaboration with fellow photographers John Stewart and Jean-Jacques Heilmann. Lyte was acknowledged as the inventor of "the honey process," a technique of adding a syrupy solution to wet collodion plates in order to retain a level of humidity that would allow the plates to be prepared several days in advance of making the prints. He was also noted for his discovery of the dangers posed to photographic prints by the "antichlor" (an agent used in a process to block the deleterious actions of bleaching) impurities in paper mounts.

This untitled photograph is a fine example of picturesque photography and an exquisite salted paper print. Yet the subject remains tantalizingly elusive. In the centre, a group of people is clustered behind a tree. A wood-cutter stands to their left, an axe in his right hand, while a figure dressed in religious garb strides into the picture from the right. The smallest child in the gathering, barely visible, is supported by one of the women as he stands on a fallen tree trunk. The presence of a ladder is as puzzling as the inclusion of the cleric. Like Lady Augusta Mostyn (see cat. 39), Lyte was more interested in the picturesque quality of the damaged trees than in the presence of human figures included merely for scale. A fascination with broken branches and decaying trees was in favour with artists influenced by the writings of William Gilpin, whose eighteenth-century treatise on forest scenery was quoted in many nineteenth-century texts: "What is more beautiful, for instance, on a rugged foreground, than an old tree with a hollow trunk? Or with a dead arm, a drooping bough or a dying branch?"[1]

This print was a part of an album known as the Thorncote Scrap Book, whose bookplate identified it as belonging to the library of William Sinclair (1804–1878), rector of Pulborough in Sussex.[2]

The photograph is related to *Study of Trees* (fig. 35.2), shown in 1855 at the second exhibition of the Photo- graphic Society in London. Like the image from the scrapbook, it includes a man in religious robes, a similar landscape with denuded trees, low rock fences, and the inscription *Lux Fecit* (made by light) written on the negative.

The rich reddish coloration and gentle tonalities of the National Gallery photograph are characteristic of many salted paper prints. Because the image is held by the silver salts embedded in the paper itself, the print has a distinctive depth and warmth. Markings at the extreme edges of each of the corners attest to the fact that a wet collodion plate was used as the negative, a relatively new process at the time that was highly regarded for its abilities to render sharp details and to produce multiple copies.

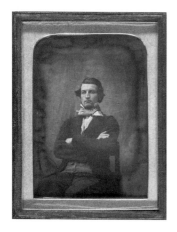

Fig. 35.1 Unknown (British, mid-19th century), *F. Maxwell Lyte as a Young Man,* c. 1850, daguerreotype. National Gallery of Canada, Ottawa, Gift of David Lewall, Andorra, and of Edward and John Lewall, British Columbia, 2003 (41332)

Fig. 35.2 Farnham Maxwell Lyte, *Study of Trees, Avenue in the Parc, Pau, France*, 1853, albumen print. The Royal Collection, Windsor Castle (RCIN 2906059)

36 Robert Macpherson
Edinburgh 1811–17 November 1872 Rome

Theatre of Marcellus from the Piazza Montanara, Rome c. 1858–63

Albumen silver print, 40.6 × 28.9 cm

19930

Inscriptions secondary support, l.r., brown ink, *Theatre of Marcellus* –,verso, l.l., graphite, *MacPherson 500.4 (#163),*
l.r., graphite, *CEF / 773*

Provenance gift of Charles Polowin, Ottawa, 1981

Although the details of Robert Macpherson's early life are still unclear, there are suggestions that he was born in Edinburgh and raised in Forfarshire. When he was still a child, his parents moved to Canada, but he returned to Scotland at the age of seventeen to pursue a career in medicine at the University of Edinburgh. Macpherson also became interested in art during this period and may have studied painting at the Edinburgh Art Academy.

Around 1839 or 1840, Macpherson left Edinburgh without obtaining a medical degree, ending up in Rome, where he began working as a landscape painter, art dealer, and, occasionally, a journalist. In 1849 he married Gerardine Bate, a British student of Italian art and the favourite niece of the art historian and author Anna Jameson. By about 1851, Macpherson had been introduced to the new art of photography. He quickly grasped the business opportunities afforded by this medium, and between 1851 and 1866 came to be regarded as one of the foremost photographers working in Rome.

Macpherson rarely included people in his photographs, concentrating instead on the famous monuments and architecture of Rome. In *Theatre of Marcellus*, Macpherson has moved close to the building, denying the viewer an overall picture of the architecture and its distinctive curved shape, which is the more typical mode of portraying this ancient structure (see fig. 36.1). The strong sunlight accentuates the various architectural details that decorate the stone surface of the building, while at the same time plunging certain areas (such as the lower right corner of the image) into deep darkness. Still a popular site for tourists, the Theatre Marcellus would have appealed to Macpherson's British and American clients in the 1850s and 1860s who desired photographic souvenirs of their Italian sojourns. The theatre was also a subject for nineteenth-century artists such as Giovanni Battista Piranesi and Jan Goeree.

Macpherson began working with large glass plates coated with albumen, but eventually switched to the more reliable wet-plate collodion process. His prints were usually made on albumenized paper and are identified by an oval blind stamp that incorporates his name (R. Macpherson Rome) with a catalogue number written in pencil in the centre of the oval. His wife and her mother, Louisa Bate, assisted with the photography business – including the practical tasks of developing, touching up, and printing his photographic plates.

Macpherson seems to have kept up his contacts back in Britain, occasionally returning to visit relatives, and exhibiting his photographs from 1855 to 1861 at various photographic association and institutional exhibitions.[1] He also engaged William Ramsay (1806–1865), who was appointed to the Chair of Humanity at Glasgow University, to act as his representative in Britain. Ramsay, who came to live in Rome in 1863, is thought to be one of the first amateur practitioners of photography in Scotland.[2]

In 1863 Macpherson published *Vatican Sculptures*, a book of engravings done by his wife and made from his photographs. Macpherson was in ill health as early as 1857.[3] He died in Rome, apparently as the result of contracting malaria.

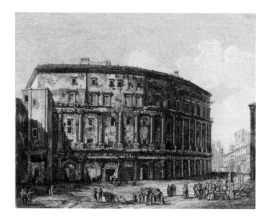

Fig. 36.1 Luigi Rossini, *Avanzi del Teatro di Marcello* (Ruins of the Theatre of Marcellus), 1821, etching. Achenbach Foundation for Graphic Arts, Fine Arts Museums of San Francisco (1963.30.37622)

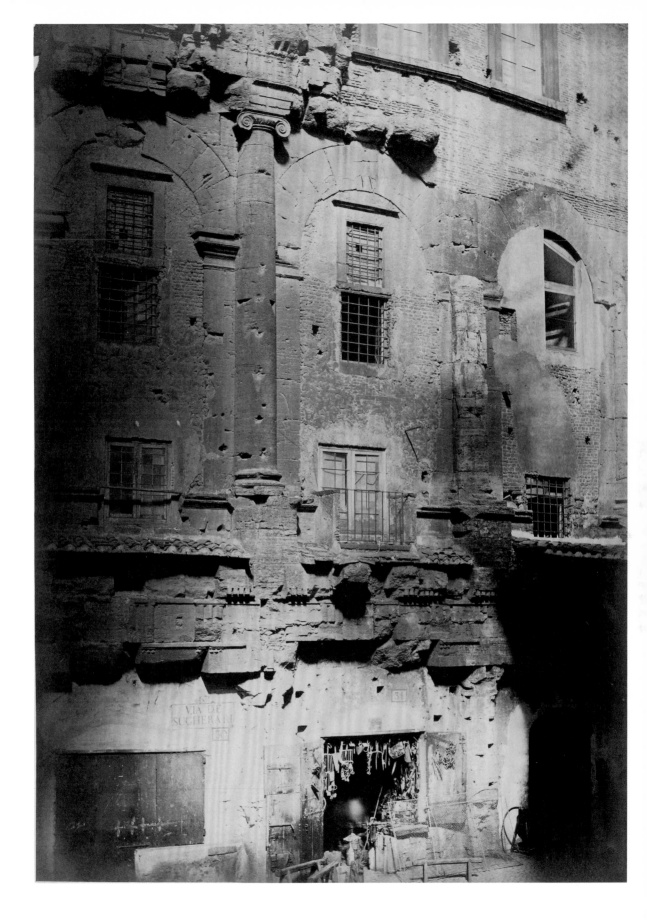

St. Peter Port, Guernsey 1809–11 June 1879 St. Peter Port, Guernsey
Highland Cottage, Village of Ardnahèrra, Loch Fine, Argyleshire July 1854
From The Photographic Album for the Year 1855, 1855, pl. 44
Albumen silver print, 16.5 × 21.3 cm
20515.40
Provenance purchased from Phillips, Son & Neale, London, 1973

Like other scientifically minded men and women of his time, Dr. Thomas Lukis Mansell was an enthusiastic supporter of photography and a member of the Photographic Exchange Club and the Photographic Society Club. Mansell also became proficient with both the paper negative and the wet-plate collodion processes and even went so far as inventing his own formula for the collodion mixture.

Thomas Lukis Mansell was born on the island of Guernsey, the eldest son of Rear Admiral Thomas Mansell and his wife, Catherine Rabey Lukis. The younger Mansell earned his BA and a degree in medicine at Trinity College, Dublin. Well known for his keen interest in the weather, he also became a respected authority on meteorology. In 1851 he married Elizabeth Collings, the eldest of six daughters of Joseph Collings, a merchant in St. Peter Port, and his wife, Elizabeth. In 1868 Mansell was elected to the magistracy, where he would have undertaken the duties of a Justice of the Peace. According to his obituary, Mansell bequeathed five hundred pounds to a charity that ensured impoverished fishermen would have their boats replaced if they had been damaged as the result of a storm.[1]

Mansell submitted *Highland Cottage, Village of Ardnahèrra* to the Photographic Society Club as his contribution to the first "exchange" album that was produced by the Club.[2] The photograph shows a scene in a small, rural township that would eventually be depopulated by the second wave of the Highland Clearances of the eighteenth and nineteenth centuries. These townships – what Queen Victoria referred to as "primitive villages" – were typically composed of six to twelve families who lived and worked as tenant farmers on a large area of hilly and agriculturally difficult land. It is possible that the building in Mansell's image is a cottar's house, the dwelling of a farm labourer who carried out specialized tasks such as weaving. Only women and children appear, most likely because in summer, when this photograph must have been taken, the men were off tending cattle.

Mansell continued to contribute photographs to the Photographic Exchange Club and the Photographic Society Club (see fig. 37.1). It was Mansell who encouraged the other members to provide all the technical information – the type of lens used, the process, and so on – to accompany their photographs in the albums of 1855 and 1857. He also contributed photographs to exhibitions held by the London Photographic Society in 1856 and 1858 and the Manchester Art Treasures Exhibition of 1857.

Fig. 37.1 Thomas Lukis Mansell, *Port de Dinan, Brittany*, 28 June 1856, albumen silver print, toned. George Eastman House, Rochester, New York (79:1992:0024)

38 Count de Montizón (Don Juan Carlos Maria Isidro de Borbón)
Madrid 15 May 1822–21 November 1887 Hove, Sussex
The Hippopotamus at the Zoological Gardens, Regent's Park 1852
From *The Photographic Album for the Year 1855*, 1855, pl. 9
Salted paper print, 11.2 × 12.4 cm
20515.8

Provenance purchased from Phillips, Son & Neale, 1973

The Count de Montizón was a name adopted by Don Juan Carlos Maria Isidoro de Borbón (he was also known to use the more prosaic Mr. Montagu). He spent his early childhood at the court of his uncle, King Ferdinand VII. In 1834 Juan moved with his family to England, and in 1847 he married the Archduchess Maria Beatrix of Austria-Este, with whom he had two sons. A founding member of the Photographic Society, he published in the *Journal of the Photographic Society* and contributed at least 166 photographs to exhibitions in Great Britain, including the London Society of Arts in 1852, the Royal Infirmary Fund Exhibition in Dundee in 1854, and the London Photographic Society Exhibitions of 1854, 1858, and 1859. Other than a few copies of paintings, most of the Count de Montizón's subjects were animals.

The hippopotamus in this photograph was one of the star attractions of London's Zoological Gardens (see fig. 38.1). The hippo was a gift to Queen Victoria from Abbas Pasha of Egypt arranged through the diplomatic efforts of Sir Charles Augustus Murray (1806–1905), British Consul General at the time. Obaysch (named after the island where he was captured) arrived at the zoo on 25 May 1850, but his journey had actually begun in 1849, when he was loaded onto a specially built boat and floated up the Nile to Cairo. Once in Cairo, Obaysch was kept in a yard at the British consulate while awaiting passage to England. Charles Murray's letters reveal that the young hippo had become surprisingly domesticated and was particularly attached to his trainer, Hamet Saaffi Cananna: "The hippopotamus is quite well, and the delight of every one who sees him. He is as tame and playful as a Newfoundland puppy; knows his keepers, and follows them all over the courtyard."[1] Obaysch was extremely popular, with attendance rising to some 10,000 people a day, thus reversing the lack of public interest in the zoo before his arrival. The animal inspired a fascination that became known as hippomania: silver hippo-shaped souvenirs were sold, drawings were made, and even a polka was written in honour of the zoo's new addition (see fig. 38.2).

The photograph was included in the Royal Photographic Society's Photographic Exchange Club's publication *The Photographic Album for the Year 1855* as plate 9. The salted paper print was made with a wet-plate collodion negative using "a double lens" and "instantaneous exposure."[2] The relatively short exposure times afforded by the wet-plate collodion process were ideally suited for photographing live animals. De Montizón must have had permission to enter Obaysch's enclosure, giving us an unobstructed view of the recumbent creature, his likeness reflected in the pool next to him, while the human onlookers are seen behind the bars that separated them from the zoo's inhabitants.

Fig. 38.1 Frederick York, *Obaysch, The Hippopotamus*, c. 1870, albumen silver print? Zoological Society of London

Fig. 38.2 L. St. Mars, title page of "The Hippopotamus Polka" (New York: W. Hall & Son 1848–58). Cover illustration by Napoleon Sarony. Department of Special Collections, University of Pennsylvania

39 Henrietta Augusta Mostyn (née Henrietta Augusta Nevill)

Birling Manor, near Tonbridge, Kent 18 June 1830–25 January 1912 Llandudno, Conwy

Oak Tree in Eridge Park, Sussex before 1857

Albumen silver print, 17.7 × 19.7 cm, sheet 18.2 × 19.7 cm

37218

Inscriptions secondary support, verso, l.l., graphite, 2020

Provenance purchased from Hans P. Kraus, Jr., Inc., New York, 1994

The fifth child of William Nevill, 4th Earl of Abergavenny, Lady Augusta Mostyn took up photography as a young woman. She and her two sisters, Caroline and Isabel – nicknamed "the trio" by friends and family – may have been introduced to photography by W. J. Thoms (1803–1885).[1] Widowed in 1861 (she had married the Honourable Thomas Lloyd-Mostyn in 1855), Augusta was left to care for their two young boys. Energetic and apparently a shrewd businesswoman, Lady Mostyn transformed an inheritance of what was then considered "wasteland" property in North Wales into a profitable tourist resort area. She seems to have managed her portion of the family estate with great aplomb and was instrumental not only in building parish churches in the two villages close to the estate, but also in ensuring that the people who lived on the estate lands were properly fed and educated in practical arts such as sewing.[2]

Oak Tree in Eridge Park, Sussex presents us with a view of the countryside that formed part of her father's estate in Sussex. It is possible that the woman seated next to the tree is Lady Mostyn herself (or one of her sisters) and the man could be Thomas Lloyd-Mostyn. This photograph was included in the Photographic Exchange Club *The Photographic Album for the Year 1857* and seems to have a slightly different cropping than a print at the George Eastman House (see fig. 39.1). Another photograph of the oak tree alone is attributed to Lady Mostyn (see fig. 39.2).

The oak tree was a popular subject in mid-nineteenth century art, owing in part to its symbolic role in European culture as a representation of both nature and history.[3] Corot, Rousseau, and Courbet all painted images of oak trees, and many early photographers such as William Henry Fox Talbot, Gustave Le Gray, and Comte Olympe Aguado trained their cameras on the solid trunks and gnarled branches of this stately tree. Posing people at the base of a tree was also a common pictorial convention at the time. By setting human figures next to such massive props, the artist could suggest not only differences in scale but also the fleetingness of the human life span when compared to that of an oak.

While French photographers and painters worked in the Fontainebleau forest, English photographers such as William John Newton were busy making photographs of the Burnham Beeches.[4] Like the beeches in Newton's photographs, there is a suggestion of an anthropomorphic quality to the tree depicted here. Since both possess trunks and limbs, the comparison of human bodies to trees has had a long tradition in Western culture. Whether either photographer was aware of the human resemblances in the trees they photographed is not known, but such natural curiosities were certainly considered worthy subjects for artists from at least the eighteenth century onward.[5]

Fig. 39.1 Henrietta Augusta Mostyn, *Oak Tree in Eridge Park*, early 1850s, albumen silver print. George Eastman House, Rochester, New York (1968:0088:0018)

Fig. 39.2 Henrietta Augusta Mostyn, *Oak Tree Etheridge Park, Sussex*, albumen silver print, c. 1854. Private collection

40 James Mudd
Halifax, Yorkshire 1821–1906 Bowdon, Cheshire

Dona Maria Pia Locomotive, Built by Beyer, Peacock Locomotive Works, Manchester, for South Eastern Portugal Railway 1863

Albumen silver print, 24.7 × 37.4 cm

28639

Annotations modern secondary support, verso, l.l., graphite, *James Mudd 1863*, l.c., *South Eastern of Portugal Railway gauge 5'6"*, l.r., *450 –*

Provenance purchased from Paul Katz, North Bennington, Vermont, 1984

With the spread of photography in the nineteenth century, its chief purpose became the communication of information (see figs. 40.1 and 40.2). Undoubtedly, this was James Mudd's intention in photographing the Dona Maria Pia engine for the Beyer, Peacock Locomotive Works in Manchester. In fact, we might even say that this is an early example of an advertising photograph. By opaquing the factory yard from the background with a black varnish on the negative, Mudd has presented his subject as though it were a studio portrait. All that remains of context is the ground on which the rails and engine sit.

Either consciously or unconsciously, Mudd has understood that literal description not only serves the manufacturer's purpose, it is also a powerful element of the photographic aesthetic. His glass negative and albumen silver print record the sheen of metal and the detail of machinery with a precision and clarity that is fitting to the subject and seductive to the eye. The Victorian was meant to be impressed, for this was the cutting edge of modern technology, both in locomotive engineering and in photographic processes. To our eyes the engine may appear quaint, but William Henry Fox Talbot's prediction has been served: through photography the future will know what the past looked like.

At least as early as 1850, Mudd was working in Manchester as a designer for calico fabric printers. He began to photograph as an amateur around 1850, with a special interest in landscapes, and possibly under the influence of John Benjamin Dancer, the early Manchester daguerreotypist (see cat. 14). By 1854 he was listed as both photographer and designer, but by 1861 he had dropped the design part of his business. A founding member of the Manchester Photographic Society in 1855, he was represented in the important Manchester Art Treasures Exhibition of 1857. Exhibition reviews between 1857 and 1865 considered his work to be equal to that of Francis Bedford, O. G. Rejlander, and H. P. Robinson.[1] A critic reviewing the 1861 Société française de photographie exhibition compared the poor quality of the French landscapes to the superior atmospheric perspective of Mudd's photographs. Mudd had been one of the earliest practitioners in doing so with glass negatives,[2] something that had been much easier to accomplish with the paper negative. He may have been the first in Britain to make photographs for use as evidence in court cases, having done so in 1857 to illustrate the effects of industrial pollution on plant life. He is also thought to be the first British photographer to make industrial photographs on a regular basis, beginning in 1856.[3] Toward the end of his life, he concentrated on drawing and painting.

Fig. 40.1 Unknown (British, mid-19th century), *"Puffing Billy" Locomotive, Wylam Colliery, Northumberland*, c. 1855, albumen silver print. National Gallery of Canada, Ottawa (28822)

Fig. 40.2 Alexander Henderson, *Deck Bridge over the St. Scholastique River*, c. 1877–78, albumen silver print. National Gallery of Canada, Ottawa, Study collection (PSC71:003:19)

41 Eadweard Muybridge (born Edward James Muggeridge)

Kingston upon Thames, Surrey 9 April 1830–8 May 1904 Kingston upon Thames, Surrey

Baseball, throwing c. June 1885–11 May 1886; printed November 1887

From Animal Locomotion, 1887

Collotype, 25.2 × 28.8 cm, sheet 46.7 × 59.2 cm

31743

Inscriptions each of the 24 images shows an inscribed number printed in the negative

Annotations below image, l.c., letterpress, *ANIMAL LOCOMOTION. PLATE. 286 / Copyright, 1887, by EADWEARD MUYBRIDGE. All rights reserved.*

Provenance gift of Benjamin Greenberg, Ottawa, 1981

Born in England, Eadweard Muybridge spent most of his working life in the United States. Arriving in New York in the early to mid-1850s, he was employed as a publisher's agent and a bookseller there and in other American cities. Muybridge began his artistic career photographing in the Yosemite Valley (see fig. 41.1) as well as in Alaska and Central America. He also made documentary photographs recording the expansion of the railroad, the damage from the 1868 San Francisco earthquake, and the Modoc Indian War. But he is most celebrated and remembered for his innovative locomotion studies – immediately recognizable in their format of geometrically regular grids – showing consecutive phases of movement in animals and humans.

Muybridge's reputation as a landscape photographer brought him to the attention of Leland Stanford, former governor of California and equine enthusiast, who engaged him to determine whether all four feet of a trotting or galloping horse were ever off the ground at once (see fig. 41.2). After a series of early experiments in 1872, Muybridge resumed his project for Stanford in 1877, and eventually was able to capture what moved too fast for the eye to see, proving that a horse was completely in the air at one point in its gait. The ingredients of success included a bright white background illuminated by California sunshine, English Dallmeyer lenses, electrically triggered shutters that permitted extremely short exposure times – according to the photographer, 1/1000th of a second – and a series of specially commissioned cameras positioned at right angles to the track.

Muybridge had a falling out with Stanford when *The Horse in Motion* was published in 1882 without Muybridge's name on the title page. The photographer spent the next several years giving illustrated lectures using the zoopraxiscope[1] and looking for support to further his studies in animal locomotion. Primarily through the interventions of two Philadelphia natives, the painter Thomas Eakins, who was also a photographer, and the scientist Fairman Rogers, the University of Pennsylvania agreed to underwrite the next phase of Muybridge's research.

From 1884 to 1886, Muybridge produced 781 motion studies (published in 1887 as *Animal Locomotion*), with a primary focus on humans performing activities such as walking, running, dancing, and playing various sports.[2] Many of his models were drawn from University of Pennsylvania faculty and students, among them Morris Hacker, Jr., a student athlete shown here in the sequential acts of throwing a baseball. It has been discovered that many of Muybridge's motion studies are not perfectly sequential (sometimes the elements are assemblages of different photographic sessions), but even if the "representations of movements that make up *Animal Locomotion* are not scientific, they are still the most convincing *illusion* of natural movement that had hitherto been achieved."[3]

Fig. 41.1 Eadweard Muybridge, *Valley of the Yosemite: Early Morning from Moonlight Rock*, 1872, printed 1977, albumen silver print, gold toned. National Gallery of Canada, Ottawa (31990.1)

Fig. 41.2 Eadweard Muybridge, *"Annie G." Galloping*, c. June 1884– 11 May 1886, printed November 1887, collotype. National Gallery of Canada, Ottawa, Gift of Dr. Robert W. Crook, Ottawa, 1981 (31880)

42 Hugh Owen

Market Drayton, Shropshire 1808–1909 Paddington, London
Camel Gun before September 1851, printed c. September–November 1851
Salted paper print, 17.3 × 22.1 cm
30752

Annotations secondary support, below image, letterpress, *CAMELGUN.*, l.r., letterpress, *INDIA.*,verso, l.l., graphite, *CTF.86*, l.r., graphite, *0.5*

Provenance purchased from Sander Gallery, New York, 1990

Hugh Owen is usually remembered for his photographs of objects on display at the Great Exhibition of 1851. Photography was a hobby since he spent his days working his way from the position of clerk to head cashier for the Great Western Railway.[1] He also found time to become an expert and published authority on the subject of the history of ceramics in Bristol and Leeds.

Owen, along with the French photographer Claude-Marie Ferrier, was commissioned to produce 150 photographs of objects from the Great Exhibition.[2] It is not surprising to learn that as an employee of the Great Western Railway, Owen had made images of trains and other mechanical objects, and it was on the strength of some of this earlier photographic work that the Executive Committee of the Great Exhibition invited Owen to make photographic records of some of the objects as illustrations for the exhibition publication, *Reports by the Juries*. These images included a view of large blocks of coal, an embroidered saddle, agricultural implements, an anchor, chain metal, swords, and several other articles that were on display.

This photograph of a camel gun is a typical example of Owen's series of images from the Great Exhibition. The gun and its elaborate saddle cloth are shown in isolation, set against a dark backdrop with a light source casting a strong shadow of the rifle barrel. Camel guns (also known as zamburaks, or "little wasps," because of the sound that early versions made) were used in India and other countries where the rough terrain made using more conventional artillery extremely difficult or impossible. This gun was displayed in the India section of the Exhibition along with several other objects from India, including a buffalo carriage (see fig. 42.1), a stuffed and mounted elephant, an ivory throne, and the famous Koh-I-Nor diamond.

The city of Bristol and its buildings and parklands also appear frequently in Owen's photographs (see fig. 42.2), and it may have been scenes from Bristol that were shown at the Great Exhibition. While little is known about how Owen became a photographer, it appears that he had been making daguerreotypes in the early 1840s before switching to Talbot's calotype process some time after 1845.

Owen's work was shown at several exhibitions between 1839 and 1865. This particular image was on view at the London Society of Arts in 1852.

Fig. 42.1 Hugh Owen, *Buffalo Carriage*, before September 1851, printed c. September–November 1851, salted paper print. National Gallery of Canada, Ottawa (29154)

Fig. 42.2 Hugh Owen, *Queen Square, Bristol*, about 1847, calotype. Scottish National Portrait Gallery, Edinburgh, Presented by the Muir Wood family, 1985 (PGP W 252)

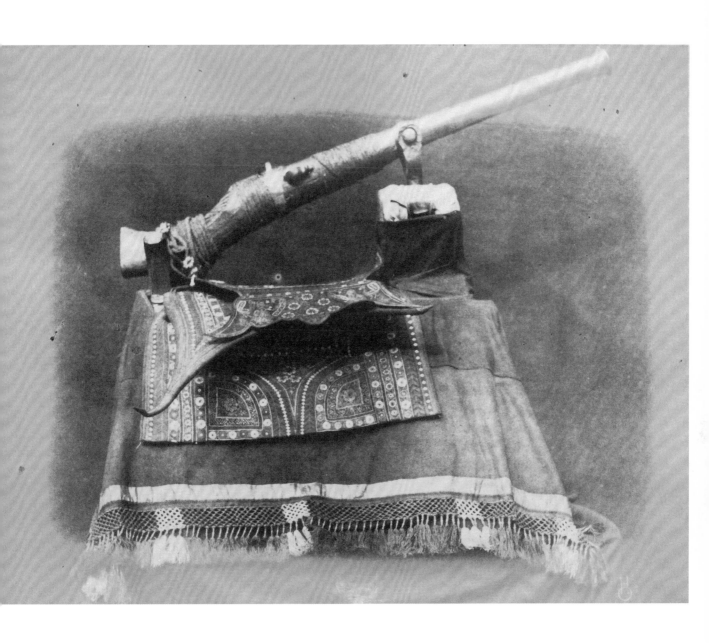

43 Henry Alexander Radclyffe Pollock
Holborn, Middlesex 17 February 1826–15 May 1889 St. Marylebone, London

Windsor Castle July 1855
From *The Photographic Album for the Year 1855*, 1855, pl. 4

Albumen silver print, 14.8 × 26.2 cm

20515.3

Provenance purchased from Phillips, Son & Neale, London, 1973

This slightly enigmatic image by Henry Pollock was included in *The Photographic Album for the Year 1855*. Although titled *Windsor Castle*, the true subject of the photograph appears to be rowing. The castle, in soft focus, seems to hover, dreamlike, over the sharper foreground scene, a group of six men and one boy gathered on the riverbank near two rowing sculls moored on the Thames. Competitive rowing became extremely popular during the nineteenth century and attracted large crowds that watched the sport from the riverbanks. Such a crowd can be glimpsed in the distance, suggesting that Pollock's photograph is a record of a competition that must have taken place in July of 1855. It is possible that the small boy standing in the centre of the image was the "coxswain,"[1] the person who sat at the front of the boat and was in charge of navigation.

Henry Pollock was the eleventh of twelve children born to Sir Jonathan Frederick Pollock (1783–1870) and his first wife. He attended Trinity College, Cambridge, but left before actually obtaining a degree. During the 1850s, Henry accompanied his father, who was Lord Chief Baron of the Exchequer from 1844 to 1866, as Sir Jonathan travelled to various places across England as a circuit court judge. Like his father, Henry pursued a career in the judiciary, first as a judge's marshal,[2] and eventually as Master of the Supreme Court of Justice. It was probably on one of these trips that he made *After Luncheon on the Circuit* (fig. 43.1), an exquisite salted paper print of a still life showing the remains of a meal. Pollock was a frequent contributor to the photographic journals of the time, including an article titled "Directions for Obtaining Positive Photographs upon Albumenized Paper," which appeared in the *Journal of the Photographic Society* in 1853. Three years later, he published directions on a glycerine process for dry-collodion plates.

Henry, his older brother, his younger half-brother, Arthur Julius, and their father were all avid amateur photographers and members of the Photographic Society. Sir Jonathan was president of the Society from 1855 to 1869. Arthur Pollock's photograph titled *Wye Bridge at Hereford* (fig. 43.2) was also included in *The Photographic Album for the Year 1855*.

Fig. 43.1 Henry Pollock, *After Luncheon on the Circuit*, c. 1856, salted paper print. George Eastman House, Rochester, New York (1968:0088:0038)

Fig. 43.2 Arthur Julius Pollock, *Wye Bridge at Hereford*, July 1855, albumen silver print. National Gallery of Canada, Ottawa (20515.19)

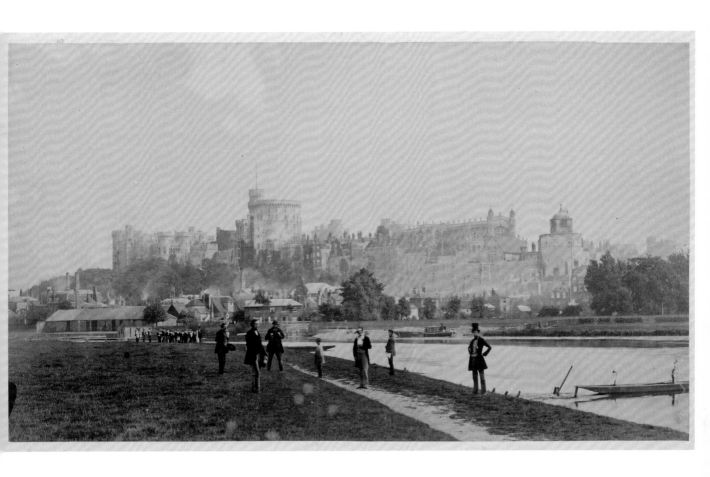

44 William Frederick Lake Price

Marylebone, London 18 October 1810–9 December 1896 Kent

The Miniature June 1855

From **The Photographic Album for the Year 1855**, 1855, pl. 14

Albumen silver print, 22.1 × 18.4 cm oval

20515.13

Provenance **purchased from Phillips, Son & Neale, London, 1973**

The photograph that William Lake Price submitted for inclusion in *The Photographic Album for the Year 1855* was titled *The Miniature*, and was accompanied by lines from Moliere's play *Pastorale Comique* (1667) praising and celebrating the beauty of youth. The image shows two well-dressed young women posing close together in front of what appears to be a studio backdrop. One of the women is holding a miniature painting worn on a necklace by her companion. They are both looking in opposite directions, their gazes fixed on something or someone outside the picture frame.

The son of Francis William Price and his wife Caroline Matilda (née Lake), William Lake Price was born into a well-off family. During the late 1820s, he studied architectural and topographical drawing and watercolour with the Paris-born architect, draftsman, and painter Augustus Charles Pugin (1762–1832). Price's paintings and drawings were exhibited at the Royal Academy between 1828 and 1832 and at the Old Watercolour Society in London between 1837 and 1857. His continuing interest in architecture was evident in two photographs he made between 1854 and 1855 documenting the construction of the Reading Room of the British Library.[1]

Price also contributed to photographic literature with *A Manual of Photographic Manipulation Treating of the Practice of the Art and its Various Applications to Nature,* published in 1858.[2] In this book, he provided a brief history of the medium along with chapters devoted to practical issues, including photographic chemistry, cameras, lenses, photographic papers, and advice for posing people and composing images of still lifes or landscapes. That same year, he also published *Portraits of Eminent British Artists*, a collection of albumen silver prints featuring many of his fellow artists at the Royal Academy, among them David Roberts, Charles West Cope, Alfred Elmore, and Daniel Maclise (see fig. 44.1). All of these portraits include props such as easels, palettes, or still-life objects to signify that the subjects are artists.

Price, like Oscar G. Rejlander and Henry Peach Robinson, became best known for his genre scenes of figures from literature or history, including the fictional portraits of Don Quixote (see fig. 44.2) and the Robinson Crusoe series, which included a profusion of stuffed animals.[3] These carefully staged photographs were sometimes made using several different negatives, a method of photographic printing known as combination or composite printing, which Rejlander and Robinson also practised. Price's photographs were included in several photography exhibitions during the latter half of the 1850s at the London Photographic Institution, the London Photographic Society, and the Art Treasures Exhibition in Manchester in 1857.

Fig. 44.1 William Lake Price, *Daniel Maclise* (1806–1870), 1857, albumen silver print. Cleveland Museum of Art, James Parmelee Fund (1994.19)

Fig. 44.2 William Lake Price, "*Don Quixote in His Study*," 1855, albumen silver print. Metropolitan Museum of Art, New York, Gift of A. Hyatt Major, 1969 (69.635.1)

45 Oscar Gustave Rejlander
Sweden 1813?–1875 London
Poor Jo before 1862, printed after 1879
Carbon print, 20.2 x 15.6 cm, sheet 20.3 × 15.7 cm

37076

Provenance purchased from Hans P. Kraus, Jr., Inc., New York, 1993

Although often referred to as the "Father of Art Photography," Oscar Gustave Rejlander is a surprisingly enigmatic figure. A Swede by birth, Rejlander lived in Rome for a time, then moved to England and tried to set up a business as a portrait painter. He later settled in Wolverhampton, where he became interested in photography and took lessons with William Henry Fox Talbot's assistant, Nicolaas Henneman. A water-colour self-portrait from 1842 shows him to have been a competent and sensitive portraitist (see fig. 45.1).

First exhibited in 1857, the allegorical image *Two Ways of Life* was Rejlander's most ambitious attempt at producing what was called a "high art" photograph. It was also almost instantly controversial, challenging common assumptions about photography with its large size (79 × 41 cm), portrayal of nudes (too realistic), and method of printing (about thirty negatives were combined to produce one image). Models posed as personifications of Victorian ideals were contrasted with figures that represented vice. The underlying theme of good versus evil suited a public who appreciated the moralistic message behind Rejlander's photographic tour de force.

One of the most popular works from Rejlander's genre studies is *Poor Jo*.[1] Using a boy from the local Ragged School,[2] Rejlander apparently re-created a scene he had witnessed in London during the summer of 1860. One version of the photograph was exhibited at the London World's Fair in 1862, and reviewers congratulated Rejlander for being "one of the most skillful and imaginative of all true artists," singling out *Poor Jo* for special praise: "Night in London is the name of one of these pictures, which is full of the most eloquent pathos and expression. A poor vagrant, dilapidated entrance porch and, crouched in an attitude suggestive of despairing wretchedness, nearly forbidden luxury, sleep. The pose, the deep masses of shadow and the feeble light all help the story. There the poor desolate outcast sleeps upon the cold damp stone, forgetting even those dreaded persecutors, the shelter equally unsafe and uninviting."[3]

This photograph aroused sympathy from a society sensitized to the plight of the poor thanks to Henry Mayhew's *London's Labour and London's Poor* (1851) and through works by Charles Dickens. Although it was always acknowledged to be an image made in a studio, some reviewers felt compelled to provide a fictional narrative about the taking of the photograph. As the original "poster child" for the homeless, the story of Poor Jo (the name of a character from Dickens's *Bleak House*) became the story for all London's destitute children.

Differences in poses, clothing, and lighting suggest that Rejlander made at least four negatives (see fig. 45.2). In the original albumen print, the boy faces left. Rejlander seems to have had difficulty in spreading the collodion emulsion onto the glass during the preparation of the negative plate, for there is a veil-like darkness that hangs over the top half of the image in the albumen prints. The image in the National Gallery's collection is a carbon print, most likely made after Rejlander's death by the photographer Hector MacLean.

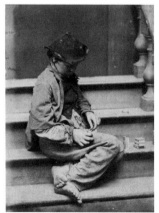

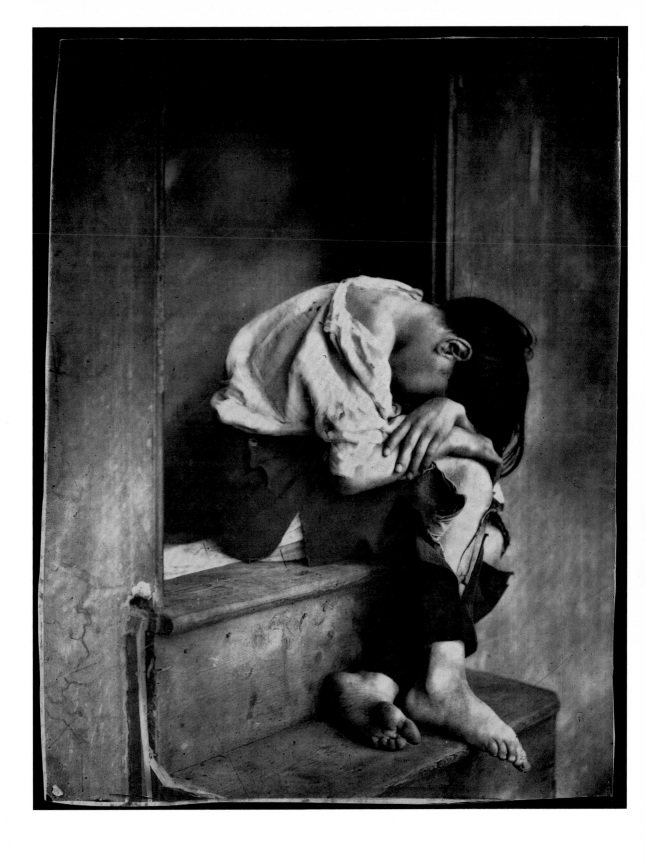

Fig. 45.1 Oscar Gustave Rejlander, *Self-Portrait,* 1842, watercolour.
Private collection

Fig. 45.2 Oscar Gustave Rejlander, *Boy Sitting on Stairs*, c. 1860,
albumen silver print. Moderna Museet, Stockholm (FM 1965 001 771)

46 James Robertson and Felice Beato

James Robertson
Middlesex, England 1813–1888 Yokohama ? Japan
Felice Beato
Venice 1832–29 January 1909 Florence
Constantinople, Panorama 1857
From *Voyage en Orient*, 1863
Five albumen silver prints, 24.6 × 153.9 cm
21513.18

Inscriptions **written in negative, third print from left, l.l., *le Bosphore*, fourth print, l.l., *point du Serail*, l.r., *Robertson & Beato. / photog.*, fifth print, l.l., *Robertson & Beato. / photog.***

Annotations **secondary support, letterpress, l.c., *CONSTANTINOPLE / Panorama***

Provenance **purchased from André Jammes, Paris, 1970**

In 1857 James Robertson and Felice Beato carried their heavy wooden camera, tripod, fragile glass plates, and chemicals to the top of the Beyazit Tower in Constantinople (now Istanbul). The fifty-metre stone fire tower, built in 1828, provided an ideal vantage point from which to survey the city, with its dense accumulation of buildings, markets, and streets. In order to make this five-part panorama, which encompassed a 180-degree sweep of the city below, the photographers divided the view into five sections of roughly equal size. For each section, multiple negatives were produced (from which the final selection would be made), before moving the camera a predetermined distance to the right, all the while maintaining a continuous horizon line and overlapping slightly the right-hand edge of the preceding image's coverage. Once developed, the negatives were individually printed, the prints carefully trimmed, aligned, and mounted onto a single sheet of paper.[1]

In the nineteenth century, photographic panoramas were commercially marketed luxury items, created to celebrate cities, simultaneously describing their often unique topographic features and their prominent civic and religious structures. This panorama is anchored at its left-hand edge by the Külliye of Süleyman, with the Ministry of Defence in the foreground; the Golden Horn is visible behind the mosque, and the Unkapani Bridge is shown to its right. In the centre of the panorama is the Galata Bridge with the Valide Mosque to its immediate right; from there the Bosphorus opens up. The Palace of Topkapi with its extensive gardens occupies the tip of the peninsula in the fourth section. To its right are Hagia Sophia, the Nuruosmaniye Mosque, and the Mosque of Ahmet 1, popularly known as the Blue Mosque. Beyond is the Sea of Marmara.

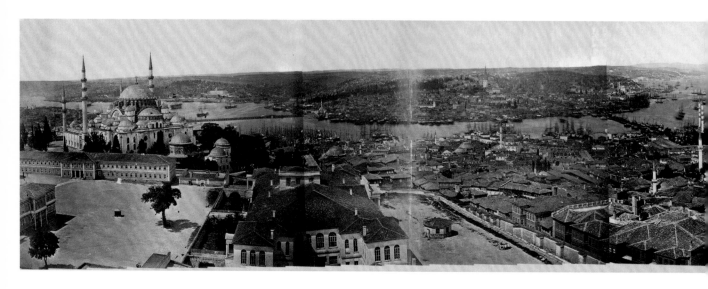

This panorama forms part of an elaborate 1863 French travel album, *Voyage en Orient*, comprising forty-one photographs, with sixteen signed by Beato and Robertson. The album traces a journey from Cairo through Jerusalem, Baalbec, Constantinople, Athens, Venice, and Trieste, ending with views of Milan. Along with the other photographs, the panorama functioned as a touchstone for evoking the sights and memories associated with the tour.

James Robertson, chief engraver of the Imperial Mint in Constantinople from 1841 until his retirement in 1881, also practised architectural and topographical photography from early 1853 until 1857 or slightly later. Felice Beato learned photography from Robertson, who was his brother-in-law, in 1854 or 1855, and served as his assistant in the Crimea and in Malta; by early 1857 they had formed a partnership. In 1858 Beato established his own independent, peripatetic career, travelling first to India (1858–59), then to China (1860) and Japan (1861–84), before ending his career in Burma (1887–1904).[2]

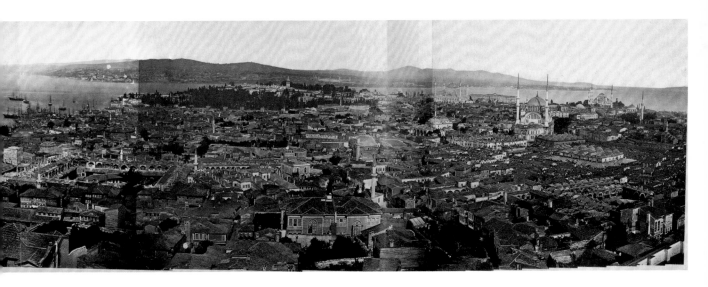

47 Henry Peach Robinson
Ludlow, Shropshire 9 July 1830–29 February 1901 Tunbridge Wells, Kent
Arrivals 23 May 1881
Albumen silver print, 27.0 × 37.2 cm
32675

Inscriptions secondary support, below image, l.l., graphite, *Arrivals –*, below image, l.r., *H. P. Robinson, May 23/81 –*
Annotations secondary support, l.r., graphite, *$750*
Provenance **purchased from Daguerreian Era, Pawlet, Vermont, 1975**

> It is necessary for the pencil of light to get into the hands of the artist if that white paper is to be artistically covered.[1]

Henry Peach Robinson developed a strong interest in drawing and painting as a child, but spent the early part of his adult life working for booksellers and printers. He learned the daguerreotype process in about 1851, and by 1856 had established his first photographic studio in Leamington Spa. A strong advocate for the recognition of photography as an art form, he articulated this position in publications such as *Pictorial Effect in Photography* (1869) and *The Elements of a Pictorial Photograph* (1896). In 1892 Robinson, along with other photographers who were dissatisfied with what they saw as the Photographic Society's narrow criteria, founded the Linked Ring, an exhibiting organization devoted to photography as a fine art.

Robinson's place in photographic history rests largely on his virtuoso use of "combination printing," a technique of piecing together several negatives to produce a single printed image. In *Fading Away* (fig. 47.1) – a combination of five different negatives – a consumptive young woman reclines on her death-bed. The principal object and most luminous part of the image is the "dying" girl. She is framed by two women wearing masses of clothing, while a dark-suited male figure with his back to the viewer stares out at a threatening sky through the heavy, parted drapes. Made during the height of Robinson's career, the photograph excited criticism from the time it was first shown in 1858 at the exhibition of the Edinburgh Photographic Society. Initially, the controversy centred around what some viewers found an inappropriately tragic subject for a photograph. Later, others, including the critic A. H. Wall, felt they had been duped upon learning that the photograph comprised several different negatives and that the scene had been staged.

In *Arrivals*, made more then twenty years later, a fashionably dressed woman, her back to us, gazes expectantly out the window of a Victorian drawing room. The photograph employs many of the same strategies as *Fading Away*, among them some of Robinson's "prescriptions" for composing a pictorial photograph: the massing of "the deepest dark" brought into immediate contact with the highest light," to create "the glamour and witchery of perfect chiaroscuro,"[2] repeated forms and repeated lights (the voluminous fabric of the dress and curtains, the ornate chairs, the shafts of sunlight on the woman's face, hands, and the room's furnishings, the patches of light on the carpet and surrounding the pair of slippers awaiting their owner's arrival), and strong diagonals. The elaborately decorated room takes on the role of a stage set for this consciously composed visual narrative.

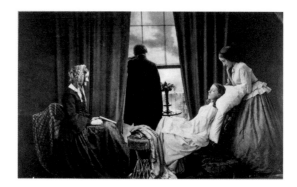

Fig. 47.1 Henry Peach Robinson, *Fading Away*, 1858, albumen print, combination print from five negatives. George Eastman House, Rochester, New York, Gift of Alden Scott Boyer (76:0116:0001)

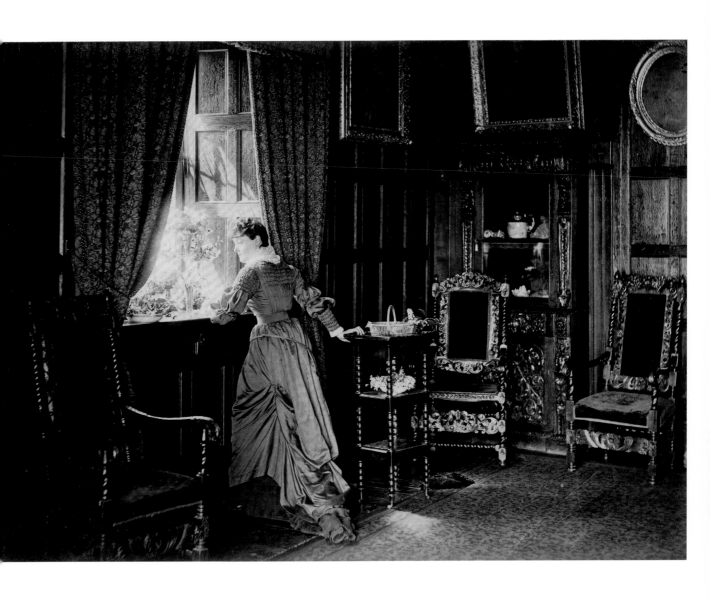

48 William Sherlock
Lambeth, Middlesex 1812/1813– 25 March 1889 Budleigh Sulterton, Devon
***Portrait of a Woman* 13 November 1843**
Salted paper print, 11.7 × 9.8 cm, sheet 12.1 × 10.2 cm
33540

Inscriptions l.l., black ink, *W*ᵐ· *Sherlock Nov. 13. 1843*

Provenance **purchased from André Jammes, Paris, 1973**

In November 1843 the young amateur William Sherlock wrote to the inventor of photography, William Henry Fox Talbot, apologizing for the delay in sending some example portraits: "The weather here is most unfavorable but I enclose three which were taken the last few days." This image is one of those three primitive portraits, taken by a self-taught calotypist "quite unaware of the time usually occupied in taking a portrait never having exchanged a word with anyone acquainted with the art or derived any knowledge upon the subject except from the Edinburgh Review and my own perseverance"[1] (see fig. 48.1). The study is probably of his wife, Anne (née Henshaw), the daughter of a music professor, suffering through an uncomfortable exposure time of twenty to twenty-five seconds. Sherlock, a London attorney, had opened discussions with Talbot a year earlier about securing a license to practise calotype portraiture in London. Since the capital city was already spoken for, Sherlock suggested Bristol, Liverpool, and Dublin as possible alternatives. In 1846 Talbot sent him a parcel of prints and Sherlock expressed the wish to enter his employ: "In the formation of your projected Establishment I yet hope there may be some situation in which I may be found useful."[2] Although the correspondence was sustained and friendly, the two men never collaborated.

Fellow calotypist Roger Fenton gave up photography for the practice of law, but Sherlock took the opposite route, and around the time of the Great Exhibition of 1851, he devoted his full efforts to the new art. In the 1852 Society of Arts photography exhibition – the first of its kind ever held in London – Sherlock was one of the chief contributors, showing more than forty paper views of architecture, landscape, and portraiture (see fig. 48.2). He was so well known by 1853 that John Ruskin's friend Pauline Trevelyan referred to him as "Sherlock the Calotypist." Around 1855 he converted from Talbot's calotype paper negative process to collodion on glass, publishing with the influential print seller Joseph Hogarth. The catalogue of the 1856 Norwich Photographic Society exhibition admired one of his entries as "a pure photograph" – the "best in the room" – and pronounced his cloud studies "extraordinary." He moved to Devon and practised as a commercial photographer until the end of his life. In 1878 Sherlock's animal photographs secured a medal from the Paris International Exhibition. His daughter Ann carried on with his photographic studio in Devon, and his son, William Jr., immigrated to New Zealand, where he became a well-known photographer.

 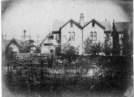

Fig. 48.1 Letter (detail) from William Sherlock to William Henry Fox Talbot, 15 November 1843. British Library (32710)

Fig. 48.2 William Sherlock, *Urban Scene*, panorama of two salted paper prints, 1844? Courtesy of Hans P. Kraus, Jr., New York

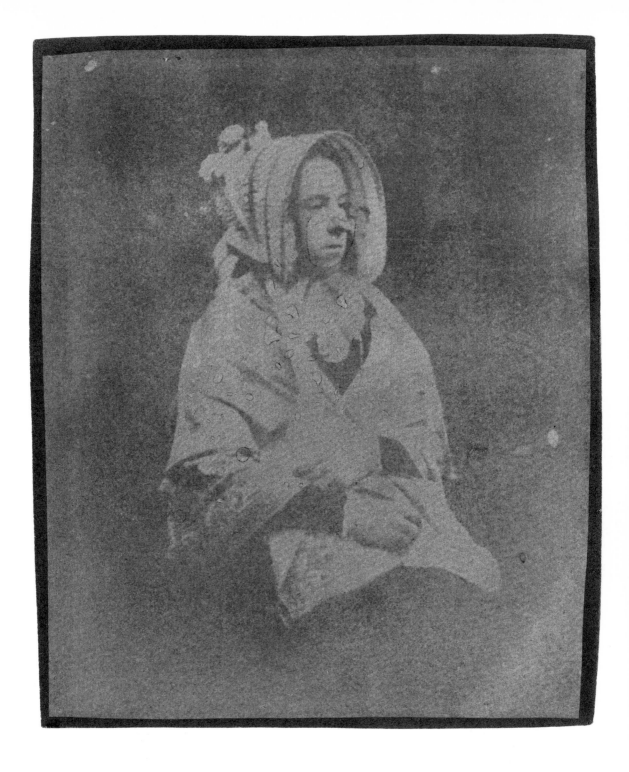

49 W. L. H. Skeen and Co.
Colombo, Ceylon 1868–c. 1920
Durian c. 1862–1903
Albumen silver print, 28.0 × 21.6 cm
33032

Inscriptions l.r., in negative, *SKEEN + Co 537*, verso, u.r., graphite, *Durian*

Provenance purchased from Photographic Antiquarian, Montreal, 1976

Images of exotic places had a ready market in nineteenth-century Britain. W. L. H. Skeen & Co., the most successful commercial photographers in Ceylon (now Sri Lanka), offered an extensive catalogue ranging from landscape views and portraits of the inhabitants (see fig. 49.1) to studies of the ancient ruined cities of Polonnaruwa and Anuradhapura. The firm had its beginnings when William Skeen (1822–1872), who had been appointed the colony's first official government printer, bought J. Parting's Colombo daguerreotype studio in 1860. A year later the business was operating as S. Slinn & Co., a name explained by the brief stay in Ceylon of one S. Slinn Skeen (his relationship to William Skeen is not known, but William's mother was born Sarah Slinn). It became known as W. L. H. Skeen & Co. in 1868. William Lewis Henry Skeen (1 July 1847–1903), William Skeen's son, was born in England, but moved at a young age to Ceylon with his family. After the younger Skeen returned from training at the London School of Photography in 1862 or 1863, with his father's help he set up a photography studio in Colombo. He began working on commissions to record major construction projects – roads, railways, and the Colombo Breakwater – as well as aspects of the island's expanding plantation economy, including a series illustrating the coffee industry and later, the production of tea, cinnamon, cocoa, rubber (see fig. 49.2), cardamom, and plumbago. These photographs provide a visual document of an important period in Ceylon's economic history. William Lewis Henry established a partnership with John Edward Wilshaw (who had originally worked with S. Slinn Skeen), and then with his brother, F. A. E. Skeen, beginning in 1878. W. L. H. Skeen & Co. occupied various studios in Colombo, but by 1891 a branch had been opened in Kandy at 21 Ward Street, where Skeen's wife, Elizabeth, also ran a millinery business. When the firm closed in 1920, Platé and Company acquired the negatives.[1]

It is unclear whether W. H. L. Skeen made all the photographs himself, but attributed to him is a series of botanical subjects, including this image of the durian, a fruit notable for its large size, thorny husk, and distinctive smell (durians are banned from public transportation in some parts of southeast Asia). The photographer chose a neutral background, and except for the presence of the leaves, which serve as anchors and identifiers, this otherwise free-floating object might be mistaken for something native to another element – the deep sea, perhaps. The close observation of the durian's spiny geometry, a triumph of form over content, gives the photograph a strong graphic appeal and a decidedly modernist appearance.

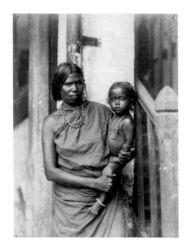

Fig. 49.1 Attributed to W. L. H. Skeen & Co., *Tamil Woman and Child*, c. 1862–1903, albumen silver print. National Gallery of Canada, Ottawa (33038)

Fig. 49.2 Attributed to W. L. H. Skeen & Co., *India-rubber Tree*, c. 1862–1903, albumen silver print. National Gallery of Canada, Ottawa (33034)

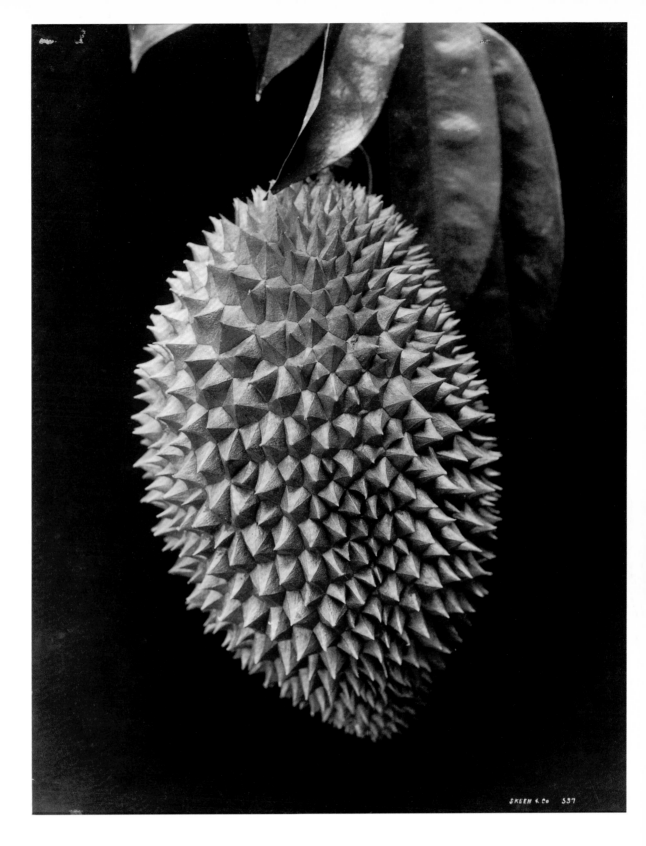

50 John Benjamin Stone
Birmingham 9 February 1838–2 July 1914 Birmingham
Man at Entrance to Houses of Parliament, London between 1895 and 1909
Platinum print, 20.6 × 15.5 cm, sheet 21.4 × 16.3 cm
19763

Inscriptions verso, l.l., graphite, *1.*

Provenance purchased from Sotheby's, London, Lot 264, 27 June 1980

John Benjamin Stone was born to a prosperous family of glass makers in Birmingham.[1] This, together with an insatiable appetite for knowledge about the world and a desire to record history, led him to a life in photography. Money allowed him to indulge his passion. Curiosity compelled him to travel. He began collecting photographs as travel records in 1862. Because photographs of the subjects that interested him were not available, he began to make his own in 1868. His first subjects were the old manor houses of the Midlands. Eventually, his heavy 6 × 8 camera and tripod accompanied him wherever he went. By the end of his life, he had amassed a prodigious number of glass negatives – some twenty-five thousand or more. Many of these images formed the basis of the National Photographic Record founded by Stone in 1895 and later housed at the British Museum. Stone's photographic activities kept him busy enough to hire two assistants to do the darkroom work. Once platinum papers became available in 1879, he stopped printing on albumen silver. He recognized the advantages of platinum salts, which have greater permanence, as well as providing a broader tonal scale that gives more detail in the shadow areas.

Stone was knighted by Queen Victoria in 1892, presumably for his many benevolent activities. He became a Conservative Member of Parliament in 1895, holding his seat until retiring in 1909. His was a lacklustre political career, for he spent more time on photographic expeditions than in attending sessions of the House. No friend of art photography, Stone's use of the camera was simply to make straightforward historical records of people and places, occupations and trades (see fig. 50.1), ceremonies and ancient customs (see figs. 50.2 and 50.3).[2] He was the true amateur, pursuing his craft for love rather than profit. None of his work was done for commercial reasons.

The subject of *Man at Entrance to Houses of Parliament* is unknown. The portrait surely dates from the period when Stone was a member of the House, so we may safely assume that he was a fellow parliamentarian. Since every photographer knows that the camera often makes its own choices, we have to ask ourselves to what extent Stone allowed the camera to make decisions about his subject and about the amount of background to include. Stone walked a fine line between a naïve eye and a subtle vision that avoided artifice. The result is a charming freshness. For us, Stone's portrait is of interest because of the organic rapport between the frock-coated figure and the historical portal that frames him. What might also occur to us is the metaphor that results from the relationship between the four-square stance of the man and the solid pillar at the left. Stone's photograph is both deceptively simple and richly complex.

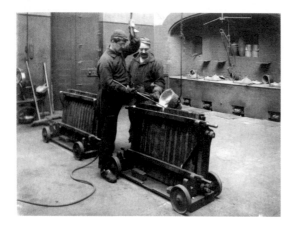

Fig. 50.1 John Benjamin Stone, *Gold Melting Room, Running the Metal into Moulds (Bars)*, c. 1897–1914, platinum print. National Gallery of Canada, Ottawa (19750)

Fig. 50.2 John Benjamin Stone, *The Stocks at Rock Church*, c. 1897–1905, platinum print. National Gallery of Canada, Ottawa (19745)

Fig. 50.3 John Benjamin Stone, *Ancient Chain Armour, belonging to the City of Lichfield, Displayed at the "Court of Arraye,"* 1903, platinum print. National Gallery of Canada, Ottawa (19739)

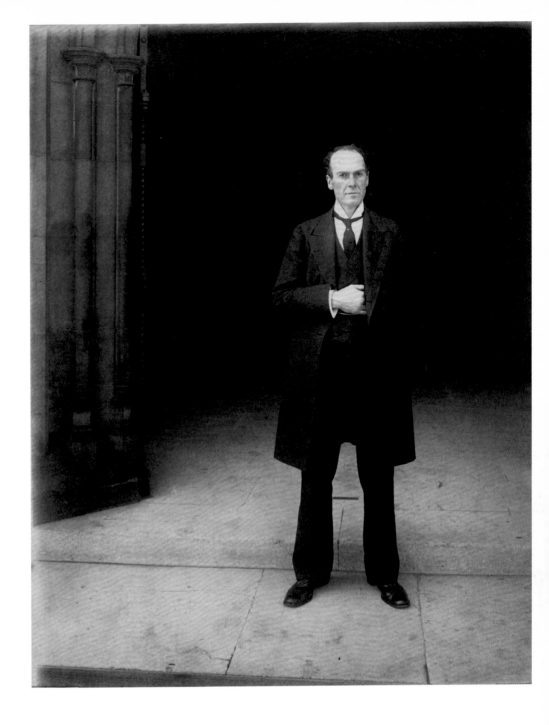

51 Francis (Frank) Meadow Sutcliffe

Headingley, West Yorkshire 6 October 1853–31 May 1941 Whitby, North Yorkshire

Two Daughters of the Photographer, Lulu and Catherine, Hart Hall, Glaisdale
c. 1890–1900, printed before 1974

Gelatin silver print, 25.3 × 20.2 cm

33365

Annotations verso, u.l., graphite, $20-, l.c., stamped in red ink, *From an Original Glass Plate Negative by ... / FRANK MEADOW SUTCLIFFE, Hon. F.R.P.S. (1853–1941). / stamped in blue ink with black ink addition, One of a series of Photographs, many of which were awarded over sixty / Gold, Silver and Bronze Medals at International Exhibitions during the / last century. / By agreement with Whitby Literary and Philosophical Society the copyright / is now the property of ... / W. EGLON SHAW, THE SUTCLIFFE GALLERY, / 1 FLOWERGATE, / WHITBY, YORKSHIRE, ENGLAND, / to whom all enquiries should be made regarding further copies or reproduction / rights, quoting Ref. No. 13-17 Telephone: Whitby 2239, l.c., graphite, 13-17*

Provenance purchased from the Witkin Gallery, New York, 1974

Francis (Frank) Meadow Sutcliffe is best known for his photograph *Water Rats* (fig. 51.1), which shows a group of mostly naked boys playing with boats in a shallow bay. Like the painter Thomas Eakins's work *The Swimming Hole*, done only two years earlier, Sutcliffe used the activity of swimming as a socially acceptable way of posing nudes. He was awarded a medal for this photograph at the 1886 Photographic Society exhibition in London.

As the eldest son of the painter and amateur photographer Thomas Sutcliffe, Frank Sutcliffe learned about painting, etching, and photography from an early age. William Lake Price's (see cat. 44) *A Manual of Photographic Manipulation* was part of the family library and one of the young Frank's favourite books on art and photography. Like many boys of his generation, he went to work at the age of fourteen as an apprentice at the Tetley brewery in Leeds. His employment at the brewery was short-lived, however, and he was soon spending his time learning as much as he could about the art and craft of photography. By 1872 Sutcliffe was making photographs in the Lake District, and later that year was employed by Francis Frith (see cat. 25) to make views of abbeys and castles in the Yorkshire region.

Sutcliffe spent most of his career photographing in and around the North Yorkshire village of Whitby. His familiarity with the place and its people allowed him to have a strong connection with his sitters, in particular, the fishermen and their families as well as those who lived and worked in the countryside (see fig. 51.2). He also used his own children as models, as in this tender portrait of his two eldest daughters, Catherine and Eveleen (known as Lulu). The photograph was made at a farm in Glaisdale near Whitby, known as Hart Hall, a place where Sutcliffe photographed often.

Sutcliffe showed his work in several exhibitions, including the Photographic Society of London Exhibition in 1886 and a solo exhibition at the London Camera Club in 1888. In 1892 he became a member of the Linked Ring, an association of British and American photographers founded by Henry Peach Robinson (see cat. 47), whose main goal was the promotion of photography as art.

Fig. 51.1 Frank Meadow Sutcliffe, *Water Rats*, 1890s, carbon print.
San Francisco Museum of Modern Art, Gift of Sharon and Michael
Blasgen (2004.826)

Fig. 51.2 Frank Meadow Sutcliffe, *Hunter with Two Dogs*, c. 1875–80,
albumen silver print. National Gallery of Canada, Ottawa (33368)

52 William Henry Fox Talbot
Melbury House, Dorset 11 February 1800–17 September 1877 Lacock Abbey, Wiltshire
Shadow of a Flower c. 1839
Salted paper print, 11.1 × 7.0 cm
33538

Annotations verso, u.r., graphite, *fx*, watermark, *ME* [? partial]

Provenance purchased from André Jammes, Paris, 1973

Struggling to recall his earliest thoughts on photography, Henry Talbot wondered whether the idea "had ever occurred to me before amid floating philosophic visions."[1] This ghostlike flower, sinuous and dancing almost like a creation in smoke, is such a vision, floating alive within a vase-shaped piece of paper. Photography's paradox is that it represents a precise point in time, but one available evermore. While the flower would have withered away within hours, it remains ever fresh in Talbot's rendition.

Talbot was a mathematician, botanist, accomplished scientist, linguist, Member of Parliament, and a prolific author, yet unlike his mastery of the pen, the workings of the pencil eluded him. The ability to sketch competently was a necessity for any gentleman of curiosity, but Talbot finally had to concede his failure in draftsmanship at Italy's Lake Como in October 1833. While his new wife and several relatives were sketching away, he turned to the aid of the camera lucida, but "found that the faithless pencil had only left traces on the paper melancholy to behold." It was then that he conceived of photography, harnessing Nature as his drawing mistress through the power of science. In the spring of 1834, at his Wiltshire home of Lacock Abbey, he applied light-sensitive salts to paper. Failing at first to get sufficient light through a camera lens, he turned to photograms – images made in the sun by direct contact under the subject. They were the shadows of the plant – he first called these Skiagraphs – but they presented in minutes a level of detail far beyond anything that his hand could draw. By the summer of 1835, he had mastered making negatives in tiny cameras.

Photography was but one of Talbot's endeavours in the 1830s, and he set it aside for other activities. Shocked by Daguerre's January 1839 public announcement of photography, Talbot quickly exhibited his examples and freely published his method of work. Daguerre's productions were gorgeous and detailed, but crucially limited by being unique images on expensive and cumbersome sheets of metal. Talbot's negatives could make many prints on paper, a medium familiar to the other arts and especially to book publishing. The colour and the inscription "fx" of this negative indicates fixing hypo, introduced in 1839 to photography by Talbot's friend Sir John Herschel in 1839. The first public year of photography was dark and stormy throughout, a fatal drawback for an art whose currency was the sun. Although most people favoured camera images, Talbot's photograms harvested what little sunlight there was, allowing him to continue to experiment and to distribute to others. This exuberant, seemingly random trimming of the paper was inexplicably typical of his early work. Here, it adds a fanciful tone to a lovely image.

53 William Henry Fox Talbot

Melbury House, Dorset 11 February 1800–17 September 1877 Lacock Abbey, Wiltshire

The Haystack April 1844

From Bath Photographic Society Album, 1889, pl. 31

Salted paper print, 16.4 × 21.0 cm, sheet 19.0 × 22.9 cm

33487.31

Annotations verso, l.r., graphite, *39[?]*, secondary support, l.c., black ink, *31 / Haystack at Lacock*

Provenance purchased from Sotheby's, London, Lot 184, 26 June 1975, through Daguerreian Era, Pawlet, Vermont

In the text he wrote for this plate in *The Pencil of Nature,*[1] Talbot praised Nature's draftsmanship: "One advantage of the discovery of the Photographic Art will be, that it will enable us to introduce into our pictures a multitude of minute details which add to the truth and reality of the representation, but which no artist would take the trouble to copy faithfully from nature. Contenting himself with a general effect, he would probably deem it beneath his genius to copy every accident of light and shade."[2] But there are no accidents of light and shade here. Curiously for something seemingly so unchanging, this arresting and compelling image is all about time, and Talbot shows himself to be its absolute master. The autumn's harvest was bountiful, the ancient traditions of preserving for the winter came into play, and as spring's sunlight begins to strengthen, this storehouse stands ready to sustain life until the next cycle. This photograph is defined by the shadow, Talbot's long-time artistic companion. The texture of the hay, right down to the individual little stalks, is brought out by the contrast. The shadow of the knife symbolizes the inevitable cut that will be made. But it is the shadow of the ladder that dominates. Its angle is important, but time is what controlled where its shadow would fall, and time controlled the essential patch of light that adds life around the shadow.

Talbot recognized that a conventional artist could not attempt this level of detail "without a disproportionate expenditure of time and trouble … Nevertheless, it is well to have the means at our disposal of introducing these minutiæ without any additional trouble, for they will sometimes be found to give an air of variety beyond expectation to the scene represented."[3] The extraordinary negative used to make this print preserves this unexpected variety in wonderful condition,[4] ratifying the prescient observation of an 1845 reviewer of *The Pencil of Nature* that "photography has already enabled us to hand down to future ages a picture of the sunshine of yesterday."[5]

The influential and lavishly illustrated journal, the *Art-Union*, was stunned that the haystack "is represented with a truth which never could be expected by any skill or trick of Art; and of this let us observe … that with all this minute detail of hay and straw – where not one projecting point is omitted – there is nothing hard or edgy, but the whole is presented with a harmony of parts which at once shows that when detail is associated with undue severity there is a sacrifice of truth."[6] Its contemporary, the *Literary Gazette*, drew the obvious connection when it observed that the "haystack resembles the open door in general effect."[7] Talbot had hit his stride.

54 William Henry Fox Talbot
Melbury House, Dorset 11 February 1800–17 September 1877 Lacock Abbey, Wiltshire
The Open Door April 1844
From Bath Photographic Society Album, 1889, pl. 33
Salted paper print, 14.6 × 19.5 cm, sheet 18.9 × 23.2 cm
33487.33

Annotations secondary support, l.c., black ink, *33. / Doorway at Lacock Abbey. / Built in the reign of Edward sixth.*,
verso, l.r., graphite, *36–*

Provenance purchased from Sotheby's, London, Lot 184, 26 June 1975, through Daguerreian Era, Pawlet, Vermont

In 1899 Charles Henry Talbot, the son of the inventor, collated the best photographs preserved at Lacock Abbey into a presentation album for the Bath Photographic Society. The National Gallery of Canada acquired this extraordinary album in 1975, incorporating this print as well as *The Haystack* (cat. 53) and *The Ladder* (cat. 55).

The Open Door is certainly the best-known photograph in Talbot's pioneering publication, *The Pencil of Nature*. For such an iconic image, Talbot made modest claims, wanting to "place on record some of the early beginnings of a new art, before the period, which we trust is approaching, of its being brought to maturity by the aid of British talent. This is one of the trifling efforts of its infancy, which some partial friends have been kind enough to commend. We have sufficient authority in the Dutch school of art, for taking as subjects of representation scenes of daily and familiar occurrence. A painter's eye will often be arrested where ordinary people see nothing remarkable. A casual gleam of sunshine, or a shadow thrown across his path, a time-withered oak, or a moss-covered stone may awaken a train of thoughts and feelings, and picturesque imaginings."[1]

According to the *Art-Union*, the plate "presents literally an open door, before which stands a broom, and near which hangs a lantern. It is of course an effect of sunshine, and the microscopic execution sets at nought the work of human hands. With this broom the famous broom of Wouvermans must never be compared: it becomes at once a clumsy imitation."[2] The *Literary Gazette* was equally delighted with the "broom and a lantern, perfect in reflected form, and rich in tone of colour. A back window in the darker central tint is deliciously bright, yet dim and faithful to the reality."[3]

Talbot worked on this composition for at least three years; his mother, Lady Elisabeth Feilding, titled the earliest versions *The Soliloquy of the Broom* (fig. 54.1). In April 1844 Talbot finally achieved his masterpiece, which he exhibited in the seminal 1852 Society of Arts exhibition, titled *The Stable Door*.[4]

This print is exceptional. Brushstrokes in the untrimmed border testify to the hand of the artist coating the paper with sensitive chemicals. More importantly, it is a rare close variant of the print selected for *The Pencil of Nature*. In his first paper on photography in 1839, Talbot wrote, "the most transitory of things, a shadow, the proverbial emblem of all that is fleeting and momentary, may be fettered by the spells of our 'natural magic,' and may be fixed for ever in the position which it seemed only destined for a single instant to occupy."[5] And it is the shadow that tells Talbot's story. He took two or more negatives in the same session, but the sun moved sufficiently in between to shift the shadows (see fig. 54.2). The negative for the published version survives, but the equally accomplished negative for this print is not known, perhaps having met with some accident during printing.

Fig. 54.1 William Henry Fox Talbot, *Soliloquy of the Broom*, 1841, salted paper print. Private collection, Courtesy of Hans P. Kraus, Jr.

Fig. 54.2 Shadow shift between two negatives (detail). William Henry Fox Talbot. *The Open Door*, April 1844, salted paper print. National Media Museum, Bradford ((2003-5001-2/20046); National Gallery of Canada, Ottawa (33487.33)

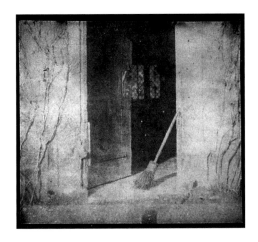

55 William Henry Fox Talbot
Melbury House, Dorset, 11 February 1800–17 September 1877 Lacock Abbey, Wiltshire
The Ladder April 1844
From *Bath Photographic Society Album*, 1889, pl. 34
Salted paper print, 17.1 × 18.3 cm, sheet 19.1 × 22.8 cm
33487.34

Annotations verso, l.r., graphite, *36*, secondary support, l.c., black ink, *34. / Doorway at Lacock Abbey / Built in the reign of Edward sixth.*

Provenance purchased from Sotheby's, London, Lot 184, 26 June 1975, through Daguerreian Era, Pawlet, Vermont

A Cambridge contemporary of Talbot's observed that "he has an innate love of knowledge, and rushes towards it as an otter does to a pond."[1] Confronting people, however, the reclusive scientist could more likely be found rushing the other way. Talbot's portraits are vastly outnumbered by architectural, landscape, and other studies.

Curiously, while people are rarely seen, we are constantly aware that Talbot's world is developed and populated. *The Ladder* is the only plate in *The Pencil of Nature* that includes people, but Talbot recognized that "portraits of living persons and groups of figures form one of the most attractive subjects of photography"[2] (see fig. 55.1).

Rather than facing one individual, Talbot seemed more comfortable – and more accomplished – arranging *tableaux vivants*. He explained, "When the sun shines, small portraits can be obtained by my process in one or two seconds, but large portraits require a somewhat longer time … groups of figures take no longer time to obtain than single figures would require, since the Camera depicts them all at once, however numerous they may be: but at present we cannot well succeed in this branch of the art without some previous concert and arrangement … But when a group of persons has been artistically arranged, and trained by a little practice to maintain an absolute immobility for a few seconds of time, very delightful pictures are easily obtained … the same … individuals may be combined in so many varying attitudes, as to give much interest and a great air of reality to a series of such pictures."[3]

In arranging this image, Talbot possibly had assistance from the miniature painter and calotypist Henry Collen: "Mr. Collen, an artist, was experimenting with Mr. Talbot, and it was proposed that they should take a ladder and a loft door, which was very much above the level of the ground. Mr. Talbot of course pointed the camera up, and produced a very awkward effect, from the peculiar manner in which the lens was placed with reference to the object. Mr. Collen said, 'You are not going to take it so, surely!' Mr. Talbot replied, 'We cannot take it in any other way;' and, then Mr. Collen said, 'As an artist, I would not take it at all'."[4] Talbot found a way. The surviving waxed negative is slightly retouched, as seen in the upper left part of this print.[5]

The *Athenaeum* observed: "In looking at this picture, we are led at once to reflect on the truth to nature observed by Rembrandt in the disposition of his lights and shadows. We have no violent contrasts; even the highest lights and the deepest shadows appear to melt into each other, and the middle tints are but the harmonizing gradations. Without the aid of colour, with simple brown and white, so charming a result is produced, that, looking at the picture from a little distance, we are almost led to fancy that the introduction of colour would add nothing to its charm."[6]

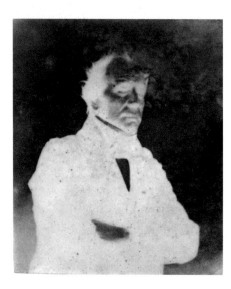 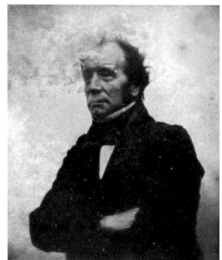

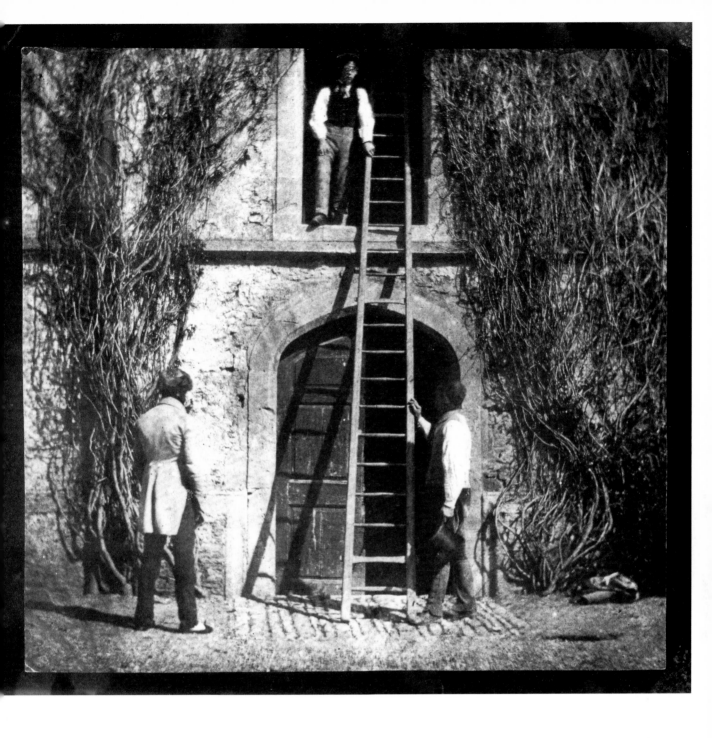

Fig. 55.1 William Henry Fox Talbot, *Portrait of a Man*, c. 1841–45, paper negative, waxed (and virtual positive). National Gallery of Canada, Ottawa (33510)

56 William Henry Fox Talbot
Melbury House, Dorset 11 February 1800–17 September 1877 Lacock Abbey, Wiltshire
Scenery of Loch Katrine 1844
From *Bath Photographic Society Album*, 1889, p. 46
Salted paper print, 8.4 ×10.7 cm, sheet 9.3 × 11.6 cm
43120

Annotations verso, l.r., black ink, *LA41*

Provenance Sotheby's, London, sold at auction, 19 May 2009, to Lee Gallery, Winchester, Massachusetts; purchased from Lee Gallery, 2010

During the autumn of 1844, William Henry Fox Talbot travelled to Scotland, where he planned to photograph various sites connected to the work of Sir Walter Scott (a hugely popular figure in Scotland at the time)[1] for a publication he was preparing. Completed by 1845 and sold by subscription, *Sun Pictures in Scotland* contained twenty-three photographic images. *Sun Pictures in Scotland* was Talbot's second publishing venture – the first being the famous *Pencil of Nature* – showing how several prints could be made from one photographic negative, a significant step forward in the evolution of book illustration.

This image, included as plate seventeen in *Sun Pictures*, shows a man dressed in a waistcoat, pants, and long-sleeved shirt leaning with his right arm high over his head, against a rough-hewn stone and timber hut. The Talbot expert Larry J. Schaaf has suggested that the man is Talbot's uncle on his mother's side, the Hon. John George Charles Fox-Strangways (1803–1859).[2] The hut appears to be what is known in Scotland as a "shieling," a small building made of stone and earth used by farmers from medieval times until the eighteenth century to house farmers and their families when they relocated their cattle and sheep to higher pastures during the summer. Shielings were typically located near a fresh source of water. This tangible connection to the past found along the shores of Loch Katrine (see fig. 56.1), a place that featured prominently in Sir Walter's writings, would have fit perfectly with Talbot's project and suited the air of Romanticism that fills the pages of *Sun Pictures* (see fig. 56.2).

Scenery of Loch Katrine shows a more nostalgic and intimate side of Talbot's work than we see in his better known masterpieces such as *The Haystack* or *The Open Door*. The density, rich tones, and sharper contrasts of this image reveal the extent to which print quality affects photographic expression. The strong diagonal pattern of the shieling's wooden doorway or the lumpy protuberances of the rocks that are stacked upon each other are articulated through the contrast between strong sunlight and deep shadow.

Fig. 56.1 James Valentine & Sons, *Loch Katrine and Ben Venue*, c. 1880–90, albumen silver print. National Gallery of Canada, Ottawa (33465)

Fig. 56.2 William Henry Fox Talbot, *Scenery of Loch Katrine*, October 1844, salted paper print. National Gallery of Canada, Ottawa (33514)

57 William Henry Fox Talbot
Melbury House, Dorset 11 February 1800–17 September 1877 Lacock Abbey, Wiltshire

A Fruit Piece before June 1845
Salted paper print, 16.5 × 19.8 cm, sheet 18.4 × 22.6 cm

37358

Inscriptions **verso, l.r., graphite, *Talbot***

Provenance **purchased from Hans P. Kraus, Jr., Inc., New York, 1994**

As the inventor of the negative-positive process – the basic principle of photography in which a "negative" image is used to produce a "positive" print, William Henry Fox Talbot holds a crucial place in the history of photography. He was a man of many interests, including physics, mathematics, botany, and Assyriology. Between 1844 and 1846, he published (in instalments) *The Pencil of Nature*, the world's first book to illustrate the potential of the new medium of photography. *A Fruit Piece* was included as the final illustration of the publication. In the text accompanying the image, Talbot made no reference to the still life itself, but discussed the number of photographic prints that can be made from one negative and the way in which a negative should be washed.

> The number of copies which can be taken from a single original photographic picture, appears to be almost unlimited, provided that every portion of iodine has been removed from the picture before the copies are made. For if any of it is left, the picture will not bear repeated copying, but gradually fades away. This arises from the chemical fact, that solar light and a minute portion of iodine, acting together … are able to decompose the oxide of silver, and to form a colourless iodide of the metal … A very great number of copies can be obtained in succession, so long as great care is taken of the original picture.[1]

The rich, velvety brown tonality of this print is rarely seen in salted paper prints from this period, and it superbly demonstrates Talbot's mastery of the chemical and other technical aspects of crafting salted paper prints from his new invention of paper negatives. These paper negatives, which Talbot referred to as calotypes, could be used to make multiple prints and were therefore well suited to the production of illustrated books.

Two baskets – one porcelain, one wicker – overflow with fruits, among them a pineapple, apples, and what appear to be pomegranates or peaches. In the iconography of still-life painting, the fruit basket is traditionally the attribute of Pomona, the Roman goddess of fruit and orchards. The still life itself was often used by painters as a metaphor for the ephemerality of life (see fig. 57.1).

The inclusion of the pineapple (see fig. 57.2) – something of a status symbol in the nineteenth century, often serving as an exotic gift meant to impress – is no doubt a reflection of Talbot's fascination with botany, and it has actually been suggested that this example may have been grown in his own greenhouse.

The Scottish tartan covering the table appears again in *Flowers on a Check Table Cloth*, another image made by Talbot, and is most likely an allusion to his interest in all things Scottish. The photographer's alignment of the white stripe of the tartan's pattern along the right edge of the table separates the dark areas of the cloth from the dark recesses of the background and gives the photograph depth. This attention to aesthetic qualities indicates that Talbot's intentions were as much artistic as they were scientific.

Fig. 57.1 Jan Davidsz. de Heem, *Still-life with Fruit and Butterflies*, c. 1645–55, oil on oak. National Gallery of Canada, Ottawa (28140)

Fig. 57.2 Roger Fenton, *Still Life with Fruit*, 1860, albumen silver print. Gilman Collection, Gift of The Howard Gilman Foundation, 2005, Metropolitan Museum of Art, New York (2005.100.15)

58 John Thomson

Edinburgh 14 June 1837–29 September or 7 October 1921 Streatham, London

Palace of the Leprous King 1866, printed 1867

From **The Antiquities of Cambodia**, 1867, pl. XVI

Albumen silver print, 19.1 × 23.5 cm

37368.12

Provenance Britnell's Bookstore, Toronto; Gift of C. Ainslie Loomis, Brantford, Ontario, 1993

Considered one of the founders of social documentary photography, John Thomson is known for his photographs of London tradesmen and street people (see cat. 59). Thomson published *Street Life in London* (1877) in twelve monthly issues in collaboration with the journalist Adolphe Smith. The aim of the series was to portray the squalid living conditions of the urban poor. This publication was the first instance of combining photographs and text for the purposes of social commentary. Towards the end of his life, Thomson made photographic portraits of another stratum of society, the residents of London's fashionable Mayfair district.

Thomson's career as a photographer began in much less familiar and often more uncomfortable surroundings. After studying chemistry at the University of Edinburgh, Thomson travelled to Asia. He settled on the island of Penang (Malaysia) and opened his first photography studio in 1862 at the age of twenty-five. A year later he moved to Singapore, where he continued in the business of photographic portraiture. Bored with photographing other European residents and inspired by the travel writings of Henri Mahout (*Travels in Indo-China, Cambodia and Laos*), Thomson soon resolved to "cross the country and penetrate to the interior of Cambodia for the purpose of exploring and photographing its ruins."[1]

Although many tried to dissuade him from making such a dangerous trip, Thomson began his journey into the forests of Cambodia on 27 January 1866. Upon reaching the ruins of the ancient temple-palace of Angkor Wat (also known as Nakhon Wat, "the temple of the capital"), he and his entourage spent several days photographing and mapping the site of the ruins and the former capital city of Cambodia, Inthapatapuri.[2]

Aware of European interest in such sites, Thomson presented lectures on his Cambodian travels to the Royal Geographic Society on his return to London that same year. The Society later published his photographs in album form in 1867. Of the sixteen albumen silver prints of Nakhon Wat and its environs included in *The Antiquities of Cambodia*, three are panoramic views of the ruined temple (see fig. 58.1). In his introduction to the album, Thomson informs his readers that the majority of the photographs depict the "greatest" of all Cambodian antiquities, Nakhon Wat. According to Thomson, the Cambodian natives believed that the temple's construction was the work of the gods. He assumed that the recurring ornament of a seven-headed snake was evidence for Nakhon Wat's having once been used as a place for snake-worship.[3] The photographs in this album include views of the temple gateway's western facade, details of portal carvings, and bas-reliefs that depict battles, triumphant processions, and other scenes from the epic Ramayana poem.

Fig. 58.1 John Thomson, *Western Front of Nakhon Wat*, 1866, printed 1867, albumen silver prints. National Gallery of Canada, Ottawa, Gift of C. Ainslie Loomis, Brantford, Ontario, 1993 (37368.1 a–c)

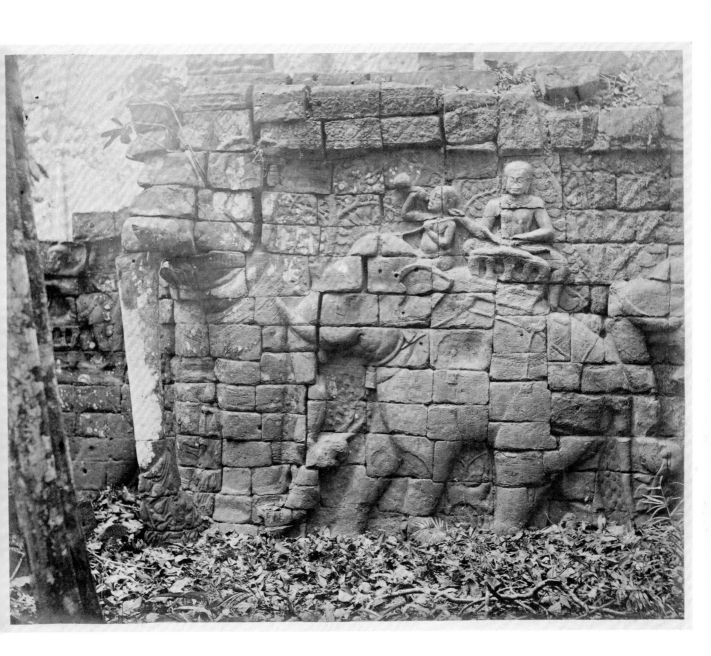

59 John Thomson
Edinburgh 14 June 1837–29 September or 7 October 1921 Streatham, London
The Crawlers before 1877
From *Street Life in London*, opp. p. 81
Woodburytype, 11.6 × 8.8 cm
PSC85:224:30

Annotations secondary support, l.c., red letterpress, *THE "CRAWLERS."*
Provenance purchased from Helios Rare Books, Toronto, 1985

The young John Thomson worked as an apprentice to the Edinburgh optician James Mackay Bryson, from whom he may have learned to make photographs.[1] Thomson moved to Singapore in 1862, joining his brother William, a watchmaker and photographer.

By the time Thomson returned to Britain in 1872, his photographic skills were widely known through the volumes of photographs he had been publishing from his travels in China and Southeast Asia (see cat. 58). Between 1876 and 1877, he produced a series of photographs featuring those who lived and worked on the London streets,[2] a popular subject in British art since the eighteenth and the early part of the nineteenth century (see fig. 59.1). Texts by the journalist Adolphe Smith accompanied Thomson's photographs. Reformist in tone, Smith's writing, like Thomson's images, was sympathetic to the plight of the unfortunate men, women, and children who made up London's working poor.

In *The Crawlers*,[3] an old woman is seated on a step at street level, a swaddled baby on her lap and a teacup at her side. Her exhaustion is communicated by the way she rests her head against the edge of a brick wall. Smith's text tells her story:

> A fellow crawler, who used to doze on the same step leading to St. Giles's workhouse, had actually obtained employment in a coffee-shop, and, while awaiting an opportunity to follow this example, my informant was taking care of her friend's child. This infant … is entrusted by its mother to the tender mercies of the crawler at about ten o'clock every morning. The mother returns from her work at four in the afternoon, but resumes her occupation at the coffee-shop from eight to ten in the evening, when the infant is once more handed over to the crawler, and kept out in the streets through all weathers with no extra protection against the rain and sleet than the dirty and worn shawl which covers the poor woman's shoulders; but, as she explained, "it pushes its little head under my chin when it is very cold, and cuddles up to me, so that it keeps me warm as well as itself"… The only reward she receives for the eight hours' nursing per day devoted to this little urchin, is a cup of tea and a little bread. Even this modest remuneration is not always forthcoming, and the crawler has often been compelled to content herself with bread without tea, or tea without bread, so that even this …is not always to be had.[4]

Street Life in London and Thomson's other publications, including *Illustrations of China and Its People* (1873–74), are now considered among the earliest forms of photojournalism. Their influence is evident from the many reproductions made from their images (see fig. 59.2).

Fig. 59.1 John Augustus Atkinson, *Chimney-sweepers, May Day,* c. 1813–14, pen and grey ink with grey wash and watercolour over traces of graphite, touched with gum arabic, on buff wove paper. National Gallery of Canada, Ottawa (6550)

Fig. 59.2 After John Thomson, *Beggars,* c. 1868–72, wood engraving on paper. National Gallery of Canada, Ottawa, Gift of Donald C. Thom, Ottawa, 1980 (32198.23)

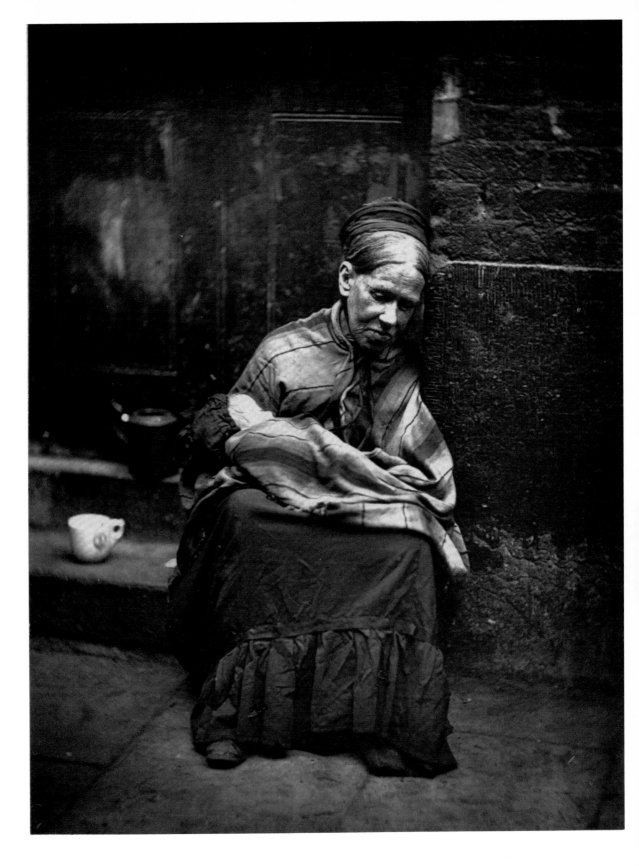

60 Linnaeus Tripe
Devonport, Devon, 14 April 1822–2 March 1902 Devonport, Devon
Pugahm Myo, Kyoung near the Ananda Pagoda, Burma 20–24 August 1855
Albumen silver print, 24.9 × 34.3 cm
20621
Provenance purchased from the Jane Corkin Gallery, Toronto, 1984

When Linnaeus Tripe arrived in India in December 1839 to take up his post as an ensign, the East India Company had been governing the country for over two hundred years. To exercise its authority, the Company maintained a standing army, and, like countless others of his generation, class, and background, Tripe enrolled, aged seventeen, to begin his career as an officer.

For the next eleven years he remained in India, moving with his regiment from place to place as circumstance dictated. On furlough back in Britain during the early 1850s, Tripe took up photography just as it was gaining widespread popularity among the gentlemen amateurs of society. For them, the calotype process proved especially appealing for its soft detail and rich tonalities, and was also better suited to the extreme heat and ubiquitous dust that challenged every photographer working in India. By the time Tripe returned to Madras in 1854, he had already mastered the chemical complexities of the process, and had enough self-confidence to make large-format negatives using a camera of truly heroic proportions.[1]

Following a successful photographic expedition to document the ancient temples in December 1854, Tripe's photography came to the attention of Lord Dalhousie, Governor General of India, resulting in an appointment as the official photographer to the Government of India's Mission to Ava (Burma) that took place between August and November 1855.[2]

The mission's alleged purpose was the formal ratification of a peace treaty between Britain and the Burmese king. In truth, the undertaking was also a pretext to gather information and intelligence about Burma, which, apart from a handful of accounts, remained mysterious, remote, and largely unexplored. To this end, the mission included trained geologists, surveyors, and map-makers, as well as a topographic artist, Colesworthy Grant, who was instructed to "convey a good idea of the natural features of the Kingdom of Burmah from the frontier to the capital (with) sketches of the people, of cities and palaces."[3] Tripe's appointment was something of a new departure, acknowledging the ability of photography to record the same information, but with unprecedented objectivity.

By late August, the mission had reached Pugahm Myo, which had been the seat of government for over twelve hundred years and contained the most extensive remains of antiquity in Burma.[4] Tripe took twenty studies of the various pagodas, including the Ananda Pagoda, whose interior resembled a "Christian cathedral rather than a Heathen Temple"[5] (see fig. 60.1).

Perhaps the most enigmatic study of the Pugahm Myo series is this image of the *Kyoung near the Ananda Pagoda*, as it is not apparent what attracted Tripe to include a picture of this monastery in his overall documentation. When we learn that the monastery had only recently been built by a Burmese oil entrepreneur, the photograph takes on a different meaning within the context of the mission.[6] The image now assumes a resonance that hints at the riches of the oil trade, reverence for the Buddhist religion, and the philanthropic nature of its wealthy residents, all of which represented valuable intelligence to the Government of India.

Fig. 60.1 Linnaeus Tripe, *Pugahm Myo, Ananda Pagoda*, 20–24 August 1855, albumen silver print. British Library (083882)

61 Benjamin Brecknell Turner

London 12 May 1815–1894 Lambeth, London

Bredicot Court, Worcestershire April 1853
From *The Photographic Album for the Year 1855*, 1855, pl. 19

Albumen silver print, 20.8 × 25.7 cm

20515.18

Provenance **purchased from Phillips, Son & Neale, London, 1973**

The area around Bredicot Court in Worcestershire provided Benjamin Brecknell Turner with some of his favourite subjects in his early days as a photographer. Since it was the family home of his wife, Agnes (née Chamberlain), it had a strong personal connection for him. Agnes's father, Henry Chamberlain, had been a porcelain manufacturer until 1837, when he purchased Bredicot farm,[1] most of whose buildings could be dated to the sixteenth and seventeenth centuries. Turner photographed the farm and its environs during holiday visits to the Chamberlains. Agnes remembered his camera as a "huge square box,"[2] and his son recalled that Turner would "take about with him his enormous camera and portable dark room … on … a two-wheeled go-cart."[3] In this image, Turner has focused his attention on the main house and the "piggery" that was located just across a small laneway. Bredicot farm, with its quaint cottages, historic architecture, and rustic farm implements, provided Turner with a rich supply of picturesque imagery. According to the notes that accompanied *Bredicot Court, Worcestershire* in *The Photographic Album for the Year 1855*, Turner photographed the scene in the month of April at ten o'clock in the morning "in clear sunshine" and with an exposure time of thirty minutes, and then developed it using Fox Talbot's Gallo-nitrate wash.[4] Turner's image was also accompanied by a quotation from Geoffrey Crayon (a pseudonym for the American writer Washington Irving) that celebrated the "rural repose" of the English countryside.[5] In addition to picturesque landscape views, including those like *Farmyard, Elfords, Hawkhurst* in Kent (fig. 61.2), Turner also made portraits of friends and family both in a studio and outdoors.

Benjamin Brecknell Turner was one of eight children born to Samuel Turner and Lucy Fownes. His family were tallow chandlers (candlemakers) in London, a business he joined at the age of sixteen and took over in 1841. One of the founding members of the London Photographic Society, Turner showed his photographs in a number of exhibitions over a period of ten years starting in 1852 with images included in the London Society of Arts exhibition (where his work was highly praised)[6] until 1862 at the London International Exhibition. A "master of the large paper negative," Turner was not won over by the wet-collodion process, which he reserved for making portraits.[7]

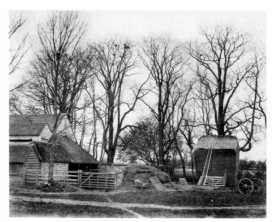

Fig. 61.1 Benjamin Brecknell Turner, *Humphrey Chamberlain; Agnes Turner (née Chamberlain)*, c. 1855, albumen silver print. National Portrait Gallery, London (NPG P1003)

Fig. 61.2 Benjamin Brecknell Turner, *Farmyard, Elfords, Hawkhurst*, c. 1852–54, albumen silver print. National Gallery of Canada, Ottawa (23998)

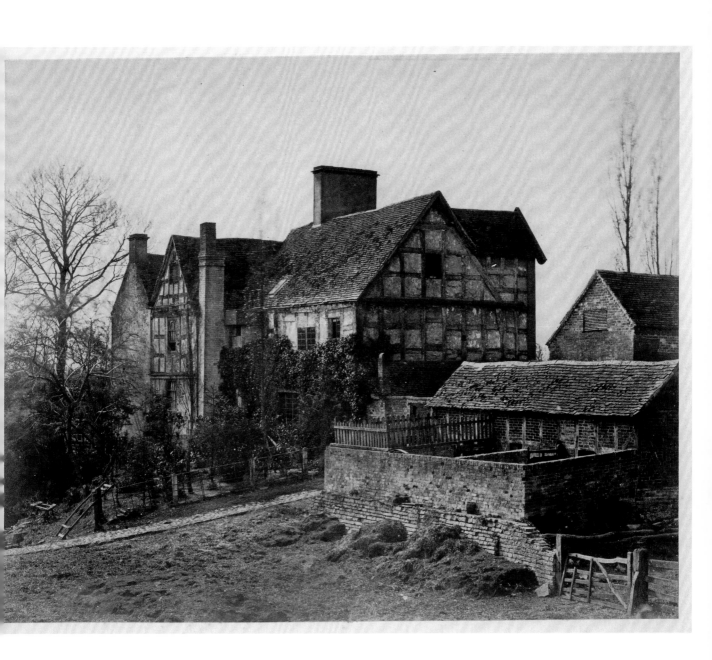

Robert Christopher Tytler
Alahabad, India 25 September 1818–10 September 1872 Simla, India
Harriet Christina Tytler (née Earle)
Sikora, India 3 October 1828–24 November 1907 Simla, India

Upper and Lower Sections of Qutb Minar, Delhi c. 1857–58, printed 1859
Albumen silver prints, 51.0 × 40.4 cm (top); 50.2 × 41.1 cm (bottom)
38614.1-2

Annotations top: secondary support, u.c., letterpress label, *47*, bottom: secondary support, u.c., letterpress label, *48*
Provenance gift of the Vancouver Public Library, 1997

It is difficult to know why Harriet Tytler, writing about her life in India between 1828 and 1858,[1] was virtually silent about her (and her husband's) photographic work. The memoirs trace the arc of her life from early childhood in India, to the years spent with an aunt in Scotland, and back to India as a young bride, where she was an eyewitness to the Indian uprising that began on 10 May 1857. References to drawing lessons in her youth and portrait painting instruction from an artist in Portsmouth indicate that Harriet had formal artistic training. She also spent time copying paintings as a way of improving her skills. It is believed that her husband, Major Robert Tytler, learned the rudiments of photography from Felice Beato (see cat. 46) and Dr. John Murray.[2] Murray, a physician with the Bengal Medical Service, had been producing large-format, waxed-paper negatives in India from about 1853, similar to the format used by the Tytlers when making their calotype negatives in 1858 (see fig. 62.1).

Following the traumatic events of the Indian rebellion and the subsequent siege of Delhi (when she and her family took refuge in the Flagstaff Tower along with other British civilians and officers), Harriet Tytler was feeling restless and unsettled. Her husband suggested that in order to keep herself busy, she could create a visual record of the city – in a circular panoramic format they referred to as a cyclorama. For this first attempt at landscape painting, she managed to obtain a canvas and paint from an artist who had decided to leave India and return to England. She originally intended to offer the large-scale painting to P. T. Barnum, presumably for use in his museum, but by the time the work was completed she concluded that depicting the scenes of the rebellion would no longer be of interest to the general public.

The thirteenth-century minaret in Delhi known as the Qutb Minar is one of the architectural sites the Tytlers photographed from various angles in 1858. Considered one of the finest examples of early Mughal architecture, the red sandstone tower was the subject of work by several other photographers, including Samuel Bourne (see fig. 62.2), Felice Beato, and Eugene Impey, even though it had no particular historical significance in connection with the 1857 rebellion.

Although Robert Tytler has been credited with making some five hundred waxed-paper negatives of the mutiny and its aftermath, he "wished it to be understood that the full merit of his photographs did not lie with himself; that Mrs. Tytler, who is a most successful photographer, not only selected many of the subjects, but even developed the pictures herself." [3]

Robert Tytler died a year after Harriet gave birth to the last of their ten children, of whom eight survived. Their eldest son, Frederick, and their eldest daughter, Edith, both immigrated to Canada. Harriet Tytler remained in India, where she founded and ran an orphanage in Simla, designed furniture, and exhibited and sold her paintings.[4]

Fig. 62.1 Robert C. Tytler and Harriet C. Tytler, *Upper and Lower Sections of Qutb Minar, Delhi*, c. 1857–58, paper negatives, top and bottom negatives with black ink additions. National Gallery of Canada, Ottawa, Gift of the Vancouver Public Library, 1997 (38615.1-2)

Fig. 62.2 Attributed to Samuel Bourne, *Qutb Minar, near Delhi*, c. 1863–64, albumen silver print. National Gallery of Canada, Ottawa (20514.33)

63 James Valentine & Sons
Dundee, 1878–1963
Forth Bridge from the South-west c. 1887
Albumen silver print, 18.8 × 28.8 cm
33458

Annotations l.c., in negative, *FORTH BRIDGE FROM S.W. 9681 J.V.*

Provenance purchased from the collection of Ralph Greenhill, Toronto, 1972

The expansion of the railways in Victorian Britain, which made travel faster and easier, and the subsequent rise of tourism as a national pastime created a demand for scenic views as souvenirs. The appetite for tourism has been credited with being "the single most effective stimulus in the development of professional landscape practices in the nineteenth century, both in terms of the quantity of work it generated and in the incentive it provided for photographers to explore previously unphotographed regions."[1]

Among the commercial photographers who benefited from this phenomenon was the firm of James Valentine (which added "& Sons" in 1878). Initially, James Valentine (1815–1879) had helped run his father's printing business before he expanded into photography. Trained as a portrait painter in Edinburgh, he studied photography in Paris in the late 1840s, and by the mid-1850s had established a portrait studio in Dundee, which then branched out by making topographical views. After his death in 1879, his sons inherited a business that by the late 1880s had a catalogue that included more than 20,000 views of Great Britain, Ireland, and Norway.[2]

Scenic views destined for tourists included not just stunning natural scenery, but what William Henry Fox Talbot, in his *Sun Pictures in Scotland* (1845), called "the symbolic representation of contemporary culture through a major building project."[3]

The Forth Bridge surely qualifies in this category. Designed by John Fowler and Benjamin Baker after the disastrous collapse of the Tay suspension bridge in 1869, it was the first major steel structure in Europe and a triumph of nineteenth-century engineering. The construction process had been officially documented by the young civil engineer Evelyn Carey in a series of glass plate negatives made between 1883 and March 1890, when the bridge was officially opened (see fig. 63.1).

The image by Valentine & Sons also shows the bridge in progress, with the trio of massive cantilevers still solitary and separate. The bridge can be read as a symbol of how contemporary technology, such as the advent of steam power and the availability of steel, served the era's increasing concentration on speed and mobility, yet this exercise in pure engineering also has a strong aesthetic appeal. Defenders of the structure's unadorned design praised its "immense power," a characteristic associated with the concept of the sublime: feelings of awe, terror, and exaltation while experiencing the powers of nature.[4] Here, it is the forces of industrialization that wield power. Yet some of the power of this photograph may lie in the unfinished state of the bridge, which casts the same spell as an abstract painting or sculpture. The monumental cantilevers and scaffolding possess a dark grandeur of their own, in some respects even more awe-inspiring than the image of the completed bridge (see fig. 63.2).

Fig. 63.1 Evelyn George Carey, *Construction View Showing the Gap between the Inchgarvie and Fife Cantilevers to be Closed, Forth Bridge, Scotland*, 24 May 1889, albumen silver print. Collection Centre Canadien d'Architecture/Canadian Centre for Architecture, Montreal (PH1979:0071:02:046)

Fig. 63.2 James Valentine & Sons, *Forth Bridge from the South*, c. 1880–90, albumen silver print. National Gallery of Canada, Ottawa (33446.102)

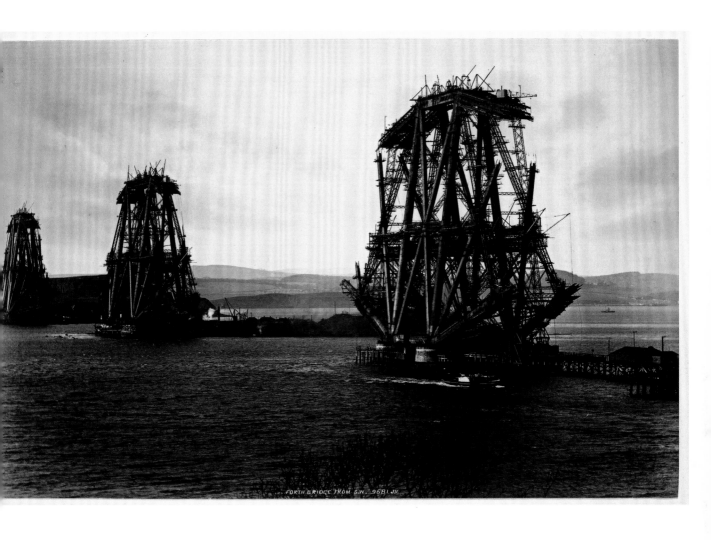

FORTH BRIDGE FROM S.W. 9681 JV

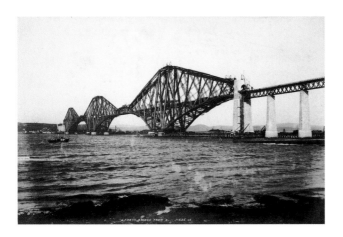

FORTH BRIDGE FROM S. 11655 JV

7 July 1819–1903
The Garden Chair **11 September 1854**
From *The Photographic Album for the Year 1855*, 1855, pl. 11
Albumen silver print, 17.8 × 14.0 cm
20515.10

Provenance **purchased from Phillips, Son & Neale, London, 1973**

This double portrait, titled *The Garden Chair*, was one of the forty-four photographs included in *The Photographic Album for the Year 1855*. The image, like all of the others in the album, was accompanied by a poem, in this case, "The Garden Chair, Two Portraits," by the nineteenth-century novelist and poet Dinah Maria Mulock (1826–1887).[1] The poem suggests the meaning of White's photograph: it alludes to the subject of youth and old age, very similar to another photograph in the *Photographic Album for the Year 1855* by Fallon Horne (see cat. 30). This theme of the cycles of life, with one life just beginning as another nears its end, is a common one in Victorian art and literature. Whether White made the photograph with the poem in mind or found it later is not known, but it is well-suited to images evoked by Mulock's text. The older woman sits in repose in a Victorian wheelchair, a modified version of what was known at the time as a Bath chair,[2] while the younger woman stands below a vine of blooming roses, her left hand on the steering rod of the chair.

Henry White was a talented amateur photographer who made his living as a lawyer in London. His father, Richard Samuel White, had established a law firm in London, which Henry joined in 1841. Henry White's contribution to *The Photographic Album of the Year 1855* is one of the earliest known examples of his work; that same year he won the gold medal at the Exposition Universelle in Paris and again in 1856 at the Exposition Universelle in Brussels. He participated in several exhibitions, submitting over two hundred photographs between 1855 and 1863. Many of the titles of the photographs that he exhibited indicate that they were primarily landscape studies and probably included prints such as a work now known simply as *Landscape* (fig. 64.1)[3] or *Hunford Mill, Surrey* (fig. 64.2). White's skills at capturing elusive and atmospheric effects in the landscape were highly praised by exhibition commentators of the day.[4]

Fig. 64.1 Henry White, *Landscape*, 1856, albumen silver print. Cleveland Museum of Art, Dudley P. Allen Fund (1993.162)

Fig. 64.2 Henry White, *Hunford Mill, Surrey*, 1855–57, albumen silver print. Metropolitan Museum of Art, New York, Gift of Mrs. Harrison D. Horblit, 1995 (1995.368)

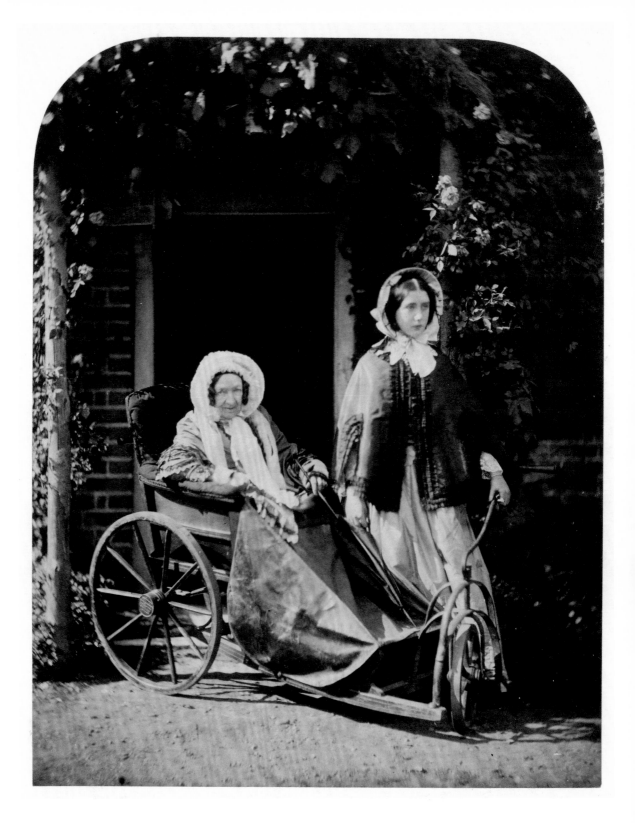

65 Thomas Richard Williams
Blackfriars, London 5 May 1824–5 April 1871 Finchley, London
Articles of Vertu c. 1853
Daguerreotype, 7.9 × 6.7 cm (each of two)
35589

Annotations paper label on cover glass, brown ink, 7
Provenance purchased from Morri Mostow, Montreal, 1991

Articles of Vertu, a stereo daguerreotype by T. R. Williams,[1] is a skilfully designed still-life arrangement of objects of taste, connoisseurship, and scientific knowledge. The image contains items that act as symbols of three of the four senses: the guitar represents the sense of hearing, the spiny shells, the sense of touch, and the stereoscopic camera alludes to the sense of sight. Also part of the still life is a book and a bell jar containing a small statuette of a seated cherub holding a basket on his head. This image is believed to be part of a larger group of twenty-six photographs that were made between 1851 and 1855 and fall under the general heading of the "First Series." The group's diverse subject matter includes scenes that seem to have been inspired by seventeenth-century Dutch painting, such as *The Old Larder* (fig. 65.1) or *The Basketmaker* (fig. 65.2). Most of the images were printed as albumen stereographic cards (although it seems that copy daguerreotypes were also made of some of the images) by the London Stereoscopic Company in 1856.[2]

The son of Marie and Thomas Williams, who operated a coach company that ran between London and Reading, T. R. Williams is recognized for his skills as a daguerreotypist, in particular, his production of stereo daguerreotypes. As a young man, he worked as an apprentice to the French daguerreotypist Antoine Claudet (see cat. 10) until some time in the 1840s. Claudet's interest in reproducing binocular vision through stereography influenced Williams in his choice of photography as a profession. By 1851 he had opened his own photography studio in London at 35 West Square, Lambeth, the same year he photographed the nave of the Crystal Palace, the glass building constructed for the Great Exhibition of 1851. Williams opened his second studio at 236 Regent Street in 1854.

Williams was a member of the Photographic Society from its beginnings in 1853. He was also a member of the North London Photographic Society, the South London Photographic Society, and a founding member of the Solar Club, whose members included Oscar G. Rejlander (see cat. 45) and Henry Peach Robinson (see cat. 47). Williams exhibited regularly in photographic exhibitions in England and abroad, and was awarded medals at the Paris Exposition of 1855, the London International Exhibition of 1862, and by the Photographic Society of London in 1866.

The stereo daguerreotype that belongs to the National Gallery of Canada appears to have been sold through Carpenter & Westley, a firm that specialized in the manufacture and sale of lenses, microscopes, telescopes, and magic lanterns. Located at 24 Regent Street in London, they remained in operation there until the 1920s.

Fig. 65.1 T. R. Williams, *The Old Larder*, after 1850, daguerreotype. National Gallery of Canada, Ottawa, Gift of Phyllis Lambert, Montreal, 1988 (30711)

Fig. 65.2 T. R. Williams, *The Basketmaker*, after 1850, daguerreotype, heightened with colour. National Gallery of Canada, Ottawa, Gift of Phyllis Lambert, Montreal, 1988 (30712)

66 Unknown

British, mid-19th century
John Barritt Melson (1811–1898) c. 1850
Daguerreotype, in original frame, 30.6 × 25.5 cm
41548

Provenance John Barritt Melson; Sidney Melson, son; John Waller Melson, grandson; Alfred John Wallace Melson, great grandson, and sister "Louie"; Gift of William John Melson, Barbara Elizabeth Melson Estes and families in memory of Alfred John Wallace Melson, 2004.

The direct composition and unusually large size of this half-length daguerreotype portrait of John Barritt Melson make it an imposing object that is expressive of his stature as a man of science and learning. In striking contrast to an unidentified daguerreotype portrait of a man peering into a microscope (see fig. 66.1), or Benjamin Dancer's stereo daguerreotype of a scientist with his apparatus (see fig. 14.2) or his sixth-plate daguerreotype of the celebrated British botanist Richard Buxton (see cat. 14), Melson is captured almost full-face to the camera. Supporting his head with his right hand, the sitter looks at the photographer with confidence and solemnity.

A quintessential example of a daguerreotype made in a formal portrait style, it is a work with a rich biographical history, fascinating provenance, and potentially very important associations with the early history of the daguerreotype in England.

Born in Brechin, Scotland, John Barritt Melson was the son of the Reverend Robert Melson, a Wesleyan minister (1803–1852). A gifted individual who was fluent in Greek and Latin at the age of nine years, and who would leave his mark in the fields of law, medicine, and theology,[1] John Barritt Melson's links with the practitioners of the daguerreotype in its early years were significant.[2] His first encounter with the daguerreotype occurred in October of 1839, when he and two of his scientific colleagues, John Percy and George Shaw, met with one or more French self-declared agents of Daguerre in Birmingham. Principal among the French contingency was a M. de Ste Croix,[3] who had spent some time in London giving workshops on the process and had travelled to Birmingham with the express purpose of repeating his demonstrations.

Ste Croix would have found a receptive and knowledgeable audience in Melson, Percy, and Shaw, given their combined training in chemistry, patent law, and pioneering efforts in electroplating, the latter being a process essential to the improved practice of daguerreotyping.[4] In concluding his demonstration, Ste Croix presented Dr. Melson with a daguerreotype of a Birmingham street scene, which is recorded as having hung in Melson's consulting rooms.[5]

Melson's interest in photography may well date back to August of 1839, when, as a member of the Chemical Section of the British Association, he was present at a meeting at which William Henry Fox Talbot's photogenic drawings were exhibited.[6]

The National Gallery's portrait of Dr. Melson was made some years after by a British daguerreotypist. It bears evidence of a later hand for a number of reasons. Dr. Melson looks older than the twenty-eight or twenty-nine years of age that a portrait dated to late 1839 would have had him, even taking into account the daguerreotype's tendency to age the appearance of sitters. There are also reasons to question an earlier dating from the technical perspective as a portrait of this size would have required larger cameras and plates, as well as bigger and more efficient lenses than were available in 1839.[7]

Despite the undetermined authorship[8] of this unusual daguerreotype of a figure of both international and national importance – Melson's descendants having settled in Canada – this is a work that takes pride of place in the collection along with comparable daguerreotype portraits made around the same time.

Fig. 66.1 Unknown (American, mid-19th century), *Man with Microscope*, c. 1850, daguerreotype. National Gallery of Canada, Ottawa (33977)

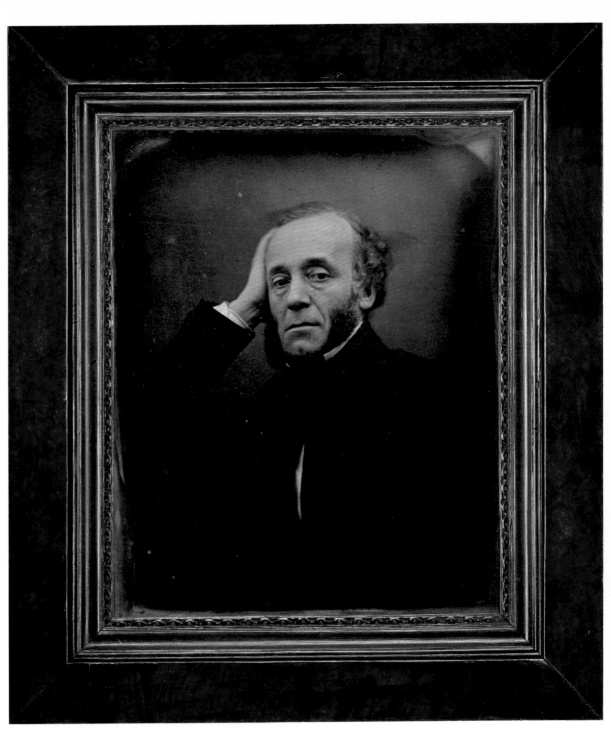

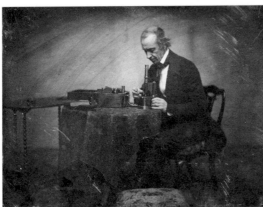

67 Unknown

British, mid-19th century
***Untitled (Hatfield Rectory)* November 1854**
From *Hatfield Rectory* album, 1855
Salted paper print, 11.2 × 15.9 cm
34515.10

Provenance purchased from the collection of Ralph Greenhill, Toronto, 1972

This album is an intimate memento of the parsonage at Hatfield Rectory signed on the opening page by Caroline (née Faithfull) Chittenden,[1] one of the rector's daughters, who had married Charles G. Chittenden in 1853, a year before the album was made. The first eighteen photographs in the album are salted paper prints[2] that were probably made in November of 1854, soon after the death of the Reverend Francis Joseph Faithfull, rector of Hatfield. These photographs, which seem to have been made as an attempt to hold onto the way of life at Hatfield, show the parsonage (known as Howe Dell) and the surrounding fields and buildings. The album contains several charming scenes, such as this one, which appears to take place on the lawn of the parsonage, where a woman stops on her walk to speak to the gardener while a man wearing a top hat looks on. Other views feature members of the family and household staff, including a man who appears to be the groundskeeper for Howe Dell. There are also images of the church (see fig. 67.1).

The original owner of the album, Caroline Chittenden, was born at Hatfield Rectory in 1822. Along with her older sisters Cecelia, Emily, and Julia and her brothers James and Valentine (see fig. 67.2), Caroline grew up in Hatfield, where her father held a prominent position not only as rector of St. Etheldreda Church but also as the founder and headmaster of the local preparatory school for boys. The Reverend Faithfull, a friend of the 2nd Marquess of Salisbury, is remembered for being the first person to play a match of tennis with the Marquess upon the renovation of the tennis courts at Hatfield House in 1842.[3]

Caroline Chittenden's signature on the first pages suggests her as the compiler of the album. It may also be the case that several albums were made for various family members and that she personalized her own copy by signing it.

Unfortunately, there are few clues about who might have actually made the photographs that filled the *Hatfield Rectory* album. A photographer called George Hilditch (1803–1857) photographed in Hatfield in 1854 and may have been asked to make a series of views of the rectory. It is also possible that the photographs were made some time before 1854, and put into the album only upon the death of Reverend Faithfull and the relocation of the rest of the family to the Chittenden family home in Hoddesdon. The death of Caroline's father one year after her marriage signalled the end of the Faithfull family's connection to Hatfield and the rectory, making the album an even more poignant record of one family's connection to the place.

Fig. 67.1 Unknown (British, mid-19th century), *Hatfield Church* [?], November 1854, salted paper print?. National Gallery of Canada, Ottawa (34515.15)

Fig. 67.2 Unknown (British, mid-19th century), *Family Group Portrait*, November 1854, albumen silver print. National Gallery of Canada, Ottawa (34515.19)

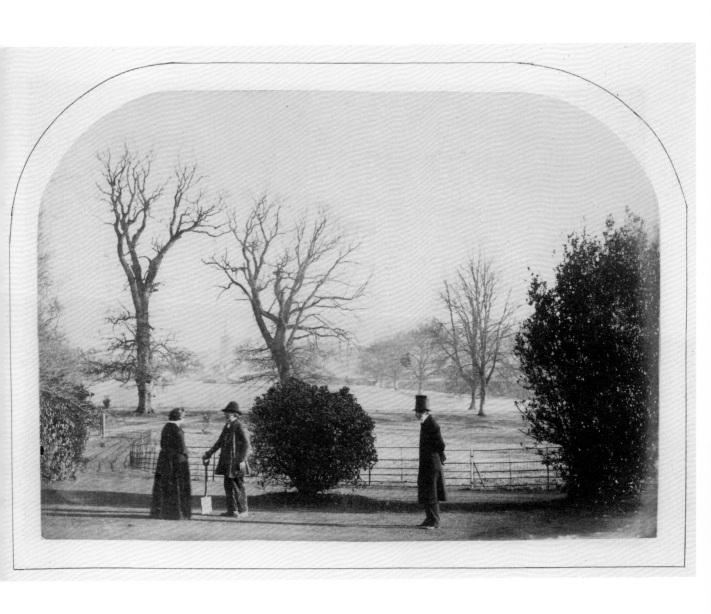

The Transition of Photographic Printing in the 1850s

As the season of practical photography declines, speculative photography raises its head. The facts or notions elicited during practice begin to ferment, to excite consideration, to range themselves on the side of new or old theories, and the combatants rush into the field.

Thomas A. Malone, October 1855[1]

During the 1850s, positive photographic prints were made from both paper negatives and from the newer collodion or albumen on glass negatives. The prints themselves were either made by a process similar to that introduced by Henry William Fox Talbot in 1839 – the salted paper print process as we now call it – or by the newer albumen print process, which had first been described by Louis-Désiré Blanquart-Évrard in 1850. This essay will explore the reasons why it may be difficult or even impossible to visually distinguish salted paper prints from early albumen prints. (This difficulty is illustrated by the examples shown in figs. 1 and 2, both drawn from *The Photographic Album for the Year 1855*,[2] which appear closely similar in their tonalities and surface characteristics, but which are thought to be different media based on the results of spectroscopic analysis.) In trying to understand these print materials, we are fortunate in having the assistance of the photographic inventors and practitioners who contributed to the evolution of printing materials in this period through the extensive record they left of their work in the form of scholarly articles, published presentations to the photographic associations, letters to the photographic press, and manuals of instruction. Less fortunate is the fact that this record is somewhat confused and often contradictory.

In an echo of the disagreements that were rife among early photographic printers, the understanding of these early photographic prints remains contested and unclear among those who now study them. Conservators, art historians, collectors, dealers, and auction houses all wish to be able to distinguish prints made by the earlier salted paper print process from albumen prints and to accurately classify those that seem to fall between these two. Accurate identification affects our opinion about their stability, conservation treatment options, historical significance, and even their desirability and monetary value. As the albumen paper manufacturing industry evolved and as tastes changed, albumen prints acquired a distinct appearance that is relatively easy to recognize.[3] But during the 1850s, when both methods were in active use, the prints made by these processes could look remarkably similar. This similarity has led into a thicket of undefined and non-standardized categorization and terminology that leaves it unclear as to what is being talked about.

This essay aims to identify the technical issues involved in revising our ideas about photographic prints made in this early period when technology, practice, and tastes were in transition. We will concentrate on the situation in Britain, leaving aside some of the important threads of this development that took place in France, such as Hippolyte Bayard's largely unrecognized innovations in paper photography (contemporary with Talbot's) and Blanquart-Évrard's innovative (and unpublished) commercial printing methods as practised in his Imprimerie photographique in Lille. It is worth noting, though, that photographers in both France and England were almost immediately aware of new ideas and methods that originated on the other side of the Channel through original publications, immediate translations, and an extensive network of personal and professional contacts.

In May of 1850, Blanquart-Évrard[4] wrote to the French Academy of Sciences describing some variations he used in preparing paper for making paper negatives.[5] In the same letter, added almost as an afterthought, he addressed the "Preparation of positive albumen paper," the first published mention of the albumen printing process. Blanquart-Évrard contrasted the appearance of these new prints made with albumen to the older plain paper prints, saying they were "somewhat glossy, but with a richer tone, and a pleasing delicacy and transparency."[6] Albumenized printing paper would eventually become the signature printing material of

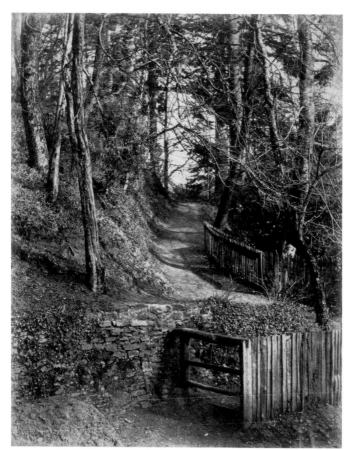

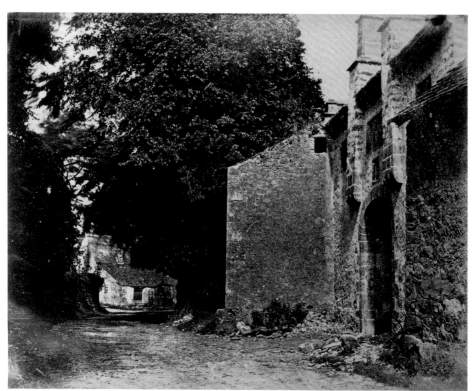

nineteenth-century photography, facilitating the growth of Talbot's negative-positive system of photography, allowing for its commercialization, stimulating the growth of a niche industry for the manufacture of photographic paper, and preparing the way for the creation of the larger photographic materials industry later in the century. But in the years immediately following Blanquart-Évrard's announcement, photographic printing would be a disputed and troublesome enterprise for the small cadre of British and European amateurs, scientists, and artists who were, at that time, the only photographers using paper to make photographs.[7]

How were photographic prints made in the 1850s?

An idea may be formed of what these (difficulties of printing) really are, when a high standard of excellence is desired, when I say, that during the brief intervals of my labours, and as a relaxation from the anxieties and disappointments of the other pursuit, I mastered easily the Daguerreotype and glass negative processes, and also perfected the Calotype on paper.

Thomas Sutton, 1855[8]

Talbot's instructions for making photogenic drawings – his term for what we now call salted paper prints[9] – were somewhat vague and layered with alternative steps, none of them particularly recommended by the author over others. Variations on the original formulation were soon introduced by Talbot himself, as well as by experimenters such as Alfred Swaine Taylor, Robert Hunt, George Thomas Fisher, and George Smith Cundell.[10]

In essence, these methods all aim to create a sheet of paper on which light-sensitive silver halide has been deposited in a two-step process: first by introducing a halide onto – or into – the paper, usually by soaking it in a dilute solution of a halide salt;[11] and second, by applying a strong solution of silver nitrate[12] to one surface of the "salted" paper. The result is the formation of silver halide on the paper surface along with a residual excess of silver nitrate. (The presence of an excess of silver nitrate is essential in printing-out processes, where it acts as a halogen acceptor during exposure, allowing the conversion of silver salt to silver metal to go forward.)

The sheet, now subject to darkening by exposure to light, can be placed in a printing frame under a semi-translucent object or a negative and "printed-out" under direct sunlight until an image forms, a procedure that can take some minutes or even hours. When the sheet is removed from the printing frame, the image is revealed with its tonalities reversed from that of the negative: where the negative is dark, the print is light, and vice versa. The

energy of light has chemically reduced the colourless silver halide to particles of metallic silver wherever light has been transmitted through the negative. The microscopic particles of silver dispersed in the paper fibres give a darkened appearance to the areas receiving the largest light exposure. An intermediate density appears in all of the areas of diminishing light exposure, progressively weakening towards those areas completely obscured by the darkest parts of the overlying negative: these areas remain un-darkened and unchanged.

At this point, however, the light and mid-tone areas of the print retain unaltered silver halide, still light sensitive, which must be removed in a subsequent step if the image is not to become obscured by an overall darkening of the sheet. In the first detailed description of his process, Talbot mentions three different chemical agents that can be used to fix the image: ammonia, iodide, and chloride (from common table salt).[13] (Talbot subsequently also used bromide to fix photogenic drawings.[14]) Ultimately, John Herschel's suggestion of using thiosulphate solutions to fix print images was universally adopted.[15]

When the sheet is removed from the fixing bath, it is washed to remove residual chemicals and then dried and flattened (see fig. 3).

Blanquart-Évrard's albumen print process conformed to the outline of salted paper printing – first, a two-step preparation of the paper in which a halide was applied followed by sensitization, which produced a silver halide and left an excess of silver nitrate. But in the albumen print process the halide was not applied by dipping the paper into a simple salt bath; rather, the salt solution was first combined with egg whites, which were then beaten to a froth. The beaten whites were allowed to settle and the

155

Fig. 1 Henry Taylor, *A Sheltered Nook,* April 1855, salted paper print? Plate 8 from *The Photographic Album for the Year 1855.* National Gallery of Canada, Ottawa (20515.7)

Fig. 2 John Richardson Major, Jr., *Gateway to Borwick Hall, Lancashire,* June 1855, albumen silver print? Plate 34 from *The Photographic Album for the Year 1855.* National Gallery of Canada, Ottawa (20515.32)

Fig. 3 William Henry Fox Talbot, *Specimen of Lace,* c. 1839–45, salted paper print. National Gallery of Canada, Ottawa (33487.19)

resulting salted albumen mixture was filtered and then spread carefully over the paper and allowed to dry. This paper, which we might now call "albumenized," was made light sensitive by treatment with silver nitrate, just as described for salted paper. Once sensitized, the albumen paper could be exposed, fixed, washed, and dried similarly to salted paper.

Unlike salted paper prints in which the silver image particles are embedded in the paper fibres, in albumen prints the silver particles form only in the thin coating of transparent albumen that sits on the surface of the paper. This albumen layer penetrates into the paper fabric to a much smaller extent than the simple salting solution of the salted paper process. The resulting image tends to be sharper since the albumen-confined silver image particles are more closely packed. The albumen print image has greater contrast since the silver image particles are surrounded by a binder with a high refractive index compared to the silver particles of the salt print that are surrounded only by air and cellulose fibres. Another difference in the image particles derives from the chemical characteristics of proteins in general and albumen in particular. All proteins are formed as long peptide chains having various reactive sites distributed along their length. These

sites interact with one another, establishing the characteristic shape of the molecule, and also interact with other molecules in the vicinity. In silver-based photographic systems, proteins interact strongly with the silver compounds applied during the sensitization step; in albumen prints, a strong covalent bond between the albumen molecule and silver is formed, especially at the sulphur-containing cysteine peptide, characteristically present in the albumen molecule and capable of forming strong bonds with silver cations. These silver-albumen compounds will be persistent in all parts of the image, both in highlight and shadow areas. Their presence in highlight areas may influence the appearance of the print as it ages, contributing to highlight discoloration (see fig. 4).[16]

The degree of dilution of the liquid albumen with water is a critical variable in establishing the degree of gloss of the resulting print; the higher the water content, the lower the resulting gloss of the surface, other things being equal. Table 1 summarizes the dilutions prescribed in early formulations. We see that while the earliest albumen formulations provided for somewhat less dilution, dilution of the liquid albumen with an equal quantity of water quickly became the standard formulation for British printers.

Table 1: Albumen dilution

Author	Year	Albumen/water ratio	Albumen strength
Blanquart-Évrard[17]	1850	3/1	75%
Le Gray[18]	1850	5/1	83%
Bingham / Blanquart-Évrard[19]	1851	4/1	80%
Blanquart-Évrard[20]	1851	4/1 or 3/1	80% or 75%
Le Gray[21]	1851	5/1 or 1/1 or greater dilution	83% or 50% or less than 50%
[Malone?][22]	1853	1/1	50%
Delamotte[23]	1853	1/1	50%
Pollock[24]	1853	4/1	80%
Diamond[25]	1853	1/1	50%
Shadbolt[26]	1853	1/1 (applied a second time for higher gloss)	50% +50%
Hardwich[27]	1855	1/1 or undiluted	50% or 100%

Fig. 4 Robert Petley, *Interior, Bramshill, Hampshire*, May 1853, albumen silver print. Plate 15 from *The Photographic Album for the Year 1855*. National Gallery of Canada, Ottawa (20515.15)

Opinion on the merits of the new prints varied. The photographer Philip H. Delamotte expressed his preference for the appearance of the new prints in 1853, noting that "positive proofs taken upon paper coated with a film of albumin attain a brilliancy of effect by a softening of the glaring white of the lights, with a transparency in the shadows, which cannot be arrived at by any other means. They are defective only when the albumin is applied too thickly"[28] (see fig. 5). In 1855 Thomas Hardwich noted that albumen "gives an agreeable gloss, and brings out the shadows and the minor details with great distinctness."[29] He further observed that "some operators employ the Albumen alone without any addition of water, but the paper in that case has a highly varnished appearance, which is thought by most to be objectionable."[30]

George Shadbolt had mentioned the possibility of applying a second coat of albumen in 1853, but two years later cautioned that although "the superior brilliancy and delicacy of detail exhibited in proofs upon albuminized paper … is owing to the surface nature of the impression … the offensive and vulgar glare which it possesses sometimes is more detrimental to pictorial effect than is counterbalanced by the other advantages."[31] And by 1859 Shadbolt was quite clear in his prescription that "paper prepared with a mixture of albumen and water, in equal parts, has quite sufficient surface and gloss to bring out all the detail, and at the same time secure adequate transparency in the shadows," and that, "the higher albumenized paper now sold is to be regarded with suspicion, as the very high glaze is not due to albumen, but to an admixture or adulteration, either dextrine or gelatine"[32] (see fig. 6).

The aesthetic qualities of the new printing medium were perhaps most severely judged by Thomas Sutton. While conceding that albumen prints may be acceptable for depicting "a small class of subjects," he contended that "the glaze destroys the atmosphere and poetry of a landscape composition. How any one can tolerate it in such subjects is to me extraordinary."[33]

> By soaking the paper in a solution of isinglass or parchment size, or by rubbing it over with the white of egg, and drying it prior to the application of the sensitive wash, it will be found to blacken much more readily, and assume different tones of colour, which may be varied at the taste of the operator.
>
> Robert Hunt, 1841[34]

Sutton was not alone in his dissatisfaction with the appearance of prints made by the new process. The photographic literature of the nineteenth century presents a dizzying array of alternative binders and additives, from culinary ingredients to extracts of seaweed, that are proposed as ways of improving the working properties of the printing paper or the appearance of the print.[35] The extent to which such additives were actually used, especially in the 1850s, is difficult to establish, but is probably rather limited. Photographic binders and additives can be classified as shown in Table 2. A distinction is drawn here between materials that can react with halogen during exposure, resulting in additional photosensitivity,[36] those which can form complex, chemically bound compounds with silver ions, and those which are chemically inactive and serve strictly as a binding film or film modifier and which provide some degree of optical saturation.

Fig. 5 Philip Henry Delamotte and Joseph Cundall, *Kirkstall Abbey, Doorway on the North Side*, 1854, albumen silver print. National Gallery of Canada, Ottawa (26633)

Fig. 6 George Shadbolt, *Green Meadows*, June 1855, albumen silver print? Plate 31 from *The Photographic Album for the Year 1855*. National Gallery of Canada, Ottawa (20515.29)

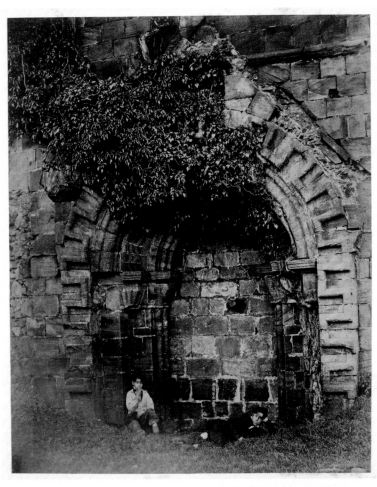

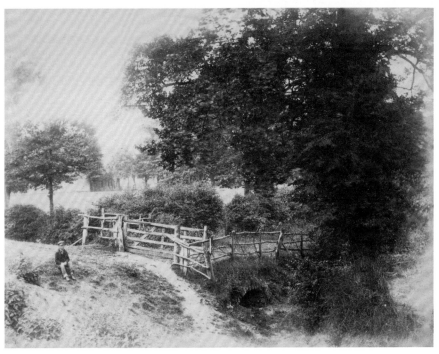

Table 2: Binders and modifiers in early photographic printing papers

Action	Class	Material	Early applications
halogen absorption *no optical effects*	organic acid	citric acid	Hunt, 1841[37]
		oxalic acid	Hunt, 1841
		tartaric acid	Hunt, 1841; Brébisson, 1852[38]
forms chemical bonds with silver ions *optical effects*	protein	albumen (from eggs)	Hunt, 1841;[39] Blanquart-Évrard, 1850
		gelatin (collagen)	Hunt, 1841; Le Gray, 1852;[40] Hardwich, 1856[41]
		sweet whey (supernatant from rennet-treated milk)	Sutton, 1855[42]
		casein (milk proteins precipitated using rennet)	
optical effects only	starch	tapioca	Brébisson, 1852[43]
		rice starch	Le Gray, 1852
		arrowroot	
		Iceland moss	Hardwich, 1856
		wheat starch	
	sugar	lactose	Blanquart-Évrard, 1851;[44] Le Gray, 1852; Thoms, 1852[45]
		glucose	
	resin	gum tragacanth	Shadbolt, 1855[46]
		gum arabic	
	polysaccharide	agar	
		carrageenan	

What are the distinguishing characteristics of prints made in the 1850s and what factors influenced their appearance?

New image-making materials often mimic the appearance of the materials they are meant to replace in order to satisfy expectations and established tastes. Early albumen prints were intentionally designed to have an appearance similar to that of salted paper prints, particularly in their surface gloss character. It is this similarity that gives rise to the confusion in distinguishing early albumen prints from salted paper prints on the basis of visual examination alone.

It can be no surprise that photographers of the time were critically concerned with the appearance of their prints and the subtle changes produced by the introduction of albumen printing; such matters are the perennial preoccupation of image makers and artists. In the 1850s, the visual and physical characteristics that were of concern can be summarized as relating to tone (or image colour), surface gloss, contrast, resolution, and stability. Tone, gloss, and stability are closely related to one another and are largely influenced by the variables particular to printing, as we shall see in the following section. Contrast and resolution, on the other hand, are largely determined by factors outside the printing process itself, most notably by the nature of the negative.[47]

> The French violet tints, when sufficiently neutral, and not dead, or sooty, are, I think, the most agreeable that have yet been obtained ... The superiority of the French printing will become instantly manifest, when we place a fair specimen of it by the side of one of our own albumenized proofs. The latter ... may be more rich and transparent, but ... these qualities may be carried to such an excess as to constitute vulgarity.

Thomas Sutton, 1855[48]

Image tone – combining colour components of both the silver image and the paper support – was critical to early photographers. The colour of the silver image is dependent on the dimensions and morphology of the silver particle formed during the photolytic printing-out process, the dispersion of the particles through the paper or binder, the nature of the silver compounds formed by the toning and fixing steps, and optical effects due to the presence of binders such as albumen. In addition, post-processing treatments such as hot pressing, calendering, and coating can change the image tone of the processed print.

Image particle formation is first determined by the nature of the paper used, and is particularly dependent on the type of sizing incorporated in the paper at the time of its manufacture.

Papermaking technology was in the midst of a disruptive revolution at the very period when photography on paper was emerging. It is likely that the "super-fine writing paper" referred to by Talbot was a handmade paper of linen fibres, surface-sized (tub-sized) using gelatin with some alum added as a coagulant and preservative.[49] But handmade paper was being steadily displaced by the manufacture of paper on the continuous web papermaking machines that had begun to appear in England in the first years of the nineteenth century.[50] In 1825 Britain produced some 22,000 tons of paper, half of which was handmade and the other half made by machine. In 1860 handmade production had fallen to less than 4,000 tons while machine-made paper output had quadrupled from 1825, by then accounting for more than 95 percent of British paper production.[51] The shift to machine-made paper in Europe followed the same pattern. It is quite certain from this, and confirmed by examination of the objects, that the overwhelming majority of photographic prints made in Britain in the 1850s used machine-made paper. English photographers used paper made in England, as well as papers manufactured in France and Germany.[52]

> We are not particular in supplying (photographers), as we consider you very whimmy. A photographer should be a paper maker, and then he would know the difficulty of pleasing.
>
> Letter from Messrs. Hollingsworth (paper manufacturers) to Thomas Sutton, 1856[53]

It was recognized early on that organic substances included in the fabric of the paper would have a decisive effect on the photographic image, particularly on its tone.[54] Gelatin was applied as an external size[55] (tub sizing), since if it was incorporated into the pulp it would cause the newly formed sheet to stick to the web. English manufacturers continued to tub size fine writing papers with gelatin, even after the arrival of papermaking machines: the sheet would be run through a tub of the gelatin/alum solution as it left the web. It was then hung in festoons in the heated loft spaces of the mill, undergoing a slow and carefully controlled air drying and hardening.

In contrast, internal (or engine) sizing with an alum/rosin soap/starch mixture had been consistently used in European machine-made paper since the 1830s.[56] Photographers made much of the differential effects of starch and gelatin sizing on image tone and absorbency.[57] George Shadbolt observed that "papers sized with gelatine give very red hues … while those sized with starch are sepia or violet; still the quality of the sizing does not influence the colour of the proofs so much as the quantity; for by increasing the quantity of starch in the paper, hues as red as those from gelatine may be obtained."[58]

Some British photographers specifically recommended the use of paper manufactured in France. "The operator will find that different kinds of paper produce varieties of colour and intensity … and should therefore be selected according to the subject. An exceedingly smooth and well-defined photograph is obtained on 'Canson Frères' positive paper; and this paper is well adapted for copying glass negatives, where much of the detail would be lost on the thicker papers."[59] This recommendation was further emphasized for papers that were to be albumenized, since the thinner starch-sized French papers had less of a tendency to curl while floating on the albumen bath.[60] Individual photographers expressed preferences for papers from particular manufacturers for each specific application: negatives or positives, landscapes or portraits, printing from paper negatives or from glass negatives.

Contradictory and confusing statements prevailed on the subject of appropriate paper characteristics. Some authorities recommended that the size be entirely removed from the paper during processing, either with hot water[61] or by using an alkaline solution (sodium carbonate) to dissolve the starch-based size.[62] Others insisted that the (gelatin) size be preserved by treatment with alum.[63] Similarly, W. J. Thoms complained that "all manufacturers … use (chlorine) bleaching materials," and that "they should be impressed with the truth, that colour is of little consequence … it is the extraneous substances in the paper itself which do the mischief."[64] But Stéphane Geoffray, in his magisterial study of photographic paper manufacture, insisted that the presence of residual chlorine bleach components presented no problems for making positive prints.[65]

Apart from the matter of sizing, there were several imperfections common in mid-century paper that remained as irritants to photographers long after they had been explicitly identified by Robert Hunt in 1841.[66] These include

- unequal absorption of solutions due to inequalities of fibre density;
- the use of mixtures of cotton, flax, and hemp fibres in pulp, each fibre type having different absorption characteristics;
- metallic particles in the finished sheets – primarily iron, copper, and brass – derived from metallic fasteners left in the rag stock, debris produced from

the blades and bearings of the beating machines, as well as from rollers and plates used for glazing;
- the presence of sulphur containing additives and residues such as sulphite bleaches and the synthetic ultramarine used to whiten some natural-fibre papers;[67]
- iron oxide impurities in clay fillers;
- minute perforations in the finished sheet;
- watermarks.

Generally, these imperfections either interfere with uniform absorption of the photographic solutions or they cause spots, staining, and discoloration in the image.

> The images obtained in this manner are themselves white, but the ground upon which they display themselves is variously and pleasingly coloured … by merely varying the proportions and some trifling details of manipulation, any of the following colours are readily attainable: sky-blue, yellow, rose-colour, brown of various shades, black.

William Henry Fox Talbot, 1839[68]

The chemical components used to form the light-sensitive silver halide and to fix and tone the silver image clearly influenced image tone. Talbot's first recommendation for a halide source was a weak solution of sodium chloride (table salt). This was soon supplemented by the use of bromide, used to make his "Waterloo" paper. For sensitizing, Talbot specified a simple solution of silver nitrate but, early in 1839, Alfred S. Taylor described an

"ammonio-nitrate of silver" sensitizer that was widely adopted for positive printing by Talbot and others. The original Talbot instruction for fixing used a strong solution of sodium chloride, but this was quickly followed by recommendations for using ammonia, potassium iodide, potassium bromide, and sodium thiosulphate (hypo). Each combination of halide mixture, sensitizer, and fixing agent was thought to produce a print with a characteristic image tone. (A modern understanding of the colours of photolytic silver images is outlined by Mike Ware.[69])

Robert Hunt extensively examined these combinations and the resulting print colours in 1841.[70] Among other effects, he notes image and highlight colours such as fine chocolate brown (ammonium chloride salting); "disagreeable" brick red (hydrochloric acid halide source); deep red ground colour (salting with mixed calcium and sodium chloride); deep brown verging on black (hydrochloric ether used as a halide source); and pale yellow highlights in potassium iodide fixed prints. With chloride salted papers fixed in strong sodium chloride, "the white parts of the photograph are changed to pale blue – a tint which is not, in some cases, at all unpleasant."

The prints made in the 1840s by the Scottish brothers John and Robert Adamson were closely examined in a 2003 study by Katherine Eremin and her collaborators.[71] They distinguished four

Fig. 7 William John Thoms, *The Castle of Herstmonceux, Sussex*, July 1855, albumen silver print? Plate 23 from *The Photographic Album for the Year 1855*. National Gallery of Canada, Ottawa (20515.21)

distinct groups of Adamson prints based on their appearance and elemental profile as determined by X-ray fluorescence analysis. A group of early prints, with blue-lilac highlights and high levels of silver and bromine, were determined as having been fixed with a bromide solution and probably salted with chloride. A group of John Adamson prints with a distinctive orange-brown image tone and bluish off-white highlights showed lower levels of silver and variable bromine levels; these were associated with prints fixed with ammonia and, possibly, bromide as a halide source. A third group, which contains the majority of prints made by Robert Adamson in his collaboration with David Octavius Hill (see cat. 26 and 27), show brown image tone and white or off-white highlights along with low levels of silver and no bromine or iodine. These correspond to prints salted with chloride and fixed using thiosulphate. A single print in the study was distinguished from the others by an orange-brown image tone and off-white highlight colour along with low levels of silver and traces of iodine. This print was tentatively identified as having been salted with iodine and fixed with thiosulphate.

Early photographic prints did not receive a separate toning bath intended to modify the image colour. The study of the Adamson prints, for instance, found no gold associated with the image material. The only "toner," although it was not immediately recognized as such at the time, was the thiosulphate fixing bath. As the fixing bath became exhausted by reaction with unreduced silver halide from the exposed prints, the chemistry of the bath changed so that it would produce a variety of silver-sulphur compounds.[72] As early as 1847, Blanquart-Évrard recommended adding silver nitrate to the thiosulphate fixing bath – artificially "ageing" it – in order to improve its colouring power.[73]

Writing in 1844 about positive prints, George Cundell noted that "there is a curious and beautiful variety in the tints of colour they will occasionally assume, varying from a rich golden orange to purple and black," and ascribed this phenomenon to both the nature of the paper and to the conditions of thiosulphate fixing.[74] But it is left to the French photographers and writers to describe in full how the "old hypo" method of toning could be used to control the resulting image tone. Blanquart-Évrard observed that the prints start in the fixing bath with "a nasty flat red hue, but go towards a beautiful brown, then bistre, and finally arrive at the black of an aquatint."[75] Dr. Guillot-Saguez, in his influential 1847 book on paper photography, outlined a similar pattern of moving from red to neutral tones in the thiosulphate bath.[76] Gustave Le Gray, the most influential writer on photographic printing at the time, consistently

recommended using old fixing baths (or artificially exhausted fixer) to control the colour of the silver image in both salt prints and albumen prints in the series of handbooks he authored in the early 1850s.[77] The Le Gray treatises were translated into English soon after their original release and were widely available in Britain.[78]

In 1847 P.-F. Mathieu mentioned using a heated solution of gold chloride – similar, he says, to that used to fix daguerreotypes – as a supplement to toning salted paper prints with old hypo. This would immediately produce "beautiful black tones" on prints of "doubtful" colour.[79] His reference to the daguerreotype gilding solution indicates that he was using gold chloride mixed with thiosulphate, the sel d'or formulation in which the gold is available in its reduced state as gold(I). This form of the metal is far more efficient as a photographic toner than the unreduced gold(III) available in a simple acidic solution of gold chloride. Le Gray's instructions regarding gold toning are more ambiguous, referring both to "sel d'or" and to "acidic gold chloride." As early as 1851, Louis-Adolphe Humbert de Molard indicated a toning method that involved moving the print directly from an ammonia fixing bath into a gold bath, a technique that may have produced an efficient alkaline gold-toning process.[80]

While Le Gray's recommendations for printing evolved somewhat over the four versions of the Traité, he consistently referred to gold toning using an acidified solution of gold(III) chloride, a technique that requires heavy overprinting in the exposure stage since the unreduced gold solution will itself bleach the silver image to a large extent. In 1852, in the third version of the Traité, Le Gray added a separate chapter describing a new processing sequence for making salted paper prints, "to obtain positive prints on paper with varied coloration and greater stability than those made using the older processes."[81] Here he placed the acidified gold-toning step before fixing in fresh thiosulphate. This sequence – toning as a separate step before fixing – would become the standard procedure for printing-out papers, including albumen paper. As early as 1856, Hardwich pointed out the advantages of using the reduced form of the metal, gold(I), in an alkaline gold toner formulation.[82] By the end of the 1850s, Le Gray was convinced of the superior performance of the neutral or alkaline gold toner in its reduced form; in his case he used a mixture of gold chloride with calcium chloride.[83]

The question of toning, whether with old thiosulphate fixing baths or with gold, was germane not only to controlling the colour of silver images but was also an important factor in the preoccupying

question of print permanence. The fact was that many – but not all – photographic prints made at this time faded and yellowed within a few years (or months, or weeks) of their production. After many heated exchanges in the photographic press and after commissions of scientific enquiry had been struck in both Britain and France, the problems of catastrophic fading were largely diagnosed and resolved.[84] Along with a number of other factors, the details of toning treatments, both with sulphur and gold compounds, were recognized as a significant influence in the stability of albumen and salted paper prints. James Reilly summarizes the chemistry of gold and sulphur toning and describes the eventual adoption of an optimal method that did away with the "old hypo" method of toning, replacing it with toning in an alkaline solution of reduced gold followed by fixing in strong fresh thiosulphate.[85]

Further complicating the material nature of early photographic prints is the frequent presence of surface coatings applied after the prints had been fully processed. Transparent coatings were applied to saturate or intensify the tones of the images giving them greater "depth," to increase or to decrease surface gloss, to protect the silver images from deterioration, and to alter their surface tension so that water-based paints could be applied.[86] Coating materials referred to in early publications include shellac resin and wax (1840s),[87] copal (1844), Canada balsam resins (1846),[88] gelatin (1847),[89] albumen used as a post-process coating on salted paper prints (1853),[90] and the water-soluble polysaccharide, gum arabic (1854).[91] Coating with "white wax" applied as a solution in turpentine ("encaustic") was widely recommended as a means of protecting the silver images of both salted paper and albumen prints from the type of fading caused by oxidizing agents in the atmosphere[92] (see cat. 31 and fig. 8).

Similarly, mechanical finishing processes could be applied to alter the surface of processed prints. As early as 1854, the photographic supply house of Alexis Gaudin, based in Paris but with a branch in London, was advertising the availability of a glazing press in which the processed print surface was placed against a polished steel plate and pressed between two rolling iron cylinders.[93] This imparted an increased gloss to the surface of the print, whether plain paper or albumen, coated or not.

As we have seen, in this transitional period of the 1850s photographers were producing both albumen prints and salted paper prints. There is no reliable distinction in the image tones inherent in the two processes, colour being much more dependant on the choice of paper and on the details of sensitization, fixing, and toning. Both plain and albumenized prints show a significant but variable tendency to fade. Only surface gloss might visually distinguish albumen from salt prints, but owing to the early practice of diluting the albumen with water before applying it to the sheet, this distinction is subtle at best and often imperceptible. Post-processing treatments such as coating and glazing may further alter the surface gloss of a print, independent of the paper surface and binder.

How should print processes of the 1850s be categorized?
How should particular prints be assigned to a category?

Ken Jacobson gives a list of medium descriptions that have been used to identify prints with characteristics thought to be intermediate between those of the salted paper print and the albumen silver print:[94]

> albumen and salt print
> albumen-sized salt print
> albumenised salt print
> arrowroot print
> coated salt print
> dilute albumen print
> early albumen print
> early albumenised print
> encaustic salt print
> hybrid print
> lightly albumenised print
> lightly albumenised salt print
> matte silver print
> starch print
> transition print
> varnished salt print
> waxed salt print

Jacobson further proposes a new classification based on degree of gloss:

Descriptor	Degree of gloss
salt print	lower gloss
non-matte salt print developed salt print light albumen print	intermediate gloss
albumen print	higher gloss

Each of the descriptors can be understood on its own terms, derived from either observable characteristics or detectable material components. In practice, though, such characteristics are rarely clear. Furthermore, relative distinctions between such terms are fluid and, as Jacobson states, "each scholar must use his or her best judgement based on experience."[95]

Fig. 8 John Stewart, *Portrait of Sir John Herschel, Bart. F.R.S.,* before 1855, albumen silver print?, waxed. Plate 1 from *The Photographic Album for the Year 1855*. National Gallery of Canada, Ottawa (20515.1)

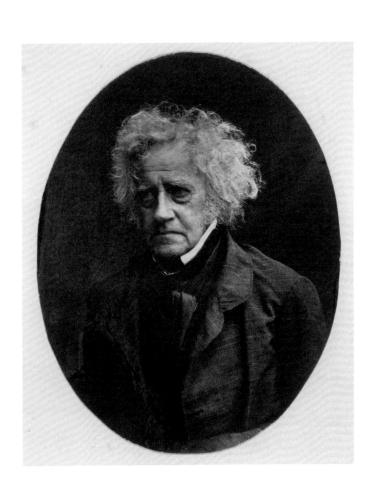

Underlying such appeals to connoisseurship is an assumption that there are prototypes that represent the most authentic form of both the salted paper print and the albumen silver print. These are distinguished by their own characteristic "feel" – combining features of gloss, image tone, and the degree of "embeddedness" of the silver image particles. The appeal to prototypes signals that we are touching on the complex area of categorization theory, a subject that has connections to philosophy, cognitive psychology, and mathematics.

The classical method of categorization, as outlined by Aristotle, posits categories built from lists of defining features. The categories are clearly defined, mutually exclusive, and collectively exhaustive. A new item is assigned to a single category based on an analysis of its features and comparison to the defining features of the category. Subcategories are arranged in a tree-like or hierarchical arrangement. This is the type of system that one might imagine is used to sort photograph print media into their various categories.

In fact, what happens is closer to the prototype method of categorization, a paradigm outlined only late in the last century by Eleanor Rosch,[96] which categorizes items based on their resemblance to a prototype that represents the category. Membership in a category is a matter of degree; some members appear to be closer to the prototype than others and there is no mandatory defining attribute necessary for membership. Nor are the boundaries between categories mutually exclusive; rather, categories may have some degree of overlap at their outer limits.

The prototype model corresponds to the connoisseurship method of visually identifying and categorizing photographic prints. The experienced and knowledgeable observer holds in her mind the models, or prototypes, of an albumen silver print and a salted paper print. New items are judged in relation to their proximity to these prototypes. Some new items will be closely similar to a prototype; others will be positioned in a "penumbra of decreasingly typical examples" surrounding the prototype.[97] Some may be in more than one category; these may be accounted for by creating new intermediate categories with new qualified names and their own prototypes. The result is medium descriptors of increasing qualification and complexity, as demonstrated by Jacobson's list cited above. It also leads to the conclusion – perhaps not an unreasonable one – that an albumen print is a print that resembles other prints that we (experts) call albumen prints.

A further variant on methods of categorization is the exemplar model. Here there are no pre-defined rules or prototypes. Category sets are generated by a dynamic process of adding one example after another and observing clusters of objects sharing similar characteristics emerge as the data set grows larger. (Of course, the characteristics that are to be observed and the means of observation must be defined and may be added to as the process proceeds.) When performed by a computer program on very large data sets, this technique is called data clustering. The clusters formed constitute categories populated with related items or examples. In this case, no example is any "truer" or more typical of the category than any other one. This is a categorization procedure that is well-suited to interpreting analytical data, such as that produced by spectroscopic analysis of photographic prints.

To categorize early photographs, the most meaningful approach is something closer to the classic model using prescriptive definitions than to data clustering or to the use of self-referential prototypes. Fundamental to our understanding of why prints look the way they do is an appreciation of the environment in which the silver halide micro-crystal is formed during the sensitization step. Is the silver halide formed in the interstices of the paper fabric or is it instead formed in a thin transparent layer of egg albumen distributed over the paper's surface? Our distinctions between printing methods should primarily reflect this fundamental distinction. While dilution of the albumen binder and post-processing coating and finishing operations may alter the surface of the print – and confuse visual and instrumental differentiation – the most meaningful and consistent distinction to be made is between prints prepared with a simple salting step prior to sensitization (salted paper) and those that use a salt and albumen mixture at that stage of the process (albumenized paper). The overwhelming majority of prints from this era should be simply classed as either salted paper prints or albumen prints. The only qualification to be added is in the case where a coating has been applied after the printing process was completed. A separate category is probably justified for the developed-out prints made by Blanquart-Évrard and others in the 1850s since the mechanism of silver image formation in these is fundamentally different from that of the printing-out processes.[98]

Jacobson points out that there are many instances of salted paper prints that are not perfectly matte and albumen prints that show less gloss than expected. Given this ambiguity, we should not

depend so much on gloss as a primary feature for determining print medium in photographic prints of the 1850s. But if we are to depend less on surface gloss for our determination, what features should we use? Inevitably, we must rely less on the observations of traditional visual connoisseurship, since it is precisely this method that has left us with questions, mis-identifications, and a proliferation of ill-defined categories. What will increasingly take the place of visual identification is evidence from several instrumental methods.

What can instrumental analysis tell us about early photographic prints?

Examination of early photographic prints with scientific instruments used to determine the identity of materials promises some clarification in this confused and confusing state of affairs.[99] Generally, these instruments fall into one of two categories: the first includes methods that project electromagnetic energy onto a surface and then detect and analyze the energy reflected or emitted from the surface; the second category includes imaging methods – extensions of traditional optical microscopy – that use sophisticated optical and digital imaging technology to resolve the spatial distribution of various materials through the thickness of a photographic print. In some instruments, the spectroscopic and optical methods are combined.

Currently, Fourier transform infra-red (FTIR) spectroscopy is being used by a number of researchers to characterize the organic compounds found on early photographic prints as size, binders, and coatings.[100] FTIR provides reliable identification of organic compounds such as albumen, gelatin, wax, and other materials that may be present on photographic prints. To a limited extent, FTIR analysis can determine the relative quantities of such materials and, since infra-red energy is capable of penetrating these thin layers, can detect multiple layers of material located one on top of the other. For instance, both albumen and wax can be detected on an albumen print that has been waxed in a post-processing treatment.

FTIR analysis does not distinguish starch additives from the cellulose fibres that make up the paper support. Nor does it provide a map of the complex layering of materials that may be found on photographic prints. Such analysis does not identify the inorganic elements and organo-metallic complexes that constitute the image structure of photographs.

Identification of inorganic image materials – primarily silver, gold, and platinum in early photographic prints – is done using another spectrometric method,

X-ray fluorescence (XRF) analysis.[101] This technique allows for quantitative identification of elements present that have atomic numbers greater than 10. Since XRF, like FTIR, will not map the location of the materials identified within the structure of the photograph, some metallic impurities in the paper support of the print will be reported along with the imaging materials. Nor does XRF specify the compounds formed by the association between metals and organic compounds – organo-metallic complexes – that are commonly the state in which image material exists in early photographic prints.

In order to detect and identify these organo-metallic complexes, another technique, Raman spectroscopy, offers some promise. Furthermore, internal maps of the structure of early photographic prints, identifying and locating the position of both organic and inorganic components, may be elicited in the future by scanning electron microscopy linked to energy dispersive X-ray spectroscopy (SEM-EDX), by the application of confocal microscopy, and by other existing, non-destructive imaging techniques that will no doubt be applied to the examination of objects of cultural heritage in the near future.

During the summer of 2007, Dusan Stulik and his colleague Art Kaplan at the Getty Conservation Institute (GCI), Los Angeles, undertook the examination of the National Gallery of Canada's copy of *The Photographic Album for the Year 1855* (fig. 9) using FTIR (see cat. 13, 15, 30, 37, 38, 43, 44, 61, 64 and fig. 43.2). Their analysis of the data obtained provides us with a model for how analytical science will inform the question of medium identification of early photographs in the future. Essentially, they have distinguished eight FTIR profiles among the forty-three prints in the album based on the presence, intensity, and relative strengths of spectral signals that indicate the presence of proteins and beeswax. Their results and the resulting media identifications are summarized in Table 3.[102]

Table 3: FTIR spectra evidence from
The Photographic Album for the Year 1855

Indicated in FTIR spectra		Interpretation	Medium identification	Number of prints in this category	
protein	beeswax				
none	none	no protein present	salted paper print	4	
minimal	none	possible presence of protein, perhaps as paper size	salted paper print?	3	8
minimal	present	possible presence of protein, perhaps as paper size; coated with beeswax	salted paper print?, coated with wax	1	
present, weak	none	thin albumen layer	albumen silver print?	6	
present, weak	present	thin albumen layer, coated with beeswax	albumen silver print?, coated with wax	2	
present	none	albumen layer	albumen silver print	26	35
present, strong	none	thick albumen layer			
present	present, weak	albumen layer, possibly coated with wax	albumen silver print, coated with wax	1	

In thirty-five out of forty-three cases, the medium identification based on the FTIR examination essentially agreed – discounting queries and coatings – with the previous medium identification based on visual evidence alone. In eight cases prints that were previously thought to be salted paper were re-assigned to the albumen categories. All four of the prints found to be coated with wax had not previously been suspected of having such a coating.

How does all of this evidence point the way towards a fuller understanding of photographic practice in the nineteenth century? The GCI analyses serve as an example of what can now be accomplished with instrumentation commonly used in the analysis of museum objects. When placed in conjunction with results from complementary and yet to be tried analytical methods, especially those sophisticated imaging technologies that have emerged in the past twenty years but which have yet to be applied to the analysis of our cultural heritage, we can look forward to gaining a refined understanding of early photographic prints and a more accurate technical history of the changes that took place in printing during the 1850s.

Acknowledgements

I am thankful to the J. Paul Getty Museum, Department of Paper Conservation, and to the Getty Conservation Institute for the opportunities they gave me to study the early history of photographic printmaking during two periods of residence in Los Angeles. While at the Getty Center, my research work was greatly facilitated by the staff of both the Getty Research Institute and the Information Center of the Conservation Institute. I would particularly like to thank Judy Santos for her untiring assistance.

John P. McElhone
Conservator
Restoration and Conservation Laboratory
National Gallery of Canada

Fig. 9 Cover, *The Photographic Album for the Year 1855*

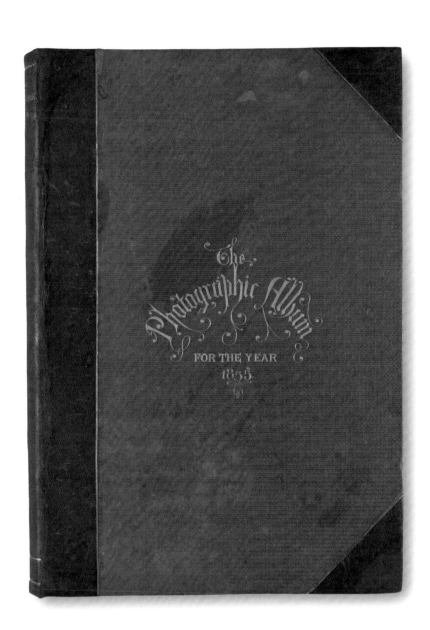

The Photographic Album

FOR THE YEAR
1855

Notes

Introduction

1 Mrs. Fulhame, *An Essay on Combustion, with a View to a New Art of Dying and Painting wherein the Phlogistic and Antiphlogistic Hypotheses are Proved Erroneous* (London: J. Cooper, 1794). Elizabeth Fulhame was married to Dr. Thomas Fulhame, who is listed as living on Edinburgh's Bristo Street in 1793 according to the *Edinburgh Directory from July 1793 to July 1794* (Edinburgh: Thomas Aitchison).

2 This patent was acquired with the help of Miles Berry, a patent agent working in Britain on behalf of Daguerre and Joseph Nicéphore Niépce.

3 British Patent #8194, 1839/02/02, p. 2/21, http:www.1839.org/ global documents/00000001.pdf

4 Called the *Journal of the Photographic Society* when it first appeared in 1853, the title was shortened in 1859 to *The Photographic Journal*. It contained exhibition reviews, practical advice, advertisements, announcements, and correspondence from members.

5 Pictures "bear the imprint of their makers," whereas documents "appear to be generated automatically without a maker." Photography, according to Edwards, is a practice that is both art and document. See Steve Edwards, *The Making of English Photography: Allegories* (University Park: Pennsylvania State University Press, 2006), pp. 11–14.

6 Julia Jackson Duckworth, the niece of Julia Margaret Cameron, became the mother of Virginia Woolf.

7 See, for example, Charles Dickens, *Hard Times* (London: Bradbury and Evans, 1854) and Henry Mayhew, *London Labour and the London Poor* (London, 1851–52).

8 These concerns are analyzed in Martin J. Wiener's classic study *English Culture and the Decline of the Industrial Spirit, 1850–1980*, 2nd ed. (Cambridge: Cambridge University Press, 2004).

9 Officially named The Great Exhibition of the Works of Industry of All Nations, the exhibition was a world's fair of culture and industry that opened 1 May and closed 1 October 1851.

Cat. 1

1 George Stillman Hillard, *Six Months in Italy*, 10th ed. (Boston: Ticknor and Fields, 1867), p. 298.

2 According to *Rome in Early Photographs: The Age of Pius IX: Photographs 1846–1878 from Roman and Danish Collections* (Copenhagen: Thorvaldsen Museum, 1977), p. 40. In 1839 he exhibited three paintings at the annual exhibition of the Società degli Amatori e Culori delle Belle Arti under the name James Anderson. In 1841, under the name William Nugent Dunbar, Anderson exhibited a watercolour titled *Roman Peasants* at the Liverpool Academy of Arts.

Cat. 2

1 He apprenticed at the firm of Tullis in Cupar. See Sara Stevenson, *Thomas Annan, 1829–1887*. Edinburgh: National Galleries of Scotland, 1990), p. 4.

2 The dates of their friendship are open to question, but "it is possible that Thomas Annan knew of the Hill-Adamson partnership when he was still a teenager, and Hill might have encouraged Annan to set up business in 1855 as a photographer rather than an engraver." In 1865 Hill asked Annan to photograph his painting *The Signing of the Deed of Demission*. Ibid., pp. 6, 8.

3 Narrow passageways leading from the street to a tenement building or courtyard. See cat. 7.

4 A second volume of carbon prints with an additional nine images (a total of forty images) was issued by the Glasgow City Improvements Trust in quarto size (one hundred copies). Two photogravure editions of *The Old Closes and Streets*, each containing fifty plates, were published in 1900. *Thomas Annan, Photographs of the Old Closes and Streets of Glasgow, 1868/1977*, new introduction by Anita Ventura Mozley (New York: Dover Publications, 1977), pp. v–vi.

5 Annan's photographs of the slums of Glasgow are seen as the precursor to other important social documentary projects such as John Thomson's *Street Life in London* (1878), A. & J. Bool's and Henry Dixon's *Relics of Old London* (1875–85), or Lewis Hine's work for the National Child Labor Committee (1907–17). *The Old Closes and Streets* is also strongly connected to earlier work, including David Octavius Hill's views of Edinburgh (1840s), the ambitious Monuments Historiques in France (1851), and, most directly, Alexander Burns's views of Edinburgh closes (1860s; see cat. 7).

6 Annan added clouds to his images and whitened the long johns and bed sheets. See *Photographs of the Old Closes and Streets of Glasgow*, p. xi.

7 See Rachel Stuhlman, "'Let Glasgow Flourish': Thomas Annan and the Glasgow Corporation Waterworks," *Image* 35, nos. 3–4 (Fall–Winter 1992), pp. 39–51.

Cat. 3

1 See Larry J. Schaaf, *Sun Gardens: Victorian Photograms by Anna Atkins* (New York: Aperture, 1985).

Cat. 4

1 Bedford may have come to the Queen's attention through the publishers Day & Son Ltd., Royal Lithographers to Queen Victoria and known as Britain's leading colour printmakers of art objects.

Cat. 6

1 Pauline Heathcote, "Samuel Bourne of Nottingham," *History of Photography* 16, no. 2 (April 1982), p. 100.

Cat. 7

1 The book was produced in two different formats, published in Edinburgh by Edmonston & Douglas and in London by Simpkin Marshall & Co. in 1868. The fifteen original albumen photographs by Archibald Burns were tipped in, with descriptive and historical notes written by Thomas Henderson.

2 A close is a narrow passageway off a street. See also cat. 2.

3 John Gifford, Colin McWilliam, and David Walker, *Edinburgh* (Harmondsworth: Penguin, 1984), p. 216.

Cat. 8

1 The National Gallery of Canada's portrait of Speedy and Álámáyou is dated 20 July 1868 and an entry in William Allingham's diary for 21 August 1868 mentions a photographing session: "Friday August 21. — Mrs. Cameron's: Captain Speedy opens the door. Little Alamayu, pretty boy, we make friends and have romps, he rides on my knee, shows his toys … They dress to be photographed by Mrs. C, the Prince in a little purple shirt and a necklace, Captain Speedy in a lion-skin tippet, with a huge Abyssinian sword of reaping-hook shape ('point goes into your skull') … Speedy grumbles a little, Mrs. C. poses." *William Allingham, A Diary*, ed. H. Allingham and D. Radford (London: Macmillan, 1908), pp. 185–86.

2 The young Álámáyou was also photographed by Jabez Hughes on the Isle of Wight. In Hughes's studio portraits, the prince is shown dressed in clothing that was conventional for young British boys of the time.

3 Quoted in Darrell Bates, *The Abyssinian Difficulty* (Oxford: Oxford University Press, 1979), pp. 218–19.

Cat. 9

1 For an account of the Cheney family and their considerable artistic interests, see Huon Mallalieu, *Watercolours of the Grand Tour*, Christie's, London, auction catalogue, 12 October 2005.

2 Quoted in Richard Pare, *Photography and Architecture: 1839–1939* (Montreal: Canadian Centre for Architecture, 1982), p. 221.

3 For a fuller account of the friendship between Cheney and Capel Cure, see Roger Taylor, *Impressed by Light: British Photographs from Paper Negatives, 1840–1860* (New Haven: Yale University Press, 2007), pp. 97–103.

Cat. 10

1 The firm sold sheet glass, lamp shades, and glass domes, but from the early 1840s began supplying optical glass and photographic materials. See Michael Pritchard, "Houghton, George," in *Encyclopedia of Nineteenth-Century Photography*, ed. John Hannavy (New York: Routledge, 2008), p. 716.

2 These daguerreotypes come through the Bokelberg collection and Phyllis Lambert.

3 Laura Claudet, "Colouring by Hand," in *Encyclopedia of Nineteenth-Century Photography*, pp. 322–23.

Cat. 11

1 See Roger Taylor, *Impressed by Light: British Photographs from Paper Negatives, 1840–1860* (New Haven: Yale University Press, 2007), p. 299; and Larry J. Schaaf, *Sun Pictures Catalogue Ten: British Paper Negatives, 1839–1864* (New York: Hans P. Kraus, Jr., 2001), pp. 92–101. Professor Lee Fontanella, an expert on the life and work of Charles Clifford, has published most of his work in Spanish. See *Clifford en España: Un Fotógrafo en la Corte de Isabel II* (Madrid: Ediciones El Viso, 1997), pp. 75–78; and *Photography in Spain in the Nineteenth Century* (San Francisco: Fraenkel Gallery, 1983), pp. 8–9, 16–20.

2 Schaaf, *Sun Pictures*, p. 92.

3 The sculpture of Saint Bruno was made in the seventeenth century by Mañuel Pereira (sometimes spelled Peyreras).

4 See letter from Lee Fontanella to Hazel MacKenzie, 13 June 1991, Artist's File, National Gallery of Canada.

5 One other print is in the collection of the Metropolitan Museum of Art in New York (2005.100.65).

6 See Maria Morris Hambourg, *The Waking Dream, Photography's First Century: Selections from the Gilman Paper Company Collection* (New York: Metropolitan Museum of Art, 1993), p. 300.

7 Schaaf, *Sun Pictures*, p. 92.

Cat. 12

1 The armour itself was recently included in the 2009 exhibition *The Art of Power: Royal Armor and Portraits from Imperial Spain*, organized by the National Gallery of Art, Washington, DC, the State Corporation for Spanish Cultural Action Abroad, and the Patrimonio Nacional of Spain (see no. 19 in the exhibition catalogue).

2 After studying the reports to the Victoria and Albert Museum prepared by John Charles Robinson as well as letters between Robinson and Jane Clifford about the photographs of objects in the Spanish Royal Armoury, the Clifford expert Lee Fontanella has concluded that the negatives for these photographs were probably made by Charles Clifford and that the prints were made by Jane Clifford. Lee Fontanella, telephone conversation with the author, 21 October 2010.

3 "In the reign of Isabel II the collection was re-installed and re-arranged. A catalogue was issued in 1849 for the first time, the author being Don Antonio Martinez del Romero, a work displaying considerable research and industry, but full of errors and completely superseded by the catalogue published in 1898 by Conde de Valencia de San Juan." Albert Frederick Calvert, *Spanish Arms and Armour, Being a Historical and Descriptive Account of the Royal Armoury of Madrid* (New York: John Lane Publishers, 1907), p. 141.

4 Calvert, *Spanish Arms and Armour*, plates 104, 100, and 24. Although the author supplies no details about the makers of the photographic illustrations in this book, in his preface he states, "I have been greatly helped by Señor Don Lacoste and Messrs. Hauser y Menet, whose photographs other than those taken by myself, are with their permission, reproduced here." Ibid., p. ix.

Cat. 14

1 See Michael Hallett, "Dancer, John Benjamin (1812–1887)," in *Encyclopedia of Nineteenth-Century Photography*, ed. John Hannavy (New York: Routledge, 2007), p. 379.

2 According to the 1861 census for Manchester, Dancer's four eldest children were involved in the family business – Josiah, aged twenty-four, John, aged twenty-two, and James, aged seventeen, were all employed as opticians. William, aged twenty, was a chemist. The three eldest sons were the subject of another of Dancer's daguerreotype portraits probably made about ten years earlier in 1851 (see fig. 14.1).

3 A stereo daguerreotype from the National Gallery of Canada's collection, and possibly Dancer's self-portrait, was probably made shortly after his invention of the binocular stereoscopic camera (see fig. 14.2).

Cat. 15

1 Other photographs included in this album were the Count de Montizón's *Hippopotamus* (cat. 38) William Lake Price's *The Miniature* (cat. 44), and Robert Howlett's *The Valley of the Mole* (cat. 31).

2 Elaine Shefer, "'The Bird in the Cage' in the History of Sexuality: Sir John Everett Millais and William Holman Hunt," *Journal of History of Sexuality 1*, no. 3 (January 1991), pp. 446–80.

3 It assumed that Fenton was also a founding member of the Calotype Club. Other members included Peter Wickens Fry, Peter le Neve Foster, Frederick Scott Archer, Joseph Cundall, Hugh Owen, Dr. Hugh Diamond, Edward Kater, Robert Hunt, Charles Vignoles, F. W. Berger, and Sir William Newton.

Cat. 16

1 The photographs appeared as 120 plates with text, published in London by the Society. The series as a whole is documented in Graham Bush, *Old London: Photographed by Henry Dixon and Alfred & John Bool for the Society for Photographing Relics of Old London* (London: Academy Editions; New York: St. Martin's Press, 1975). Dixon printed the Bools' negatives, but in 1879 Dixon & Son took over the photography and continued the project. The change may be due partly to Dixon's expertise with the now commercially available gelatin dry plates (he is credited with writing an article that year on the advantages of the new technology). See Pat Eaton, in *Relics of Old London: Photography and the Spirit of the City* (exhibition handout), Royal Academy of Arts, 10 February–22 June 2010 (static.royalacademy.org.uk/files/ra-relics-of-old-london-handout-659.pdf).

2 *Relics of Old London: Photography and the Spirit of the City.*

3 http://hansard.millbanksystems.com/commons/1984/mar/05/st-mary-overy-wharf (accessed 25 September 2010).

4 One of the most stable of photographic images, carbon prints were frequently used for book illustrations and commercial editions. It was particularly suitable for publications as it reproduced images without grain. The process takes its name from the carbon lampblack used as a colorant, although tissues with a variety of different pigments were available (the pigment-charged film of gelatin was supported on thin paper, the "tissue"). See Hope Kingsley, "Carbon Prints," in *Encyclopedia of Nineteenth-Century Photography*, ed. John Hannavy (New York: Routledge, 2007), pp. 270–71; and John P. McElhone, "Carbon Print," in James Borcoman, *Magicians of Light: Photographs from the Collection of the National Gallery of Canada* (Ottawa: National Gallery of Canada, 1993), p. 258.

Cat. 18

1 http://www.londonstereo.com/index.html (accessed 11 June 2010).

2 His brother John and sisters Sarah and Jane were all involved in some aspect of the business of photography.

3 Henry Baden Pritchard, *The Photographic Studios of Europe* (London: Piper and Carter, 1882; facsimile reprint, New York: Arno Press, 1973), p. 15.

Cat. 19

1 Practising commoners need to own or rent land with common rights attached (for example, grazing rights).

2 John R. Wise, *The New Forest: Its History and Its Scenery* (London, 1863), p. 17.

3 The tree is likely to be a pedunculate or English oak (*Quercus robur*). Information from David Mabberly, Keeper of the Herbarium, Library, Art and Archives, Royal Botanic Gardens Kew. English oaks were planted in the New Forest for their acorns, valuable as pig feed. In a practice known as pannage, New Forest commoners let their pigs loose to graze on acorns and whatever else they could find.

Cat. 20

1 Anne Hammond, *Frederick H. Evans: Selected Texts and Bibliography* (Boston: G. K. Hall & Co., 1992), p. 21.

2 Frederick Evans, "Wells Cathedral," *Photography*, 18 July 1903, p. 65.

3 Ian Jeffrey, "Photography and Nature," *Art Journal* 40, no. 1 (Spring 1981), p. 31.

4 Evans, "Wells Cathedral," p. 65.

Cat. 21

1 Alfred Stieglitz, "Our Illustrations," *Camera Work*, no. 4 (October 1903), p. 25.

Cat. 22

1 John Hannavy, "John Cooke Bourne, Charles Blacker Vignoles and the Dneiper Suspension Bridge at Kyiv," *History of Photography* 28, no. 4 (Winter 2004), p. 336.

2 Hans Kraus, "Roger Fenton: A Family Collection," in *Sun Pictures Catalogue Fourteen* (New York: Hans P. Kraus, Jr., 2005), p. 22. Fenton also photographed other wooden cottages on the banks of the Dnieper.

3 Wheatstone's reflecting stereoscope utilized mirrors in which two individual prints were positioned across from each other and allowed for a single virtual three-dimensional image to be seen on the two mirrors that reflected the photographs on either side of the viewer.

4 A work Fenton sent to his friend and colleague Paul Jeuffrain and one formerly in Robert Hershkowitz's collection.

5 Charles Blacker Vignoles, journal entry for 11 June 1853, British Library Manuscripts, in Hannavy, "John Cooke Bourne," p. 341.

6 There are at least eight examples of Fenton's work in the Wheatstone collection at King's College London, including scenes from his 1852 visit to Russia.

Cat. 23

1 The most detailed account of Fenton's life is given in Gordon Baldwin, Malcolm Daniel, and Sarah Greenough, *All the Mighty World: The Photographs of Roger Fenton, 1852–1860* ((New Haven and London: Yale University Press, 2004).

2 For details of Fenton's exhibiting activities, see Roger Taylor, *Photographs Exhibited in Britain, 1839–1865* (Ottawa: National Gallery of Canada, 2002), and the related website http://peib.dmu. ac.uk/. Between 1852 and 1862, Fenton exhibited well over 1,000 images, the largest group being his Crimean series of 360 images. To promote print sales, Thomas Agnew and Sons, his backer and publisher, exhibited the prints in towns and cities throughout Britain for almost a year.

3 Following his marriage in 1843, Fenton moved to Paris, where he became a pupil of the neoclassical artist Michel-Martin Drolling. After his return to London in 1847, Fenton studied under Charles Lucy, a history painter and Royal Academician.

4 Lt. Gen. Sir Neil Cantlie, *A History of the Army Medical Department* (Edinburgh and London: Churchill Livingstone, 1974), p. 29.

5 Roger Fenton, "Narrative of a Photographic Trip," *Journal of the Photographic Society*, 21 January 1856, pp. 284–91.

6 These statistics are given in "The Navvies at Balaklava," *London Journal*, 3 March 1855, p. 8.

7 Ibid.

Cat. 24

1 Queen Victoria, manuscript entry, 3 January 1854, Royal Archives, Windsor Castle. This manuscript, the only surviving version of the journal, is not the original but a copy transcribed by Princess Beatrice after the queen's death. Also quoted in John Hannavy, *Roger Fenton of Crimble Hall* (Boston: David R. Godine, 1976), p. 30.

2 For a detailed account of Queen Victoria's patronage of Fenton, see Roger Taylor, "Mr Fenton Explained Everything," in *All the Mighty World: The Photographs of Roger Fenton, 1852–1860* (New Haven and London: Yale University Press, 2004).

3 See Letter number 3, "Roger Fenton's Letters from the Crimea," http://rogerfenton.dmu.ac.uk/index.php

4 Quotation taken from title page of the exhibition catalogue *Photographic Pictures Taken in The Crimea* (Manchester: Thomas Agnew and Sons, 1856).

5 Fenton's invoice for this commission reveals that he made eight studies for the Queen, for which he charged her the handsome sum of five guineas each. Roger Fenton to Queen Victoria, invoice for negatives and prints, 1857, PPTO/PP/QV/PP2/22/7526, Royal Archives, Windsor Castle.

6 This speculative itinerary has been drawn up from titles of prints Fenton exhibited at the 1st Annual Exhibition of the recently formed Photographic Society of Scotland, in December 1856 (see http://peib.dmu.ac.uk). It is conceivable he made this journey in reverse order, but this seems unlikely given the lateness of the season. The date is taken from one of his subjects, the Braemar Gathering, that opened on 11 September 1856 (see "Braemar Gathering," *Aberdeen Journal*, 17 September 1856).

7 "Her Majesty's Journey Northwards," *Aberdeen Journal*, 2 and 3 September 1856. This report describes each stage of the rail journey with details of the ceremonials at each stop.

8 Quoted in Delia Millar, *Queen Victoria's Life in the Scottish Highlands* (London: Philip Wilson, 2003), p. 22.

9 Ibid., entry for 16 September 1848, p. 61.

10 The streak running diagonally above the heads of the ghillies to the right of the image was caused by a narrow pinpoint of light leaking into the camera.

Cat. 26

1 They intended to publish a portfolio of their work on Newhaven, a project never realized in their day, but finally accomplished by Sara Stevenson in *Hill & Adamson's The Fishermen and Women of the Firth of Forth* (Edinburgh: Scottish National Portrait Gallery, 1991). See fig. 26.2 for another remarkable image of fisher folk (possibly) by Hill and Adamson. The photograph may be the work of Robert Adamson's older brother, Dr. John Adamson, or someone in his circle. See Larry J. Schaaf, in *Sun Pictures Catalogue Eleven: St. Andrews and Early Scottish Photography including Hill & Adamson* (New York: Hans P. Kraus, Jr., 2002), pp. 74–75.

2 The title on a portrait of Mrs. Elizabeth Hall (née Johnstone), in the James Wilson Album, Scottish National Portrait Gallery.

3 D. O. Hill to Henry Sanford Bicknell, 17 January 1849 (erroneously dated by Hill 17 January 1848, apparently forgetting the New Year). George Eastman House, Rochester, New York.

Cat. 28

1 The identification of this sitter as William Etty's niece was made by Leonard Robinson who has devoted a section of his book *William Etty: The Life and Art* (Jefferson, N.C.: McFarland, 2007) to the subject of Betsy.

2 Alexander Gilchrist, *Life of William Etty, R. A.*, vol. 2 (London: David Bogue, 1855), p. 7. "Am going this morning (June 14th) to take Jane, Cicely, and my Betsey, to the Corregios at the National Gallery, which have just been purchased at the expense of twelve hundred guineas."

Cat. 29

1 It is possible that Hogg borrowed Beard's studio to make the daguerreotype himself – or it may have been made by Richard Beard (or his business partner) and the camera operator at his studio, John Frederick Godard. The image was most likely made to be used as an illustration in Hogg's *A Practical Manual of Photography* (London: E. Mackenzie, Cleave, Clark, 1845).

2 Both of these images were originally part of the Bokelberg collection. See *Forty Daguerreotypes from the Bokelberg Collection*, introduction by Richard Hough (Edinburgh Scottish Arts Council, 1980).

3 See James Borcoman, *Intimate Images* (Ottawa: National Gallery of Canada, 1988), p. 4.

Notes

Cat. 30

1 Willats was also a manufacturer and dealer in photographic supplies. From about 1845 onwards, he compiled an album that contains over three hundred of the earliest paper photographs. The album is now housed at Princeton University. See http://diglib.princeton.edu/xquery?_xq=getCollection&_xsl=collection&_pid=gc131willats (accessed 26 June 2010).

2 See Horne's obituary, *Journal of the Photographic Society* 5 (21 October 1858), p. 36; *Photographic Notes* 3 (1 November 1858), p. 252; and Roger Taylor, *Impressed by Light: British Photographs from Paper Negatives, 1840–1860* (New Haven: Yale University Press, 2007), p. 330.

3 Frederick Scott Archer (1813–1857), inventor of the wet-collodion negative on glass.

4 See Taylor, *Impressed by Light*, p. 330.

5 Horne adds that the focal length of the lens was eleven inches, the diameter three and a quarter inches, and that it was opened to full aperture.

Cat. 31

1 *Kelly's Directory of Norfolk and Suffolk*, ed. E. R. Kelly (London: Kelly and Company, 1882), p. 1059.

2 Howlett was to photograph "as many groups of people as possible from the roof of the cab." Thomas Sutton, quoted in Carolyn Bloore, "Robert Howlett, 1831–58," in Grace Seiberling, *Amateurs, Photography, and the Mid-Victorian Imagination* (Chicago and London: University of Chicago Press, 1986), p. 133.

3 The text is an excerpt from Shelley's "Alastor; or, the Spirit of Solitude" (1816).

4 For example, *The River Mole, Dorking Surrey* and *The Mole, Dorking, Surrey*, by Henry H. Parker (1858–1930).

Cat. 32

1 Calvert R. Jones to William Henry Fox Talbot, 21 December 1845. LA45-177, Fox Talbot Collection, British Library, London. Talbot Correspondence Project Document no. 05488.

2 Calvert R. Jones to William Henry Fox Talbot, 8 July 1846. LA46-80. Fox Talbot Collection, British Library, London. Talbot Correspondence Project Document no. 05685.

3 The original negative is in the collection of the Smithsonian's National Museum of American History, Washington, D.C.

Cat. 33

1 Chartism was a nineteenth-century political movement named for the People's Charter, a document drafted by the London Working Men's Association that called for, among other reforms, universal male suffrage, voting by ballot, and annual Parliaments.

Cat. 34

1 William Henry Fox Talbot, "Photoglyphic Engraving of Ferns with Remarks," *Transactions of the Botanical Society of Edinburgh* 7, nos. 1–4 (June 1863), pp. 568–70.

Cat. 35

1 William Gilpin, *Remarks on Forest Scenery, and Other Woodland Views,* vol. 1 (London: R. Blamire, 1791), p. 8.

2 According to the catalogue of the auction from which this photograph was purchased by the previous owner. See provenance above.

Cat. 36

1 See Roger Taylor, *Photographs Exhibited in Britain, 1839–1865: A Compendium of Photographers and Their Works,* Occasional Paper No. 5 (Ottawa: National Gallery of Canada, 2002).

2 James MacLehose, *Memoirs and Portraits of One Hundred Glasgow Men* (Glasgow, 1885).

3 Beatrice Stewart Erskine, *Anna Jameson: Letters and Friendships, 1812–1860* (London: T. Fisher Unwin, 1915), p. 301.

Cat. 37

1 Dr. Thomas Lukis Mansell, obituary, *Guernsey Magazine* 11 (July 1879).

2 The Photographic Society Club was one of the organized groups of amateurs who exchanged photographs during the mid-1850s. See Grace Seiberling, *Amateurs, Photography, and the Mid-Victorian Imagination* (Chicago and London: University of Chicago Press, 1986), pp. 1–17.

Cat. 38

1 John Timbs, ed., *The Year-Book of Facts in Science and Art* (London: David Bogue, 1851), p. 225.

2 According to the text that accompanies the photograph in the album. De Montizón's reference to a double lens means that he was using an early version of a compound lens that allowed for less distortion. The term "instantaneous exposure" is a reference to the sensitivity of the collodion plate and the speed with which exposures could be made – permitting the photographer to capture an image of animals (or humans) even if they moved slightly.

Cat. 39

1 William Thoms was the founder and editor of the journal *Notes and Queries*. See Grace Seiberling, *Amateurs, Photography, and the Mid-Victorian Imagination* (Chicago and London: University of Chicago Press, 1986), pp. 139, 146.

2 Ibid.

3 Linda Nochlin, *Courbet Reconsidered* (New Haven: Yale University Press, 1988), p. 150.

4 Richard R. Brettell, *Paper and Light: The Calotype in France and Great Britain, 1839–1870* (Boston: David R. Godine, 1984), p. 154.

5 Barbara Marie Stafford, "Rude Sublime: The Taste for Nature's Colossi during the Late 18th and Early 19th Centuries," *Gazette des Beaux-Arts* 88 (April 1976), pp. 113–26.

Cat. 40

1 John Hannavy, ed., *Encyclopedia of Nineteenth-Century Photography* (New York: Routledge, 2007), p. 956.

2 C. Jabez Hughes, "My Impressions of Photography in Paris; Autumn 1861," *The Photographic News*, 20 December 1861, p. 602.

3 "James Mudd," Collections Centre, Museum of Science and Industry, Manchester.

Cat. 41

1 The zoopraxiscope, a device Muybridge invented in 1879, consisted of a projecting lantern, a circular glass disk painted with drawn copies of Muybridge's photographs, and a slotted metal disk that acted as a shutter. The two disks spinning in opposite directions with light flickering through the slots in the metal disk gave the illusion of continuous movement. See Phillip Prodger, *Muybridge and the Instantaneous Photography Movement* (New York: Oxford University Press, 2003), p. 154.

2 Along with Thomas Eakins, many American and European artists were interested in Muybridge's work, among them Carolus-Duran, Degas, Puvis de Chavannes, Remington, Rodin, and Whistler. More recently, the American cartoonist R. Crumb used *Animal Locomotion* for his *Book of Genesis Illustrated* (2009): "It includes hundreds of photos of naked people in action, really handy for any kind of cartoon work where you have to draw people realistically in different actions and poses." See "R. Crumb, The Art of Comics No. 1," *The Paris Review,* no. 193 (Summer 2010), p. 26.

3 Marta Braun, "The Expanded Present: Photographing Movement," in Ann Thomas, *Beauty of Another Order: Photography in Science* (New Haven and London: Yale University Press, in association with the National Gallery of Canada, 1997), pp. 173–74.

Cat. 42

1 According to census records, Owen may have moved back and forth between London as a consequence of his position with the Great Western Railway. At the age of forty-two, Owen was a widower, residing in Bristol with his eight-year-old daughter, Betsey Lydia Owen, who eventually appears on the census with the occupation of artist. (In 1843 she married Benjamin Hinde, a surgeon from Ireland.) By 1871 Hugh Owen is recorded as a lodger in London, where he is still living in 1891. He died in Paddington, London, aged 101.

2 In the end, the *Reports by the Juries* included forty-three photographs by Ferrier and twenty-eight by Owen.

Cat. 43

1 From Old French *coque* (boat), and Old Norse *sveinn* (boy or lad).

2 An official who accompanied a judge on circuit, with secretarial and social duties. See *Canadian Oxford Dictionary*, 2nd ed. (Toronto: Oxford University Press, 2004).

Cat. 44

1 Work began in 1854 on a new Reading Room at the centre of the British Museum. Designed by Sydney Smirke, the round Reading Room took three years to build. Smirke requested that photographs be taken at intervals to record the progress of construction.

2 William Lake Price, *A Manual of Photographic Manipulation of Treating the Practice of the Art and its Various Applications to Nature* (London: John Churchill, 1858).

3 See Carolyn Bloore, "William Lake Price, 1810–95," in Grace Seiberling, *Amateurs, Photography, and the Mid-Victorian Imagination* (Chicago and London: University of Chicago Press, 1986), p. 143.

Cat. 45

1 Also known as *Night in Town*, *Night in London*, *The Outcast*, or simply *Homeless*.

2 The idea of providing free education for poor children was developed by John Pounds (1766–1839), a Portsmouth shoemaker. These charity schools became known as Ragged Schools. See C. J. Montague, *Sixty Years in Waifdom or the Ragged School Movement in English History* (London: Charles Murray, 1904).

3 A. H. Wall, "Exhibition Gossip," *British Journal of Photography*, 15 July 1862, p. 274.

Cat. 46

1 While this signed panorama has neither an inscribed nor published date, it was certainly made in 1857, based on Robertson and Beato's brief partnership, which lasted only one year, and on their jointly exhibiting a *Panorama of Constantinople* at the inaugural exhibition of the Architectural Photographic Association, which opened in London on 7 January 1858. Robertson had made a seven-part panorama, also taken from the Beyazit tower, in 1854. A copy was sold at Sotheby's, Belgravia (London), 28 October 1981, lot 334.

2 These skeletal biographies are drawn from the following sources: Bridget A. and Heinz K. Henisch, "James Robertson of Constantinople: A Chronology," *History of Photography* 14, no. 1 (January–March 1990), pp. 23–32; Bahattin Öztuncay, *James Robertson: Pioneer of Photography in the Ottoman Empire* (Istanbul: Eren, 1992); John Clark, John Fraser, and Colin Osman, "A Revised Chronology of Felice (Felix) Beato (1825/34?–1908?)," in John Clark, *Japanese Exchanges in Art, 1850s to 1930s with Britain, Continental Europe, and the USA: Papers and Research Materials*, 2nd ed. (Sydney: Power Publications, 2001), pp. 89–120; and Terry Bennett, "The Death of Felix Beato," in his *History of Photography in China, 1842–1860* (London: Quaritch, 2009), p. 241.

Cat. 47

1 Henry Peach Robinson, *The Elements of a Pictorial Photograph* (London and Bradford: Percy Lund, 1896), pp. 33–34.

2 Henry Peach Robinson, *Pictorial Effect in Photography, Being Hints on Composition Chiaroscuro for Photographers* (London: Piper and Carter, 1869; Pawlet, Vt.: Helios, 1971), pp. 149, 119.

Cat. 48

1 William Sherlock to William Henry Fox Talbot, 15 November 1843. LA43-86, Fox Talbot Collection, British Library, London. Talbot Correspondence Project Document no. 04896.

2 William Sherlock to William Henry Fox Talbot, 2 March 1846. LA46-34, Fox Talbot Collection, British Library, London. Talbot Correspondence Project Document no. 05593.

Cat. 49

1 This short history of W. H. L. Skeen & Co. is drawn from John Falconer's "Nineteenth Century Photography in Ceylon," *The Photographic Collector* 2, no. 2 (Summer 1981): 41–43.

Cat. 50

1 See Bill Jay, *Customs and Faces: Photographs by Sir Benjamin Stone, 1838–1914* (London: Academy Editions, 1972).

2 Benjamin Stone, *Sir Benjamin Stone's Pictures*, 2 vols. (London: Cassell and Co., 1906).

Cat. 52

1 William Henry Fox Talbot, "Introductory Remarks," in *The Pencil of Nature* (London: Longman, Brown, Green, & Longmans, 1844), no. 1, n.p.

Cat. 53

1 William Henry Fox Talbot, *The Pencil of Nature* (London: Longman, Brown, Green, & Longmans), part two, January 1845, plate X, "The Haystack."

2 Talbot's text for plate X, in *The Pencil of Nature*.

3 Talbot's text for plate X, in *The Pencil of Nature*.

4 The dated negative is in the National Media Museum, Bradford (1937-1248).

5 *Athenaeum*, no. 904, 22 February 1845, p. 202.

6 *The Art-Union* 7, 1 March 1845, p. 84.

7 *Literary Gazette*, no. 1463, 1 February 1845, p. 73.

Cat. 54

1 William Henry Fox Talbot, *The Pencil of Nature* (London: Longman, Brown, Green, & Longmans), part 2, January 1845, text for plate VI, "The Open Door."

2 *The Art-Union* 7, 1 March 1845, p. 84. None of the known works by the seventeenth-century Dutch artist Philips Wouvermans are in this style, but the comparison with Dutch painting is appropriate.

3 *Literary Gazette*, no. 1463, 1 February 1845, p. 73.

4 No. 162. "The Open Door" was one of several *Pencil of Nature* plates that Talbot placed in this exhibition. See the *Catalogue of an Exhibition of Recent Specimens of Photography Exhibited at the … Society of Arts … in December 1852* (London: Printed by Charles Whittingham for the Society, 1852).

5 William Henry Fox Talbot, *Some Account of the Art of Photogenic Drawing, or the Process by which Natural Objects may be made to Delineate Themselves without the Aid of the Artist's Pencil* (London: Printed by R. and J. E. Taylor, 1839).

Cat. 55

1 John William Ward, 1st Earl of Dudley, to Edward Coplestone, Bishop of Llandaff, 27 November 1821, in *Letters of the Earl of Dudley to the Bishop of Llandaff* (London: John Murray, 1840), p. 298.

2 William Henry Fox Talbot, *The Pencil of Nature* (London: Longman, Brown, Green, & Longmans), part 3, May 1845, plate XIV, "The Ladder."

3 Talbot's text for plate XIV, in *The Pencil of Nature*.

4 Discussion following Mr. Rothwell's talk, "On the apparently incorrect Perspective of Photographic Pictures …," *The Photographic Journal* 7, no. 103 (15 November 1860), p. 33.

5 The dated negative is in the National Media Museum, Bradford (1937-1294).

6 *Athenaeum*, no. 920, 14 June 1845, pp. 592–93.

Cat. 56

1 While Talbot was completing the photographs for *Sun Pictures*, the construction of a memorial tower for Sir Walter Scott was nearing completion in Edinburgh – a scene that Talbot photographed and included as one of the twenty-three images in *Sun Pictures*. See Larry J. Schaaf, *The Photographic Art of William Henry Fox Talbot* (Princeton and Oxford: Princeton University Press, 2000), p. 202 and plate 85.

2 Larry J. Schaaf, *Sun Pictures Catalogue Nine: William Henry Fox Talbot: Friends and Relations* (New York: Hans P. Kraus, Jr., 1999), p. 54. The Hon. John George Charles Fox-Strangways, Gentleman Usher to Queen Adelaide and Member of Parliament for Calne, was with the Foreign Office. He lived at Brickworth House in Wiltshire.

3 See http://www.metmuseum.org/toah/works-of-art/1997.382.4 (accessed 21 September 2010).

Cat. 57

1 William Henry Fox Talbot, plate XXIV, in *The Pencil of Nature* (London: Longman, Brown, Green, & Longmans, 1844), n.p.

Cat. 58

1 John Thomson, *The Antiquities of Cambodia* (Edinburgh: Edmonston and Douglas, 1867), n.p.

2 Stephen White, *John Thomson: Window to the Orient* (Albuquerque: University of New Mexico Press, 1985), p. 14.

3 Thomson, *Antiquities*, n.p.

Cat. 59

1 James Bryson claimed to have made a portrait daguerreotype as early as 1839. Around 1845 David Octavius Hill and Robert Adamson photographed his father, Robert Bryson, an Edinburgh watchmaker, holding a watch.

2 The series, which originally appeared in periodical form, was published as a book in 1877.

3 A "crawler" designated someone who lived in the street.

4 John Thomson and Adolphe Smith, *Street Life in London* (London: Sampson, Low, Marston, Searle and Rivington, 1877; New York and London: Benjamin Blom, 1969), pp. 118–19.

Cat. 60

1 From the outset, Tripe employed a large-format camera that took 15 × 12-inch negatives. For biographic details and a catalogue raisonnée of his photographs, see Janet Dewan, *The Photographs of Linnaeus Tripe* (Toronto: Art Gallery of Ontario, 2003).

2 A detailed account of the mission is given by Captain Henry Yule, *A Narrative of the Mission to the Court of Ava in 1855* (London: Smith, Elder & Co, 1858; reprint, Uckfield, Sussex: Rediscovery Books, 2006).

3 Letter of appointment Cecil Beadon, Secretary to Government of India, to Colesworthy Grant, IOR/P/SEC/191, 15 June 1855, #5. Original manuscript, British Library.

4 Charles Knight, "Birma, or the Birman Empire," in *Cyclopaedia of Geography* (London: Bradbury and Evans, 1856), vol. 1, column 1094.

5 Tripe, published caption to *Pugahm Myo, Ananda Pagoda*; see Dewan, p. 236.

6 The first version of Henry Yule, *A Narrative of the Mission to the Court of Ava in 1855* (Calcutta: Baptist Mission Press, 1856), was published as a first draft and contains numerous errata notes and marginalia. Information about the building of the Kyoung is cited in a footnote, p. 43, but was not included in the revised edition, subsequently published in London in 1858 (see cat. 60, note 2). See also Dewan, p. 237.

Cat. 61

1 The Chamberlain family sold the farm in 1864 to Robert Berkeley.

2 Possibly the camera seen in a double portrait by Turner of his wife and her brother from 1855 (see fig. 61.1).

3 Philip D. Turner, "A Brief Account of My Family," undated typescript (c. 1935), quoted in Martin Barnes, *Benjamin Brecknell Turner: Rural England through a Victorian Lens* (London: Victoria and Albert Publications, 2001), note 1, p. 73.

4 The notes from the *Photographic Album for the Year 1855* also indicate that Turner used: "Lens by A. Ross; focal length twenty inches; diameter four inches; diaphragm half an inch." Photographic Exchange Club, *Photographic Album for the Year 1855* (Bath: Royal Photographic Society, 1855–56), n.p.

5 "England does not abound in grand and sublime prospects, but rather in little home-scenes of rural repose and sheltered quiet. Every antique farm-house and moss-grown cottage is a picture." The passage is taken from Washington Irving's book *The Sketchbook of Geoffrey Crayon*, published serially between 1819 and 1820. It is from the section titled Rural Life in England, published on 31 July 1819. The writings later appeared in hardcover, published by George Putnam in England.

6 Barnes, *Benjamin Brecknell Turner*, pp. 25–26.

7 Larry J. Schaaf, *Sun Pictures Catalogue Ten: British Paper Negatives, 1839–1864* (New York: Hans P. Kraus, Jr., 2001), p. 52.

Cat. 62

1 *An Englishwoman in India: The Memoirs of Harriet Tytler, 1828–1858*, ed. Anthony Sattin (Oxford: Oxford University Press, 1986).

2 Beato arrived in Calcutta in February 1858, and in April or May of the following year he went to Delhi. Dr. John Murray was posted to India in 1833 as a part of the Bengal Medical Service, the unit that employed Robert Tytler's father. Arriving in Delhi in February 1858, Murray made sixty-two calotypes and over two hundred stereoscopic views, mostly of the area's architecture. Several sources claim that Beato and Murray gave the Tytlers instruction in photography between 1858 and 1859, the same period in which they produced most of their extraordinary images.

3 "Report of the Photographic Society of India," *Englishman* (Calcutta), 31 March 1859, quoted in Larry J. Schaaf and Roger Taylor, "Biographical Dictionary of British Calotypists," in Roger Taylor, *Impressed by Light: British Photographs from Paper Negatives, 1840–1860* (New Haven: Yale University Press, 2007), p. 386.

4 Christopher Hudson, "The Woman Who Watched Delhi Fall," *Sunday Times*, 17 June 2007.

Cat. 63

1 Ray McKenzie, "Landscape in Scotland: Photography and the Poetics of Place," in *Light from the Dark Room: A Celebration of Scottish Photography* (Edinburgh: National Galleries of Scotland, 1995), p. 77.

2 William Dobson Valentine and George Dobson Valentine. George moved to New Zealand in 1884 for health reasons and established himself there as a landscape photographer. See Orla Fitzpatrick, "Valentine, George D. (1852–1890)," in *Encyclopedia of Nineteenth-Century Photography*, ed. John Hannavy (New York: Routledge, 2007), pp. 1433–34.

3 William Henry Fox Talbot, quoted in McKenzie, "Landscape in Scotland," p. 74.

4 For an illuminating discussion of the sublime in the context of the Forth Bridge, see Iain Boyd Whyte, "A sensation of immense power," in Iain Boyd Whyte and Angus J. Macdonald, *John Fowler, Benjamin Baker, Forth Bridge* (Stuttgart and London: Edition Axel Menges, 1997), pp. 9–10.

Cat. 64

1 A PLEASANT picture, full of meanings deep,
Old age, calm sitting in the July sun,
On withered hands half-leaning – feeble hands,
That after their life-labors, light or hard,
Their girlish broideries, their marriage-ringed
Domestic duties, their sweet cradle cares,
Have dropped into the quiet-folded ease
Of fourscore years. How peacefully the eyes
Face us! Contented, unregretful eyes,
That carry in them the whole tale of life
With its one moral – 'Thus all was – thus best.'
Eyes now so near unto their closing mild
They seem to pierce direct through all that maze,
As eyes immortal do.

Here – Youth. She stands
Under the roses, with elastic foot
Poised to step forward; eager-eyed, yet grave
Beneath the mystery of the unknown To come,
Though longing for its coming. Firm prepared
(So say the lifted head and close, sweet mouth)
For any future: though the dreamy hope
Throned on her girlish forehead, whispers fond,
'Surely they err who say that life is hard;
Surely it shall not be with me as these.'

God knows: He only. And so best, dear child,
Thou woman-statured, sixteen-year-old child,
Meet bravely the impenetrable Dark
Under thy roses. Bud and blossom thou
Fearless as they – if thou art planted safe,
Whether for gathering or for withering, safe
In the King's garden.

2 The so-called Bath chair was invented in 1783 by John Dawson. These chairs, which could be steered by the user but still needed to be pushed by someone else, were typically used to transport patients and guests at the thermal water spas in the city of Bath.

3 This photograph may have been shown in 1856 as *Wood Scene with Figures* at the Exhibition of the Photographic Society of Scotland in Edinburgh. It shows a woman in a white dress standing in a wooded landscape with three young children (possibly the photographer's family.)

4 One critic, writing in *Cosmos* in October 1856, commented, "English landscapes … are generally remarkable for their wonderful delicacy of detail and sharpness of outline, joined to artistic feeling and good taste in choice of subjects. The studies and landscapes of Mr. White … have particularly struck us … they have elicited from connoisseurs an admiration without bounds." Quoted in *The Golden Age of British Photography, 1839–1900*, ed. Mark Haworth-Booth (Millerton, New York: Aperture, 1984), p. 50.

Cat. 65

1 Most of the biographical information presented here is based on the research and writing of Brian May and Elena Vidal. See http://www.londonstereo.com/index.html, the website of the London Stereoscopic Society (accessed 17 August 2010).

2 Born in 1854 as the London Stereoscope Company, by 1856 it had changed its name to the London Stereoscopic Company. In May 1859 it became the London Stereoscopic and Photographic Company.

Cat. 66

1 Melson was educated at Woodhouse Grove School from 1819 to 1825. In 1825 he was apprenticed to a Birmingham surgeon, Thomas Harris, and practised as a surgeon from 1836 until his death. He studied at Cambridge University, where he obtained his BA and MB (he was awarded his MD in 1841). In 1840 Melson was appointed magistrate of the borough of Birmingham, and in 1889 was recorded as being the senior resident magistrate of the town. Melson was also a Wesleyan preacher for forty years, a physician to Queen's Hospital, Birmingham, and a professor of experimental philosophy and hygiene at Queen's College, Birmingham. See Frederic Boase, *Modern English Biography*, vol. 6 (London: Frank Cass & Co. 1965; first published 1921), pp. 194–95; and *Birmingham Faces and Places* 1, no. 9 (1 January 1889), pp. 129–32.

2 Although claims were made at the time for his ownership of the first daguerreotype and an association with the eponymous inventor of the daguerreotype, Jacques Louis Mandé Daguerre, these claims are unfounded. Daguerre never visited England and there is no indication of John Barritt Melson's having been in Paris around the time of Daguerre's announcement.

3 The spelling appears in almost all possible variant forms: Ste Croix, St. Croix, De Ste. Croix, and de Ste Croix. It has even been speculated that this was an assumed name. One hypothesis is that he selected Ste Croix because his first demonstration of the daguerreotype in London fell on 14 September, the Catholic feast day of the Holy Cross, known as the Fête de Ste-Croix in France. See R. Derek Wood, "The Enigma of Monsieur de Ste Croix," *History of Photography* 17, no. 1 (Spring 1993), p. 106.

4 Peter James, "Ste Croix and the Daguerreotype in Birmingham," *History of Photography* 17, no. 1 (Spring 1993), p. 107.

5 Ibid.

6 Ibid.

7 John McElhone, Conservator, Photographs, National Gallery of Canada, RCL Examination Report (Supplement), 26 January 2001 [p. 1].

8 A possible contender for the authorship of this work is John E. Mayall (Manchester, 17 September 1813–6 March 1901, Southwick, near Brighton).

Cat. 67

1 Caroline Isabella Grantham Chittenden (Hatfield, Hertfordshire, 1 April 1822–21 January 1882, Broxbourne, Hertfordshire).

2 The album also contains eight albumen silver prints.

3 Hatfield House was built by Robert Cecil, first Earl of Salisbury, and completed in 1611.

The Transition of Photographic Printing in the 1850s

1 [Thomas A. Malone], *Liverpool Photographic Journal* 2, no. 22 (13 October 1855), p. 121.

2 *The Photographic Album for the Year 1855*, from which many of the figures illustrating this essay are drawn, was privately published by the members of the Photographic Society Club, an off-shoot organization of the Photographic Society. It contained prints by forty-four photographers, each elaborately mounted and described and all handsomely bound in a gilt-edged volume (see fig. 9). A second volume was produced by the Photographic Society Club in 1857.

3 The authoritative modern text on albumen prints – and salted paper prints – is James M. Reilly, *The Albumen and Salted Paper Book: The History and Practice of Photographic Printing, 1840–1895* (Rochester: Light Impressions, 1980). The website *Albumen Photographs: History, Science and Preservation* (http://albumen.conservation-us.org/) is an invaluable reference in understanding and identifying albumen prints.

4 Louis-Désiré Blanquart-Évrard (1802–1872), French inventor, entrepreneur, publisher, and photographer. Blanquart-Évrard made a number of crucial contributions to early photographic printing. Before becoming involved with photography, he studied chemistry and was known as an accomplished miniaturist. In addition to introducing albumen printing, he pioneered a method of making stable photographic prints that could be scaled up to achieve an industrial output, allowing him to successfully publish more than twenty photographically illustrated books in the 1850s.

5 Blanquart-Évrard, "Photographie sur papier," *Comptes rendus des séances de l'Académie des sciences* 30, no. 21 (27 May 1850), pp. 663–65. Three years earlier, Blanquart-Évrard had given the Académie des sciences a description of his methods for making paper negatives, neglecting to cite Talbot as the inventor of the process. The uproar that this caused – Talbot called it a "glaring act of scientific piracy" – led the Académie des beaux-arts to commission a panel of artists and scientists to report on the merits of Blanquart-Évrard's methods. Their report, while it did not satisfy the claims of patent infringement, did recognize Talbot's primacy in paper photography. The complete description of a reliable method of making paper negatives presented in such a reputable forum marked the start of the widespread adoption of photography on paper in France, where up until then the daguerreotype had dominated photographic practice.

6 Ibid., p. 665 (author's translation).

7 See Grace Seiberling, *Amateurs, Photography and the Mid-Victorian Imagination* (Chicago: University of Chicago Press, 1986), and Roger Taylor, *Impressed By Light: British Photographs from Paper Negatives, 1840–1860* (New York: Metropolitan Museum of Art, 2007) for insights on the social dynamics at work during this period, when paper photography moved from the purview of moneyed amateur experimentalists to commercial entrepreneurs.

8 Thomas Sutton, *A New Method of Printing Positive Photographs* (St Brelade's Bay, Jersey, 1855), p. 4.

9 As printing methods diversified in the 1850s, prints made in this way were also referred to as "plain paper prints" and even as "prints made in the ordinary way."

10 Alfred S. Taylor, "Our Weekly Gossip (Ammonio-Nitrate of Silver)," *The Athenaeum*, no. 670 (29 August 1840), p. 684; Robert Hunt, *A Popular Treatise on the Art of Photography* (Glasgow: Richard Griffin and Co., 1841); George Thomas Fisher, Jun., *Photogenic Manipulation* (London: George Knight and Sons, 1843); George S. Cundell, "On the Practice of the Calotype Process in Photography," *The London, Edinburgh and Dublin Philosophical Magazine and Journal of Science* 24 (third series), no. 160 (May 1844), pp. 321–32.

11 The halide used was almost invariably chloride derived from sodium chloride ($NaCl$), common table salt, although ammonium, barium, and strontium chloride are also mentioned, as well as the alternative halide, bromide, in the form of potassium bromide (KBr). Iodide is not generally used in formulations for printing-out papers, but may appear in the preparation of printing papers designed to be developed.

12 Most formulations for printing paper call for a simple solution of silver nitrate, at a concentration of between 15 and 25% (w/v), to sensitize the salted paper. An early variation is due to the forensic scientist Alfred Swaine Taylor, who sensitized the salted paper with a preparation called ammonio-nitrate of silver (ANS; silver diamine complex; $[Ag(NH_3)_2]^+$). See Mike Ware, *Mechanisms of Image Deterioration in Early Photographs* (London: Science Museum, 1994), pp. 29, 80, for explanations of how ANS sensitizer produced papers with higher photosensitivity and more neutral image tones.

13 William Henry Fox Talbot, "Photogenic Drawing (Further Discoveries)," *Literary Gazette*, no. 1153 (23 February 1839), pp. 123–24. Reprinted in Beaumont Newhall, ed., *On Photography: A Source Book of Photo History in Facsimile* (Watkins Glen, N.Y.: Century House, 1956), pp. 73–74.

14 Ware, *Image Deterioration*, p. 31. Analytical evidence of bromide fixation was found in a study of the prints of the early Scottish photographer John Adamson (1809–1870) by Katherine Eremin, James Tate, and James Berry, "On the Chemistry of John and Robert Adamson's Salted Paper Prints and Calotype Negatives," *History of Photography* 27, no. 1 (Spring 2003), p. 29.

15 The use of the sulphur compound thiosulphate, which John Herschel recommended to Talbot, was widely publicized. See John F. W. Herschel, "On the Chemical Action of the Rays of the Solar Spectrum on Preparations of Silver and Other Substances, Both Metallic and Non-Metallic, and on Some Photographic Processes," *Philosophical Transactions of the Royal Society of London*, part 1 (London: Taylor, 1840), p. 4. Available on microfilm in the *History of Photography* series (Woodbridge, Conn.: Research Publications, 1982), reel 88, no. 954. Thiosulphate was also the source of some of the complex inorganic chemical reactions that produced attractive coloration (tones) in photographic prints. At the same time, frustratingly, its use led to the destabilization of the silver images, causing the unpredictable fading of prints that plagued photography through these first decades.

16 Thanks to Dr. Mike Ware for his generous advice regarding the chemistry and material science of early photographic systems as evidenced in this paragraph and throughout this essay.

17 Blanquart-Évrard, "Photographie sur papier," p. 665.

18 Gustave Le Gray, *Traité pratique de photographie sur papier et sur verre* (Paris: Baillière, 1850), pp. 30–3. Also in English as Gustave Le Gray, *A Practical Treatise on Photography, upon Paper and Glass*, trans. Thomas Cousins (London: T. & R. Willats, 1850). See also note 78.

19 Robert Bingham, *Photogenic Manipulation*, 8th ed. (London: George Knight and Sons, 1851), pp. 36–37.

20 Louis-Désiré Blanquart-Évrard, *Traité de photographie sur papier* (Paris: Roret, 1851), p. 115.

21 Gustave Le Gray, *Nouveau traité théorique et pratique de photographie sur papier et sur verre* (Paris: Lerebours et Secretan, 1851), pp. 69–70.

22 [Thomas A. Malone?], *The Handbook of Photography* (London: Charles W. Collins / Royal Polytechnic Institution, 1853), p. 46.

23 Philip H. Delamotte, *The Practice of Photography* (London: Joseph Cundall, 1853), p. 54.

24 Henry Pollock, "Mr. Pollock's Directions for Obtaining Positive Photographs upon Albumenised Paper," *Notes and Queries* 7, no. 189 (11 June 1853), p. 581.

25 Hugh W. Diamond, "Process for Printing on Albumenized Paper," *Notes and Queries* 8, no. 205 (1 October 1853), p. 325.

26 George Shadbolt, "Albumenized Paper," *Notes and Queries* 8, no. 208 (22 October 1853), p. 396.

27 T. Frederick Hardwick [*sic*], *A Manual of Photographic Chemistry* (New York: S.D. Humphrey, 1855), pp. 203–4.

28 Philip H. Delamotte, *Practice of Photography*, p. 54.

29 Hardwick [*sic*], *A Manual of Photographic Chemistry*, p. 141.

30 Ibid., p. 204.

31 George Shadbolt, "Some Observations upon Photographic Printing," *Journal of the Photographic Society* 2, no. 36 (21 November 1855), p. 256.

32 [George Shadbolt], "Photographic Papers," *Photographic Journal* (London) 6, no. 85 (1 January 1859), p. 3.

33 [Thomas Sutton], "On Positive Printing," *Photographic Notes* 1, nos. 1 and 2 (1 and 25 January 1856), p. vii.

34 Hunt, *Art of Photography*, p. 11.

35 Many of the most important additives are addressed in chapter 2 of Reilly, *Albumen and Salted Paper Book*. A comprehensive list of such additives is presented on p. 287 of Ken Jacobson's "Problematic Low-Sheen Salt and Albumen Prints," *History of Photography* 15, no. 4 (Winter 1991), pp. 287–93.

36 Gelatin is known to act as a halogen absorber in developing-out processes. In printing-out processes, however, gelatin – and albumen – are not effective halogen absorbers and do not super-sensitize the silver halide system. See Ware, *Image Deterioration*, p. 78.

37 Hunt, *Art of Photography*, pp. 21–23.

38 Alphonse de Brébisson, *Nouvelle méthode photographique* (Paris: Charles Chevalier, 1852), p. 50.

39 Hunt, *Art of Photography*, p. 11

40 Gustave Le Gray, *Photographie: Traité nouveau* (Paris: Lerebours et Secretan [1852]), pp. 24, 25, 50.

41 T. Frederick Hardwich, *A Manual of Photographic Chemistry*, 3rd ed. (London: John Churchill, 1856), p. 245.

42 Sutton, *Printing Positive Photographs*, pp. 9–10.

43 Brébisson, *Nouvelle méthode photographique*, p. 49.

44 Louis-Désiré Blanquart-Évrard, "Photographie sur papier: Impression photographique," *Comptes rendus des séances de l'Académie des sciences* 32, no. 15 (14 April 1851), p. 555.

45 [William John Thoms], "(Reply to Nedlam)," *Notes and Queries* 6, no. 156 (23 October 1852), p. 397.

46 Shadbolt, "Some Observations upon Photographic Printing," p. 257.

47 Parallel to the arrival of new printing methods during the late 1840s and the 1850s was the introduction of new methods of making negatives. After the improvements in the handling of the Talbot calotype process suggested by a number of authors through the 1840s, there followed Niépce de Saint-Victor's albumen on glass process (1847), the wet collodion on glass process (Le Gray, 1850, Scott Archer, 1851), and Le Gray's waxed paper process (1851). Roger Taylor and Mike Ware, in "'Pilgrims of the Sun': The Chemical Evolution of the Calotype, 1840–1852," *History of Photography* 27, no. 4 (Winter 2003), pp. 308–19, summarize comprehensively the changes that took place in methods of making negatives on paper.

48 Thomas Sutton, *The Calotype Process* (London: Joseph Cundall, 1855), pp. 67–68.

49 Charles Tomlinson, ed., "Paper," in *Cyclopedia of Useful Arts* (London: James S. Virtue, 1852–56), p. 358.

50 Workable designs for a papermaking machine were developed by Bryan Donkin in the period 1803 to 1804 for the Fourdrinier brothers, based on Nicholas-Louis Robert's original invention (1798). See Peter Bower, *Turner's Later Papers* (London: Tate Gallery Publishing, 1999), p. 33.

51 D.C. Coleman, *The British Paper Industry, 1495–1860* (Oxford: Clarendon Press, 1958), quoted in Bower, *Turner's Later Papers*, p. 20.

52 English paper manufacturers known to photographers of the 1850s include Nash, Sandford, Saunders, Towgood, Turner and, most famously, Hollingsworth (Whatman). French manufacturers include Canson, Blanchet Frères et Kleber (Rives, albumenized and resold by Marion), and Lacroix. A highly respected paper brand was Saxe (or Saxony), manufactured by Steinbach (in Malmédy, Germany, now Belgium).

53 Quoted in *Photographic Notes* 1, no. 8 (17 July 1856), p. 111.

54 Herschel, "On the Chemical Action of the Rays of the Solar Spectrum on Preparations of Silver," p. 8 (see n. 14); and Hunt, *Art of Photography*, p. 7.

55 Paper size is the modifying substance added during the paper manufacturing process that alters the finish, the surface, the absorbency, the "handle," and a myriad of other characteristics in the finished sheet. Internal size refers to substances added to the pulp prior to sheet forming, whereas external sizes are applied after the sheet has been formed.

56 A. Proteaux, *Practical Guide for the Manufacture of Paper and Boards* (Philadelphia: Henry Carey Baird, 1866), p. 20.

57 But at least one respected researcher claimed that it was not the material, but the quantity and effectiveness of the size that had a marked effect on image tone. See A. Davanne and J. Girard, "Étude générale des épreuves photographiques positives," *Bulletin de la Société française de photographie* 4 (March 1858), p. 74.

58 [George Shadbolt], "Photographic Papers," *Photographic Journal* 6, no. 85 (1 January 1859), p. 3.

59 Robert J. Bingham, *Photogenic Manipulation: Part 1* (London: George Knight and Sons, 1851), pp. 17–18.

60 Hardwich, *Manual of Photographic Chemistry*, 3rd ed., p. 243.

61 W. H. Thornthwaite, *A Guide to Photography* (London: Horne, Thornthwaite, and Wood, 1852), p. 38.

62 Shadbolt, "Some Observations Upon Photographic Printing," p. 258.

63 William J. Newton, "Sir W. Newton on the Use of Common Soda and Alum," *Notes and Queries* 7, no. 175 (5 March 1853), p. 245.

64 [William John Thoms], "Turner's Paper," *Notes and Queries* 9, no. 220 (14 January 1854), p. 41. Thoms notes that a batch of Towgood paper manufactured specifically for photographic purposes is well adapted for albumenizing and printing, but is not suitable for making paper negatives, presumably owing to its chlorine bleach residues.

65 Stéphane Geoffray, *Traité pratique pour l'emploi des papiers du commerce en photographie* (Paris: Cosmos; Delahaye, 1855), p. 36.

66 Hunt, *Art of Photography*, pp. 6–7. Hunt continued to point out the problems inherent in paper available at the time in his 1851 and 1854 publications. See also William Stones, "Photographic Paper," *Journal of the Society of Arts* 2, no. 73 (14 April 1854), pp. 373–74; and Thomas Sutton, "On Photographic Paper," *Photographic Notes* 1, no. 3 (25 February 1856), pp. 10–12.

67 Proteaux, *Practical Guide,* pp. 76–79. Earlier in the nineteenth century, the cobalt-containing glass, smalt, was finely ground and incorporated into paper pulp for the same purpose.

68 William Henry Fox Talbot, *Some Account of the Art of Photogenic Drawing* (London: R. and J. E. Taylor, 1839); reprinted in Newhall, ed., *On Photography*, p. 64.

69 Ware, *Image Deterioration*, pp. 71–75.

70 Hunt, *Art of Photography*, pp. 15–16, 31–32.

71 Eremin, Tate, and Berry, "John and Robert Adamson's Salted Paper Prints and Calotype Negatives," pp. 29–34.

72 The chemistry of the fixing bath and its toning (or "colouring") properties was extensively examined by Hardwich, starting in 1854. Frederick Hardwich, "On the Chemistry of Photographic Printing," *Journal of the Photographic Society* 2, nos. 22, 24, 25 (21 September, 21 November, 21 December 1854), pp. 35–37, 60–63, 78–82.

73 [Louis-Désiré] Blanquart-Évrard, "Photographie. – Supplément à une précédente communication concernant la photographie sur papier," *Comptes rendus des séances de l'Académie des sciences* 24, no. 15 (12 April 1847), p. 653.

74 George S. Cundell, "On the Practice of the Calotype Process of Photography," *The London, Edinburgh and Dublin Philosophical Magazine and Journal of Science* 24, no. 160 (May 1844), p. 331.

75 "La nuance de l'épreuve, d'abord d'un vilain ton roux et uniforme, passera à un belle nuance brune, puis au bistre, puis enfin au noir des gravures de l'aquatinta." [Louis-Désiré] Blanquart-Évrard, "Photographie. – Procédés employés pour obtenir les épreuves de photographie sur papier," *Comptes rendus des séances de l'Académie des sciences* 24, no. 4 (25 January 1847), p. 122.

76 [A.] Guillot-Saguez, *Méthode théorique et pratique de photographie sur papier* (Paris: Victor Masson, 1847), p. 22.

77 Gustave Le Gray, *Traité pratique de photographie*, p. 21; *Nouveau traité théorique et pratique de photographie* (Paris: Lerebours et Secretan, 1851), pp. 56–57; *Photographie: Traité nouveau théorique et pratique* (Paris: Lerebours et Secretan [1852]), pp. 56–57; *Photographie: Traité nouveau théorique et pratique* (Paris: Lerebours et Secretan, 1854), pp. 53–54.

78 Le Gray was the French author most immediately and faithfully translated into English. His writings were widely discussed and respected in Britain, unlike Blanquart-Évrard, whose name was somewhat suspect because of the conflict with Talbot. See Gustave Le Gray, *A Practical Treatise on Photography upon Paper and Glass*, trans. Thomas Cousins (London: T. and R. Willats, 1850); "A Practical Treatise on Photography," in *Photographic Manuals, No. 1, Plain Directions for Obtaining Photographic Pictures* (London: T. and R. Willats` [1851?]); "Photography on Paper: M. Le Gray's Process," in Charles Heisch, ed., *Photographic Manuals, No. 1, Part 2, Plain Directions for Obtaining Photographic Pictures* (London: Richard Willats [1853]).

79 P.-F. Mathieu, *Auto-photographie* (Paris: 1847), p. 14.

80 Louis-Adolphe Humbert de Molard, ["Sur le fixage des épreuves positives"], *Bulletin de la Société française de photographie* 1 (April 1855), p. 105, in which he reads from a paper presented in 1851 to the Société d'encouragement pour l'Industrie. Humbert's methods of using gold as a toner appeared quickly in translation in *Notes and Queries* 11, no. 293 (9 June 1855), p. 451; and *Liverpool Photographic Journal* 2, no. 19 (14 July 1855), pp. 91–92.

81 Le Gray, *Photographie: Traité nouveau* [1852]), pp. 60–71.

82 Hardwich, *Manual of Photographic Chemistry*, 3rd ed., p. 174.

83 Gustave Le Gray, "Sur un nouveau mode de virage au chlorure d'or," *Bulletin de la Société française de photographie* 5 (January 1859), p. 13. This communication was quickly translated and published in the *Photographic Journal* 6, no. 87 (1 February 1859), pp. 38–39; *Photographic Notes* 4, no. 68 (1 February 1859), pp. 40–42; and *Photographic News* 1, no. 22 (4 February 1859) p. 253.

84 The authoritative contemporary text on the causes of fading and the means of preparing prints that will not fade is given by Hardwich in chapter 8, section 4 of his *Manual of Photographic Chemistry*, 3rd ed., pp. 166–176. Also published in New York: "On the fading of photographic prints," *Humphrey's Journal* 8, no. 13 (1 November 1856), pp. 196–202.

85 Reilly, *Albumen and Salted Paper Book*, p. 78. See also Mike Ware, *Gold in Photography* (Brighton: ffotoffilm, 2006), pp. 109–18.

86 The coatings used on early photographic prints on paper are comprehensively described in Clara von Waldthausen, "Coatings on Salted Paper, Albumen, and Platinum Prints," in *Coatings on Photographs: Materials Techniques and Conservation*, ed. Constance McCabe (Washington, D.C.: Photographic Materials Group-AIC, 2005), pp. 78–95.

87 Ibid, p. 80, referring to prints by Eduard Isaac Asser held in the Rijksmuseum, Amsterdam.

88 "First Report of the Committee Appointed to Take into Consideration the Question of Fading ...," *Journal of the Photographic Society* 2, no. 36 (21 November 1855), p. 252.

89 Mathieu, *Auto-photographie*, p. 15.

90 Delamotte, *The Practice of Photography*, p. 59.

91 Julien Fau, *Douze leçons de photographie* (Paris: Charles Chevalier, 1854), pp. 76–77.

92 Robert Howlett, *On the Various Methods of Printing Photographic Pictures upon Paper* (London: Sampson Low, 1856), p. 31.

93 "Presses à satiner," *La Lumière*, 4th year, no. 41 (14 October 1854), p. 165.

94 Ken Jacobson, "Problematic Low-sheen Salt and Albumen Prints," *History of Photography* 15, no. 4 (Winter 1991), p. 287.

95 Ibid., p. 291.

96 Eleanor Rosch, "Principles of Categorization," in Eric Margolis and Stephen Laurence, eds., *Concepts: Core Readings* (Cambridge: MIT Press, 1999), pp. 189–206.

97 This discussion of categorization is informed by the excellent Wikipedia entry "Concept Learning," http://en.wikipedia.org/wiki/Concept_learning (accessed December 2009); and Daniel J. Levitin, *This Is Your Brain on Music: The Science of a Human Obsession* (New York: Dutton, 2006).

98 The idea of using a developing-out process, based on the Talbot calotype process, to make positive prints was first suggested, and quickly rejected, by Talbot himself ("An Account of Some Recent Improvements in Photography," *Proceedings of the Royal Society* 4, no. 48 [1841], p. 314). Ten years later, Hippolyte Bayard and Blanquart-Évrard both announced developing-out print processes (*Comptes rendus des séances de l'Académie des sciences* 32, no. 15 [14 April 1851], pp. 552–56). Variants on these processes were commercialized by both Blanquart-Évrard and Thomas Sutton, but printing by development remained an exceptional case until the advent of true emulsion papers in the 1880s.

99 Most of the analytical techniques applied to early photographs do not require any "sampling" (removal of a representative piece of material from the print). Where sampling is required, the quantity of material removed is minuscule and its loss is undetectable by the unaided eye.

100 Herant Khanjian and Dusan C. Stulik, "Infrared Spectroscopic Studies of Photographic Material," in Joyce H. Townsend, Katherine Eremin, and Annemie Adriaens, eds., *Conservation Science 2002: Papers from the Conference Held in Edinburgh, Scotland, 22–24 May 2002* (London: Archetype, 2003), pp. 195–200.

101 J. I. Enyeart, A. B. Anderson, and S. J. Perron, "Non-destructive Elemental Analysis of Photographic Paper and Emulsions by X-ray Fluorescence Spectroscopy," *History of Photography* 7, no. 2 (1983), pp. 99–113.

102 Dusan C. Stulik and Art Kaplan, unpublished analytical report, Getty Conservation Institute, 15 August 2007 (date of analysis).